FINE ART

P H O T O G R A P H Y 2

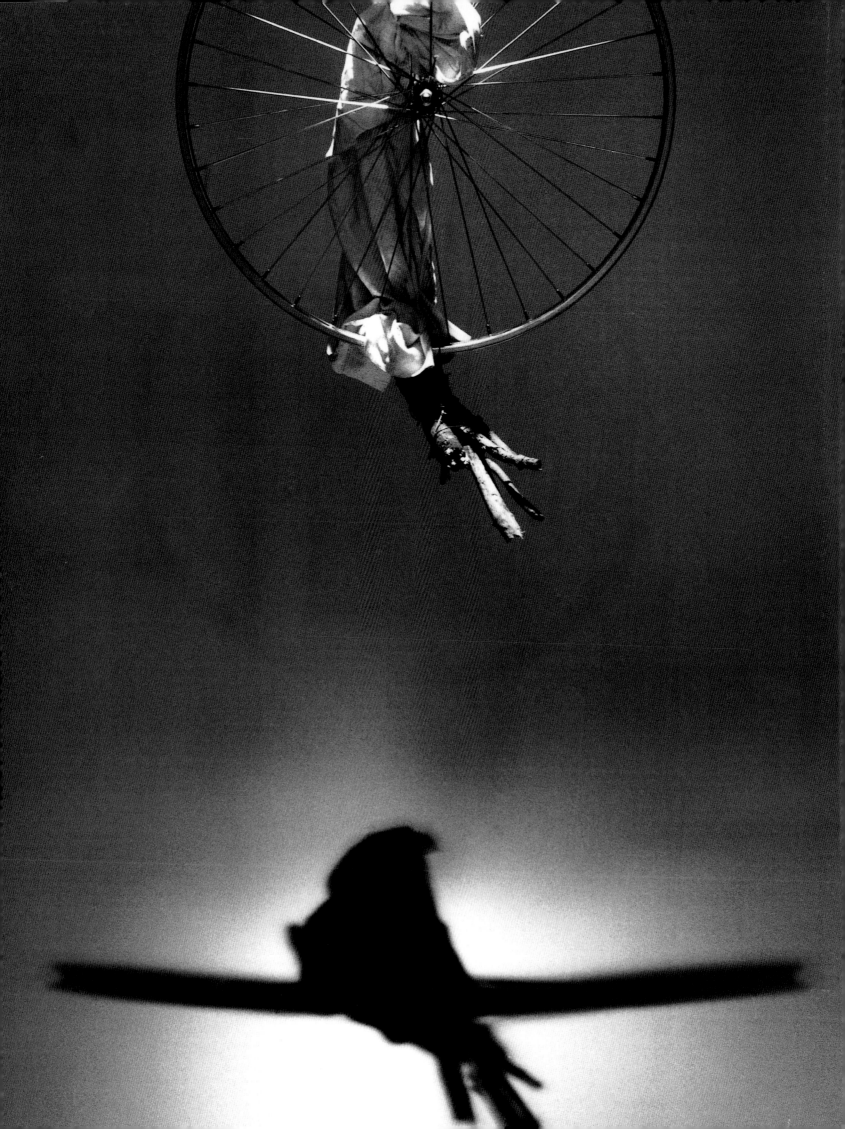

GRAPHIS
· · · · · · · · · · · · · · · ·

FINE ART

P H O T O G R A P H Y 2

PUBLISHER AND CREATIVE DIRECTOR: B. MARTIN PEDERSEN

CURATOR: CARRE BEVILACQUA

EDITORS: CLARE HAYDEN, HEINKE JENSSEN, PEGGY CHAPMAN

ART DIRECTORS: B. MARTIN PEDERSEN, JOHN JEHEBER

GRAPHIS INC.

OPPOSITE: MAC ADAMS, FROM "THE PET SHOP" SERIES

COURTESY STEFAN STUX GALLERY, NEW YORK, NY

PUBLISHED BY GRAPHIS, INC. , 141 LEXINGTON AVENUE, NEW YORK, NY 10016, USA

ISBN: 1-888001-14-3

PRINTED IN HONG KONG BY DAI NIPPON.

GRAPHIS INC. IS THE PUBLISHER OF GRAPHIS MAGAZINE: THE INTERNATIONAL MAGAZINE OF VISUAL COMMUNICATION,

AND NUMEROUS ANNUALS AND BOOKS IN THE FIELDS OF GRAPHIC DESIGN, ART AND PHOTOGRAPHY INCLUDING:

GRAPHIS PHOTO, GRAPHIS DESIGN, GRAPHIS POSTER, GRAPHIS ADVERTISING, GRAPHIS PACKAGING,

GRAPHIS MUSIC CD, GRAPHIS SHOPPING BAG, GRAPHIS PRODUCTS BY DESIGN.

FOR A COMPLETE CATALOG OF GRAPHIS PUBLICATIONS PLEASE CONTACT GRAPHIS AT:

141 LEXINGTON AVENUE, NEW YORK, NY 10016. PHONE: 212-532-9387. FAX: 212-213-3229

HTTP://WWW.GRAPHIS.COM

Opposite and Page 224: Mac Adams, From "The Pet Shop" series

Courtesy Stefan Stux Gallery, New York, NY

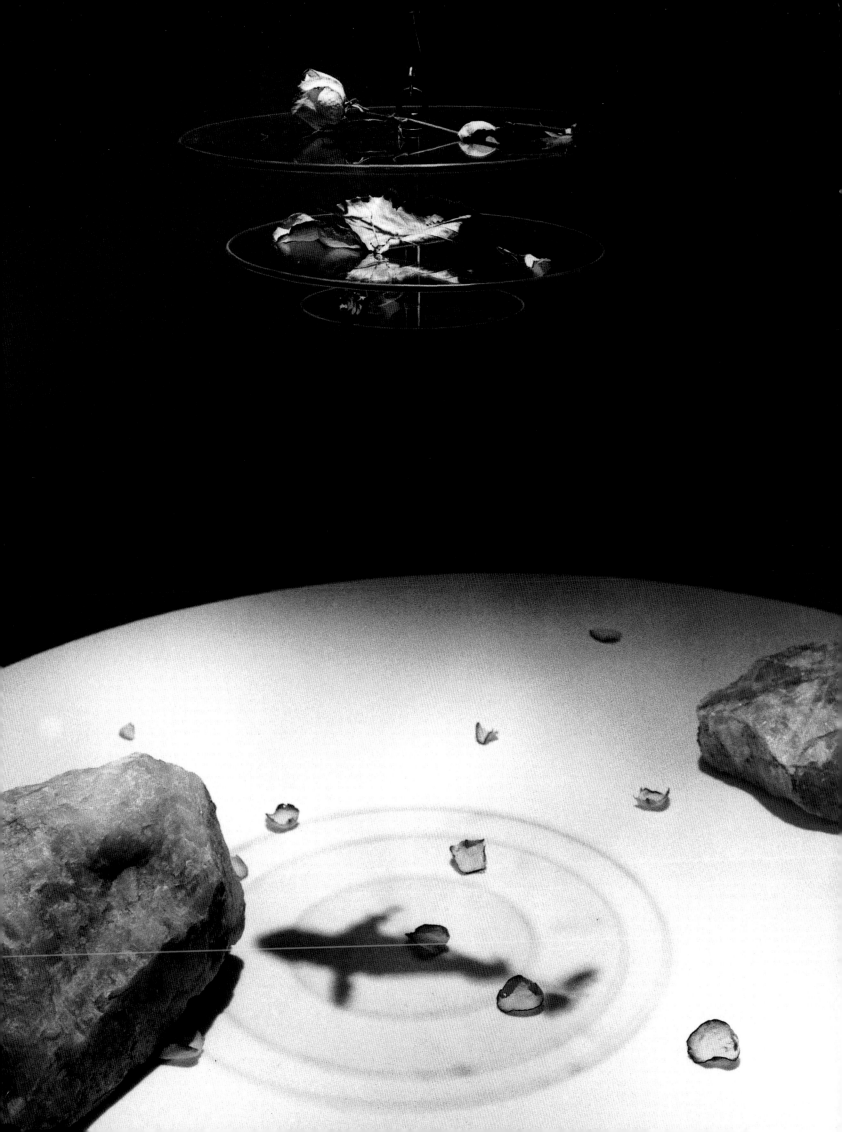

By **Charles-Henri Favrod** • Portrait by **John Phillips**

Giving Shape to an Idea

In response to the question Stieglitz asked in 1922, "Can a photograph have artistic meaning?" Marcel Duchamp answered that the question is not that of photography being art, but rather whether the medium could be employed in such a way that it could surpass painting without imitating it. • Photography said to be "art" became intolerable precisely because of its imitation of painting's darkness and sfumato backgrounds. As Walter Benjamin would soon say, the real problem lay less in the aesthetic of photography as art than in the aesthetics of art used in photography. • Using a bichromated eraser and a charcoal procedure, pictorialists have endeavored since the end of the 19th century to remove photography's tremendous precision and thereby emulate painting. At 20th century's end, artists increasingly resort to photography and invade contemporary art museums, whose curators all speak a singular language. Just as their predecessors did, most of them continue to remain ignorant of the history of photography, in the name of the "Beaux Arts." I believe that Nadar's famous drawings are still relevant today. In 1855 and 1857, his drawings appeared in the PETIT JOURNAL POUR RIRE and JOURNAL AMUSANT respectively, with the captions: "Photography requesting just a small place in the Beaux-Arts exhibit"; and

Charles-Henri Favrod IS HONORARY DIRECTOR OF THE MUSEE DE L'ELYSEE IN LAUSANNE, SWITZERLAND.

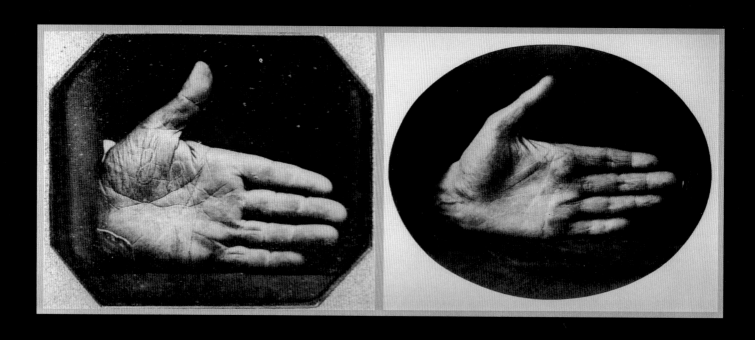

"The Ingratitude of Painting Refusing the Smallest Place in its Exhibit of Photography, To Whom It Owes Everything." Today we might imagine a new drawing with the caption: "The Beaux-Arts Excluding Photographers because Photography is the Exclusive Affair of Artists." ● This neo-pictorialism has its origins in indisputably important works. Who, for example, could contest the contributions of Joel-Peter Witkin or of Dieter Appelt, and of Urs Luthi, Andy Warhol or Edward Rusha before them? None of these artists would have ever disputed the artistic value of photography. They respected the inherent qualities of the medium, and this was reflected in their work. But after them, what accumulated was a collection of such mediocre images in an ever-larger format that only served to highlight deficiencies, and whose kitsch only gave rise to more amusement and soon encumbered the reserves of a time period that too hastily revered any newcomer. ● The lack of knowledge of photography's history is directly rooted in this multitude of followers, who shamelessly repeated experiments already attempted throughout the 1920s. It is true that Duchamp's followers are numerous in the areas he explored with genius, and that almost all of them possess the ingratitude inherent to foolish heirs. However, the time has come in which the poor use of photography is beginning to make the practice unbearable. Too many people believe that spending a few hours behind a big Polaroid is sufficient for acquiring an automatic right to proclaim themselves masters of the medium. At the Miró Foundation in Barcelona, I saw an exhibit that was so pretentious it used a huge wall in its entirety for one photograph by Annette Messager. The public responded by yawning, which was not a bad response in itself; but how could the public not be considered exploited when such significant places all make something so sacred out of nothing? ● Many contemporary art museums today reflect the uniformity of fast food restaurants and airports. The entire planet follows the dictate of conformity. And disgust ensues, as Duchamp said. No one should be ignorant of the fact that, more than any other artist in this century, Duchamp was aware of the way in which photography's birth and development shattered our vision of the world. ● I especially want to emphasize that while the great transformation introduced by photography took place, its initiators were all aware of the possibilities photography offered, if not of the formidable consequences it would bring about. Perhaps they already sensed, like Arago revealing the photographic process to the world in 1839, that this world would no longer ever be exactly the same. Photography joins civilizations to each other just as it links the future to the past. From the time photography was invented, it has offered us a common destiny, and at the same time has provided us with a language that is shared and immediately intelligible to all. We immediately moved away from writing, which had until then constituted the only system of recording information. Photography became the first language universally understood since the aborted attempt on the tower of Babel. This international means of communication spread everywhere and right away because as a medium that reflects the material world, man could express himself in images instead of words. What followed is well known in terms of the profound transformation of representation. The photograph reigned everywhere. ● Yet to celebrate photography's revolution, we must not neglect the impasses in which it went astray, giving way to its new avatar: an overabundance of pictorial practice. I therefore applaud Berenice Abbott, who was Man Ray's assistant and who realized the importance of Eugene Atget's work–his straight reproduction of everyday life without any type of clutter. Abbott said that "photography for me is its use as such, not as painting or as theater." She felt it should not be the result of a small group, but a historical movement explaining a conjunction of forces. As far as she was concerned, photography in the 1920s was a necessary revolt against the worst follies of pictorialism: manipulation of images, coloration, double exposure, vague imitation of second-rate impressionists. ● It is my feeling that today we over magnify Lucas Samuras or Arnulf Rainer, Cindy Sherman or Boyd Webb. Photography is a technique like any other. It is perfect if, in using it, one can give shape to an idea. Yet in this mixing of all styles that constitutes the postmodern world, it is not sufficient to shake the bowl to have a clear idea. It is a question of depth. As always, without fearing to appear reactionary, we can cite Victor Hugo, who had the virtue of speaking more simply than a semiologue: "Form is depth brought to the surface."

Einer Idee eine Form geben

«Kann eine Photographie eine künstlerische Bedeutung haben?» Auf diese Frage, die Stieglitz 1922 stellt, antwortet Marcel Duchamp: «Ich möchte, dass sie die Vertreter der Malerei anwidert, bis zu dem Moment, in dem etwas anderes die Photographie unerträglich macht.» Die sogenannte bildmässige Photographie wurde damals unerträglich wegen ihres Halbdunkels, ihrer Verschwommenheit. Walter Benjamin äusserte bald, dass das Problem weniger in der Ästhetik der Photographie als Kunstform läge als in der Ästhetik der Kunst, die sich des Mediums Photographie bediente. ● Mit Hilfe von Gummibichromatdruck und dem Kohleverfahren haben sich die Piktoralisten seit dem Ende des 19. Jahrhunderts bemüht, der Photographie ihre schreckliche Präzision zu nehmen, um so mit der Malerei in Wettstreit zu treten. Jetzt, am Ende des 20. Jahrhunderts, bedienen sich die bildenden Künstler zunehmend der Photographie und überschwemmen die Museen zeitgenössischer Kunst, deren Konservatoren alle die gleiche merkwürdige Sprache sprechen. Wie schon ihre Vorgänger ignorieren sie weiterhin die Geschichte der Photographie als Form der «Bildenden Kunst». Ich glaube, die berühmten Zeichnungen von Nadar sind noch immer aktuell: 1855 erschien im Petit Journal pour rire die Zeichnung «Die Photographie, um einen ganz kleinen Platz in der Ausstellung der Bildenden Künste bittend». 1857 dann, im Journal amusant, «Die Undankbarkeit der Malerei, die der Photographie, der sie so viel verdankt, auch nur den kleinsten Platz in ihrer Ausstellung verweigert». Und schliesslich, im Jahre 1859, «Die Malerei, der Photographie endlich einen Platz in der Ausstellung der Bildenden Künste anbietend». Man könnte sich heute eine weitere Zeichnung vorstellen: «Die Bildenden Künste, die Photographen ausschliessend, weil die Photographie allein Sache der bildenden Künstler ist.» ● Dieser Neo-Piktoralismus nimmt seinen Anfang mit Werken, die zweifellos wichtig sind. Wer kann zum Beispiel die Bedeutung in diesem Bereich von Joel-Peter Witkin oder von Dieter Appelt, und vor ihnen von Urs Lüthi, Andy Warhol oder Edward Rusha abstreiten? Aber keiner von ihnen hat es für richtig gehalten, die Photographie zu verleugnen. Alle, die sich ihrer bedient haben, haben sich als Photographen verhalten. Aber nach ihnen - was für mittelmässige Bilder in immer grösseren Formaten, die ihre Dürftigkeit immer deutlicher machen, Kitsch, über den man eigentlich lachen müsste. Sie werden bald die Sammlungen einer Epoche überschwemmen, die viel zu hastig jeden geschickten Strategen in den Himmel hebt. Die Unkenntnis der Geschichte der Photographie ist der Grund für die vielen Mitläufer, die schamlos die bereits in den 20er Jahren gemachten Erfahrungen wiederholen. Die Nachfahren Duchamps sind in allen Domänen, die er so meisterhaft beherrschte, zahlreich, und fast alle haben die Undankbarkeit stupider Erben. Aber es ist jetzt der Zeitpunkt gekommen, an dem der schlechte Gebrauch der Photographie beginnt, sie unerträglich zu machen. Zu viele meinen, es genüge, ein paar Stunden mit der grossen Polaroid-Kamera zu arbeiten, um automatisch Anspruch auf einen Ehrenplatz im Museum zu haben. Ich habe in der Fondation Mirò in Barcelona eine Ausstellung gesehen, die in ihrer Anmassung so weit ging, ein einziges Bild von Annette Messager auf eine riesige Wand zu hängen. Das Publikum reagierte mit Gähnen, was schon mal nicht schlecht ist, aber wie kann man verhindern, dass es auf den Arm genommen wird, wenn allerorts wichtige Ausstellungsorte völlig belanglose Bilder hochjubeln. ● Viele Museen zeitgenössischer Kunst ähneln einander heute wie Fastfood-Ketten oder

(OPPOSITE, LEFT) ALBERT SANDS SOUTHWORTH AND JOSIAH JOHNSON HAWES, CAPTAIN JONATHAN WALKER'S BRANDED HAND, 1845. ● (OPPOSITE, RIGHT) NADAR, THE LEFT HAND OF MONSIEUR D..., A BANKER, C. 1860.
CHARLES-HENRI FAVROD WAR GRÜNDUNGSMITGLIED DER STIFTUNG FÜR PHOTOGRAPHIE AM KUNSTHAUS ZÜRICH.

Flughäfen. Der ganze Planet folgt dem Diktat der Gleichmacherei. Und es widert einen an, um das Wort Duchamps wieder aufzunehmen, von dem man wissen muss, dass er sich mehr als jeder andere Künstler dieses Jahrhunderts der Umwälzung unserer Sicht der Welt durch die Erfindung und Entwicklung der Photographie bewusst war. Ich möchte vor allem betonen, dass in dem Moment, in dem die grosse Veränderung durch die Photographie stattgefunden hat, sich alle Wegbereiter absolut der Möglichkeiten bewusst waren, die die Photographie bietet, um nicht zu sagen der wunderbaren Konsequenzen, die sie zur Folge haben würde. Als Arago 1839 der Welt die Erfindung der Photographie verkündete, spürte man vielleicht bereits, dass die Welt nie mehr die selbe sein würde, nachdem man sie wahrheitsgetreu abbilden, sie entschlüsseln konnte. Die Photographie verbindet die Zivilisationen miteinander, so wie sie die Zukunft mit der Vergangenheit verbindet. Sie bedeutet ein gemeinsames Schicksal, und sie gibt uns eine gemeinsame, für alle sofort verständliche Sprache. Bald nach der Erfindung der Photographie entfernt man sich von der Schrift, die bis dahin das einzige Mittel zur Aufzeichnung von Information war. Die Photographie wird zur universellen Sprache. Diese Art der internationalen Kommunikation findet sofort überall Verbreitung, weil es eine Technik der Aneignung der materiellen Welt ist, die dem Menschen ermöglicht, sich auszudrücken. Die Fortsetzung ist wohlbekannt, was die tiefgreifende Veränderung der Darstellung angeht. Das Bild regiert überall. • Wenn man die Revolution der Photographie feiert, darf man auch die Sackgassen nicht vernachlässigen, in die sie sich zuweilen verirrt, wie jetzt in der übertriebenen Hinwendung zum Malerischen. Ich bin deswegen ganz mit Berenice Abbott einig, die Assistentin von Man Ray gewesen war und die Bedeutung von Eugène Atget erkannt hatte: «Die Bedeutung der Photographie liegt für mich in ihrer Verwendung als solche, nicht als Malerei oder Theater. Es geht nicht um die Produktion einer kleinen Gruppe, sondern um eine historische Bewegung, die eine Interferenz der Kräfte ausdrückt. Was mich anbetrifft, war sie in den 20er Jahren eine notwendige Revolte gegen die Auswüchse des Piktoralismus (bildmässige Photographie): Manipulation von Bildern, Koloration, Übereinanderkopieren, verschwommene Nachahmungen von Impressionisten der untersten Stufe.» • Das genau empfinde ich, wenn man heute Lucas Samaras oder Arnulf Rainer, Cindy Sherman oder Boyd Webb zu sehr glorifiziert. Die Photographie ist eine Technik wie jede andere. Perfekt, wenn es mit ihrer Hilfe gelingt, einer Idee eine Form zu geben. Aber in diesem Durcheinander der Stilrichtungen der Postmoderne reicht es nicht, das Einmachglas einmal zu schütteln, um eine klare Idee zu bekommen. Es ist eine Frage des Inhalts. Ohne befürchten zu müssen, als Reaktionär zu gelten, kann man Victor Hugo zitieren, der die Tugend besitzt, einfacher als ein Semiologe zu sprechen: «Form ist der an die Oberfläche gebrachte Kern.»

Donner une forme à une idée

A la question que pose Stieglitz en 1922, «une photographie peut-elle avoir un sens artistique?», Marcel Duchamp répond: «J'aimerais qu'elle dégoûtât les gens de la peinture, jusqu'au moment où quelque chose d'autre rendra insupportable la photographie.» • La photographie dite d'«art» devenait alors précisément insupportable par sa pénombre et son vaporeux. Et Walter Benjamin allait bientôt dire que ce qui faisait problème était moins l'esthétique de la photographie en tant qu'art que celle de l'art en tant que photographie. • A l'aide de la gomme bichromatée et du procédé au charbon, les pictorialistes s'efforçaient, depuis la fin du XIXe siècle, d'enlever sa terrible précision à la photographie et de rivaliser ainsi avec la peinture. En cette fin du XXe siècle, les plasticiens recourent de plus en plus à la photographie et envahissent les musées d'art contemporain dont les conservateurs tiennent un singulier langage. Ils continuent pour la plupart d'ignorer l'histoire de la photographie comme l'ont fait leurs prédécesseurs, au titre des «Beaux-Arts». Je pense que les fameux dessins de Nadar sont toujours d'actualité. En 1855, dans le *Petit Journal pour rire*, il figurait «la Photographie demandant juste une petite place à l'Exposition des Beaux-Arts». En 1857, dans le *Journal amusant*, «l'Ingratitude de la Peinture refusant la plus petite place dans son Exposition à la Photographie à qui elle doit tant». Et, en 1859, «la Peinture offrant enfin à la Photographie une place à l'Exposition des Beaux-Arts». On pourrait aujourd'hui imaginer un nouveau dessin: «les Beaux-Arts excluant les Photographes parce que la Photographie est l'affaire exclusive des Plasticiens». • Ce néopictorialisme est à l'origine d'œuvres incontestablement importantes. Qui peut, par exemple, contester l'apport de Joel-Peter Witkin ou de Dieter Appelt, et d'Urs Lüthi, Andy Warhol ou Edward Rusha avant eux? Mais aucun de ceux-ci n'a cru bon de contester la photographie. Tous, y recourant, se sont comportés en photographes. A leur suite, que d'images médiocres accumulées, au format toujours plus grand en accusant davantage la carence, dont le kitsch devrait faire plus sourire et qui vont bientôt encombrer les réserves d'une époque trop hâtive à consacrer n'importe quel manœuvrier nouveau venu. • La méconnaissance de l'histoire de la photographie est directement à l'origine de cette multitude de suiveurs, qui répètent sans vergogne des expériences déjà faites au cours des années 20. Il est vrai que les enfants de Duchamp sont nombreux dans tous les domaines qu'il a explorés avec génie et qu'ils ont presque tous l'ingratitude inhérente aux héritiers stupides. Mais, précisément, le moment est venu où le mauvais usage de la photographie commence à la rendre insupportable. Trop de gens s'imaginent qu'il suffit d'avoir à disposition quelques heures la grande caméra Polaroid pour obtenir ensuite le droit automatique aux cimaises. J'ai vu à Barcelone, à la Fondation Miró, une exposition prétentieuse au point d'utiliser toute une immense paroi pour une seule image d'Annette Messager. Le public réagissait en bâillant, ce qui n'est déjà pas mal, mais comment ne serait-il pas abusé quand des lieux importants en arrivent partout à sacraliser des riens? • Beaucoup de musées d'art contemporain ont aujourd'hui l'uniformité des fast-foods et des aéroports. Toute la planète sacrifie à la similitude. Et le dégoût vous vient, pour reprendre le mot si juste de Duchamp, dont personne ne devrait ignorer qu'il a pris en compte plus qu'aucun autre artiste de ce siècle le bouleversement apporté dans notre vision du monde par la naissance et le développement de la photographie. • J'entends surtout souligner qu'au moment où s'opère la grande mutation des temps modernes, ses initiateurs sont tous parfaitement conscients des possibilités qu'offre la photographie, si ce n'est des conséquences formidables qu'elle va entraîner. Peut-être pressentent-ils déjà, comme Arago annonçant le procédé au monde en 1839, que ce monde ne sera précisément jamais plus le même, tandis que commence sa duplication systématique, son décryptage. La photographie noue les civilisations entre elles comme elle relie le futur au passé. Elle nous vaut dès lors un destin commun, de même qu'elle nous dote d'un langage partagé et aussitôt intelligible par tous. Aussitôt, on s'éloigne de l'écriture, qui avait constitué jusqu'alors le seul système d'enregistrement de l'information. La photographie devient le premier langage universellement compris depuis la tentative avortée de la tour de Babel. Ce mode de communication international s'impose partout et tout de suite parce qu'il est une technique d'appropriation du monde des objets qui permet au sujet de s'exprimer. La suite est bien connue en ce qui concerne la transformation profonde de la représentation. L'image règne partout. • Mais, à célébrer la révolution de la photographie, il ne faut pas négliger les impasses où il lui arrive de se fourvoyer, dont son nouvel avatar: la surabondance de la pratique picturale. J'applaudis donc à ce qu'a dit Berenice Abbott, qui fut l'assistante de Man Ray et découvrit l'importance d'Eugène Atget: «La photographie est pour moi son utilisation en tant que telle, non pas comme de la peinture ou du théâtre. Ce n'est pas la production d'un petit groupe, mais un mouvement historique exprimant une interférence de forces. En ce qui me concerne, dans les années 20, je l'ai considérée comme une révolte nécessaire contre les pires folies du pictorialisme: manipulation des images, coloration, surimpressions, imitation floue d'impressionnistes de bas étage.» • Et c'est mon sentiment quand on magnifie trop aujourd'hui Lucas Samaras ou Arnulf Rainer, Cindy Sherman ou Boyd Webb. La photographie est une technique comme une autre. Parfait si, en l'utilisant, on parvient à donner une forme à une idée. Mais, dans ce brassage de tous les styles qui constitue le monde postmoderne, il ne suffit pas d'agiter le bocal pour avoir une idée claire. C'est une question de fond. Comme toujours, sans craindre de passer pour réactionnaire, on peut citer Victor Hugo, qui a la vertu de parler plus simplement qu'un sémiologue: «La forme, c'est le fond amené à la surface.»

CHARLES-HENRI FAVROD EST DIRECTEUR HONORAIRE DU MUSÉE DE L'ÉLYSÉE DE LAUSANNE, SUISSE.

FINE ART

PHOTOGRAPHY 2

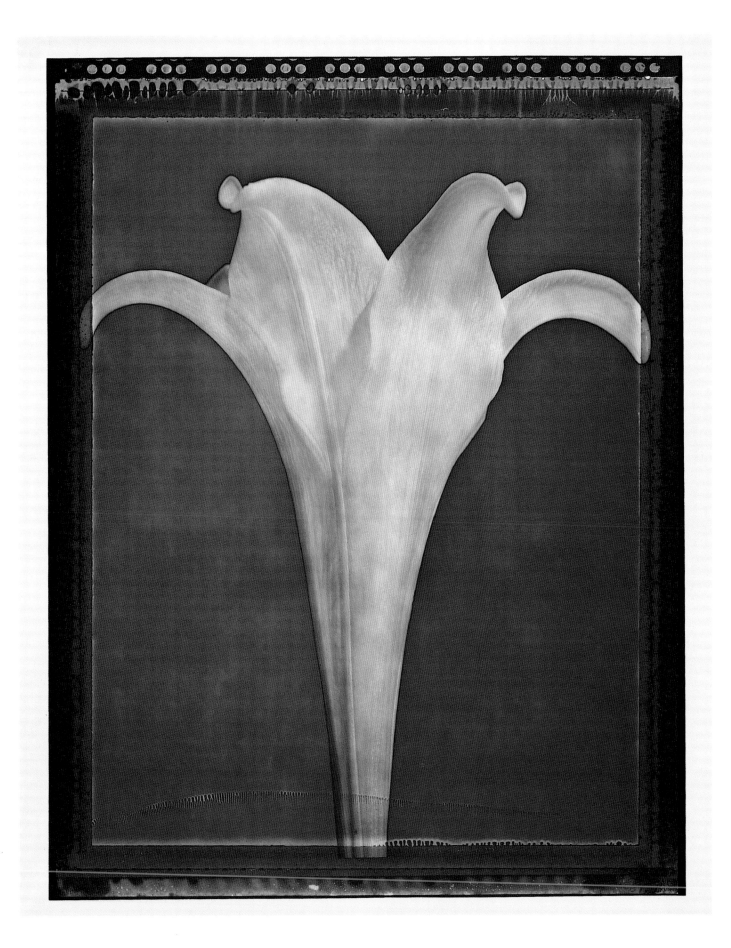

Tom Baril, Lily, 1995

COURTESY BONNI BENRUBI GALLERY, NEW YORK, NY

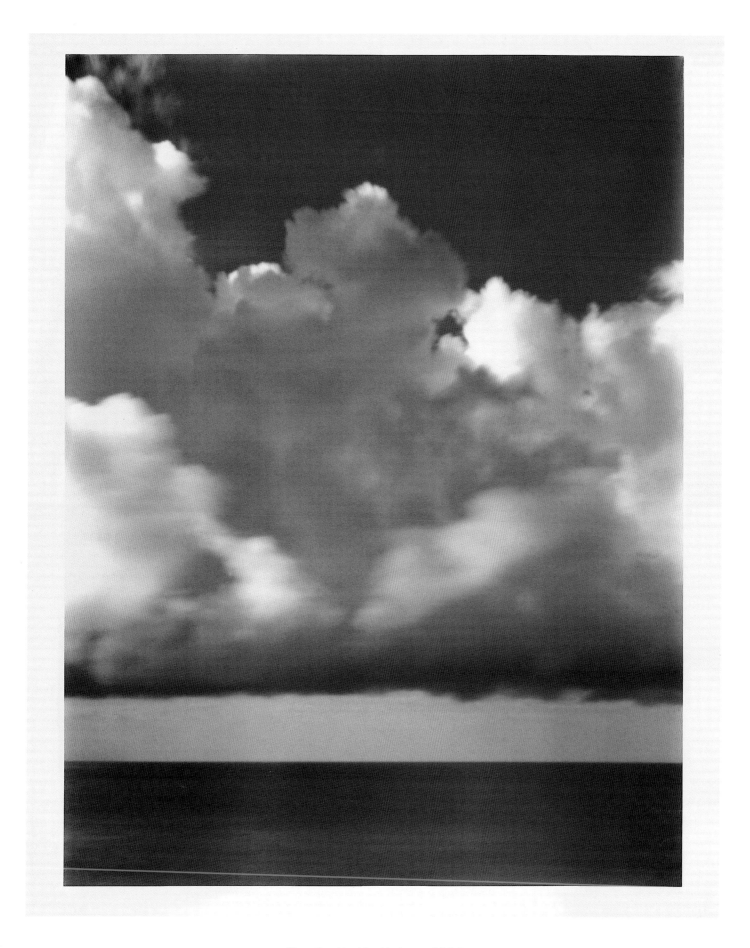

Tom Baril, Martinique, 1996
COURTESY BONNI BENRUBI GALLERY, NEW YORK, NY

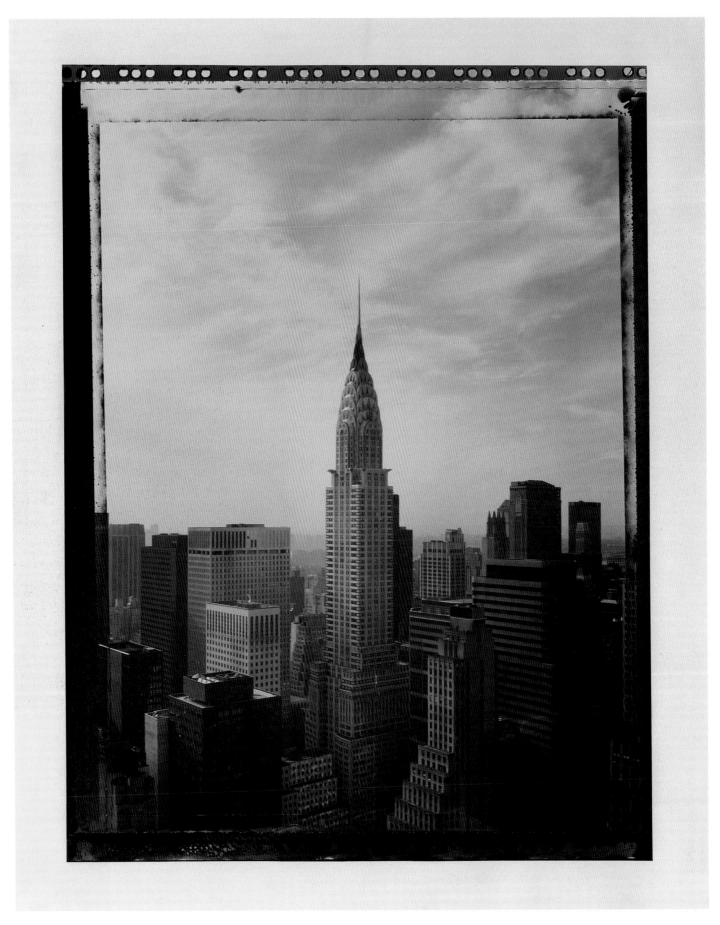

Tom Baril, Chrysler Building, NYC, 1995

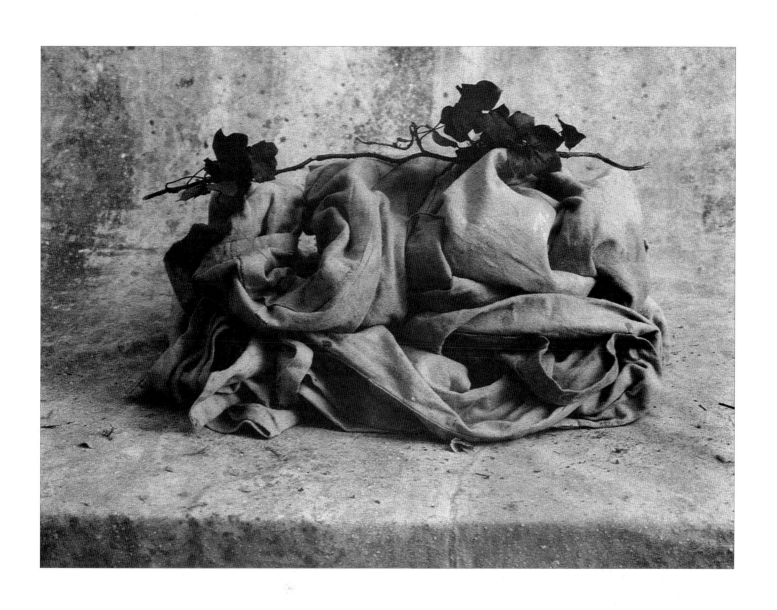

John Stewart, Cloth and Ivy

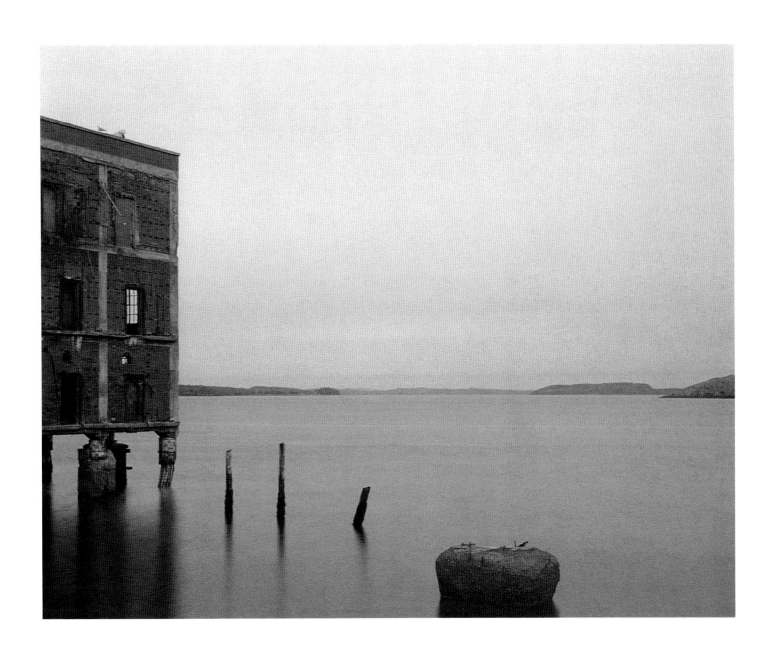

Carl Austin Hyatt, Lubec, ME, 1993

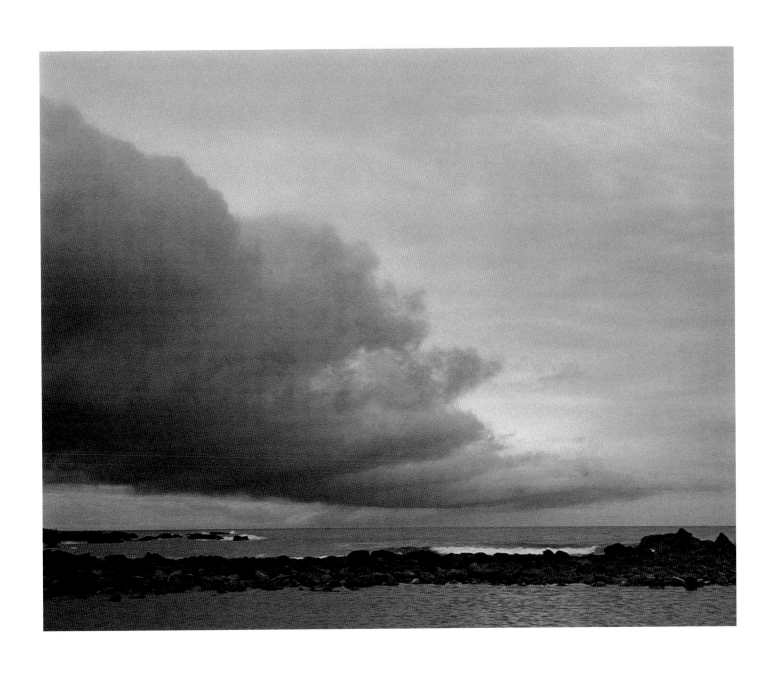

Carl Austin Hyatt, Toward Odiorne Pt., NH, 1995

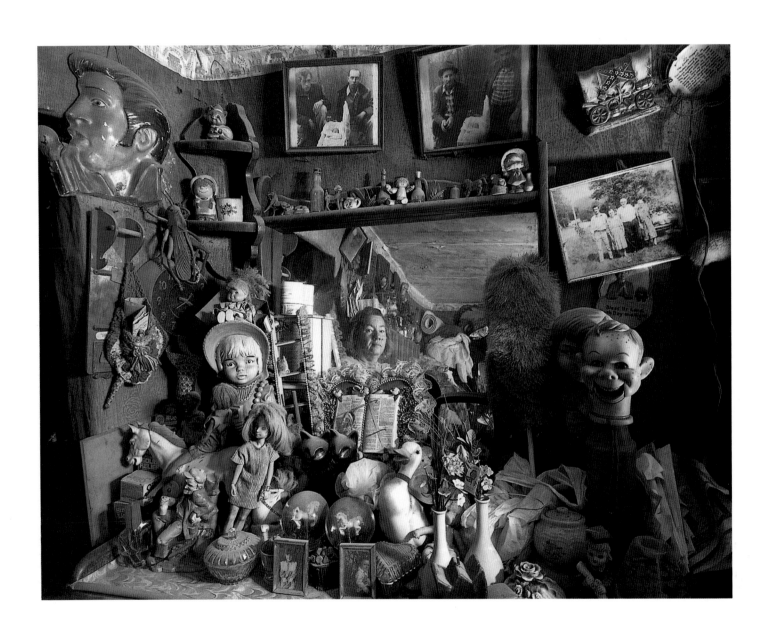

Shelby Lee Adams, Nora's Bedroom, 1995
COURTESY CATHERINE EDELMAN GALLERY, CHICAGO, IL

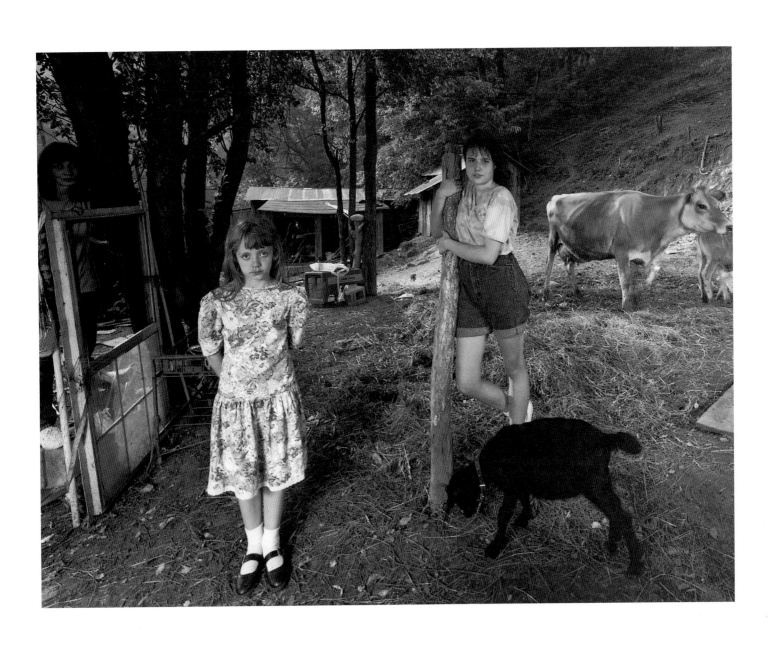

Shelby Lee Adams, Lost Creek, 1996

COURTESY CATHERINE EDELMAN GALLERY, CHICAGO, IL

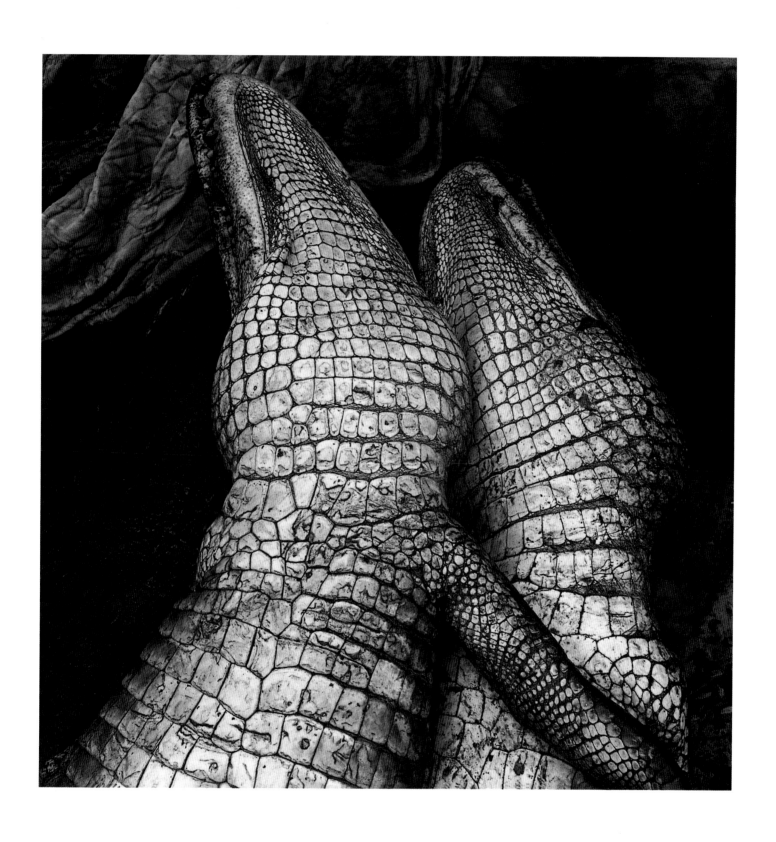

Debbie Fleming Caffery, September 1995, Louisiana

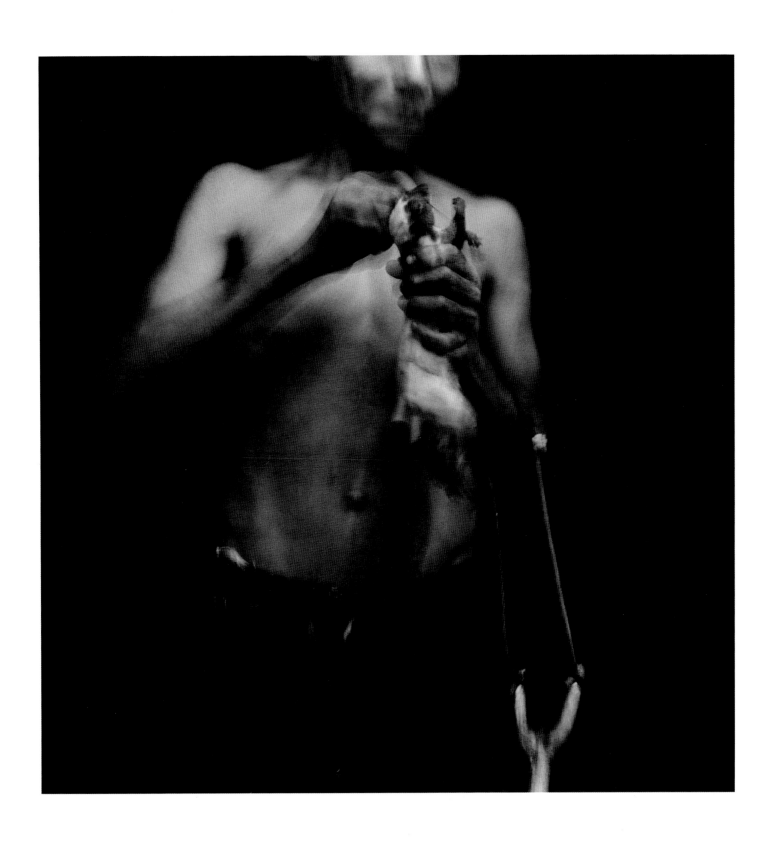

Debbie Fleming Caffery, July 1996, Mexico

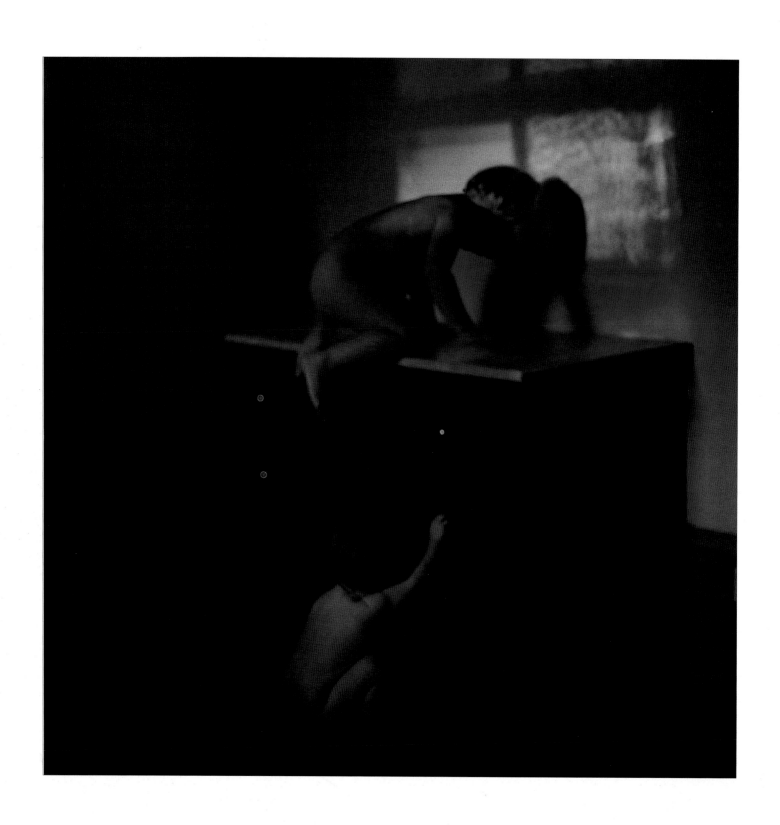

Debbie Fleming Caffery, Joshua and Ruth, Louisiana, c. 1985

COURTESY HOWARD GREENBERG GALLERY, NEW YORK, NY

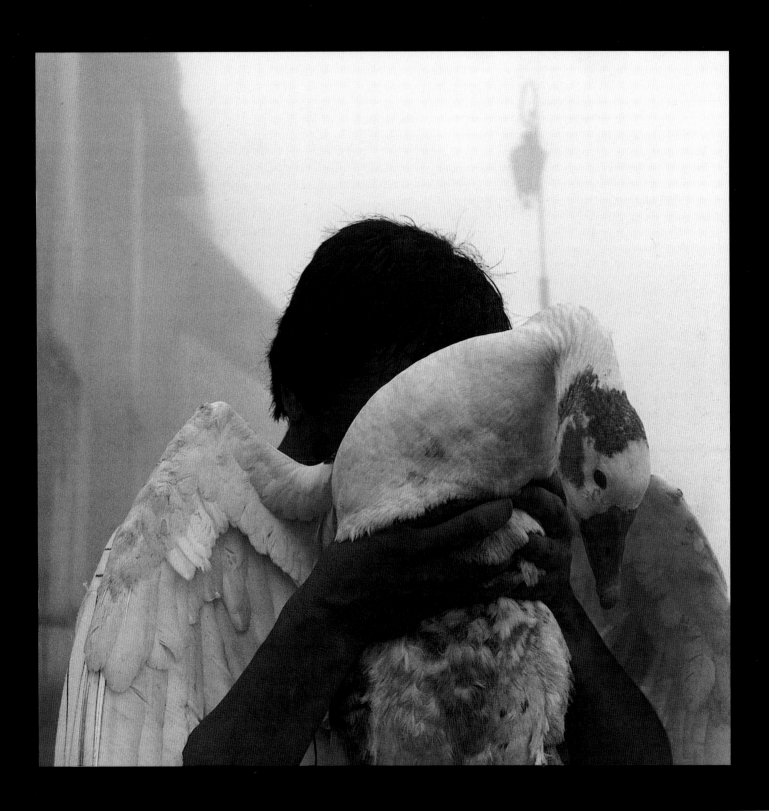

Debbie Fleming Caffery, Nexicalis II, November, 1995

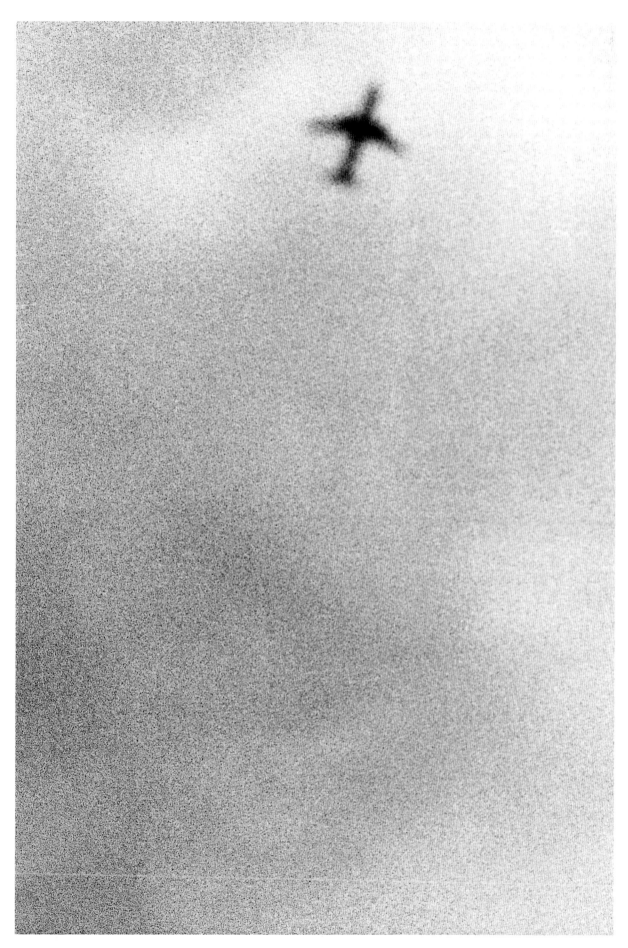

Joanne Dugan, from "Honeymoon, A Journey," 1996

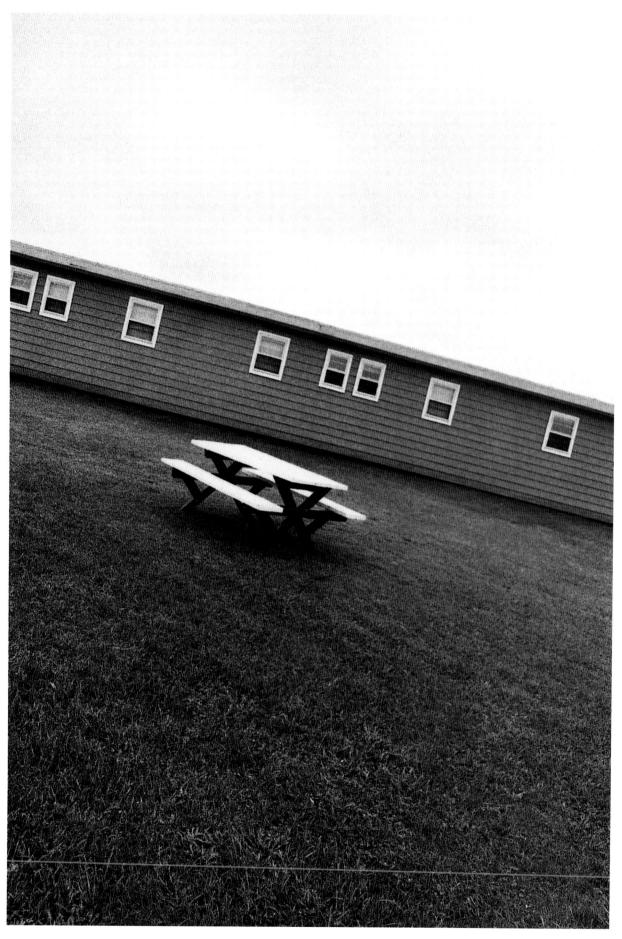

Joanne Dugan, Before the Storm, Montauk, 1996

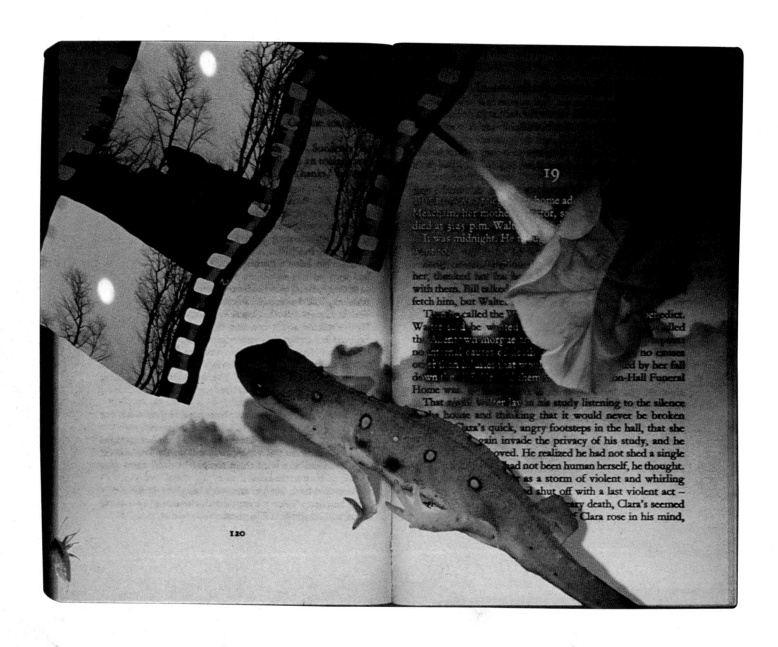

Peter Campus, Blunder, 1995
COURTESY PAULA COOPER GALLERY, NEW YORK, NY

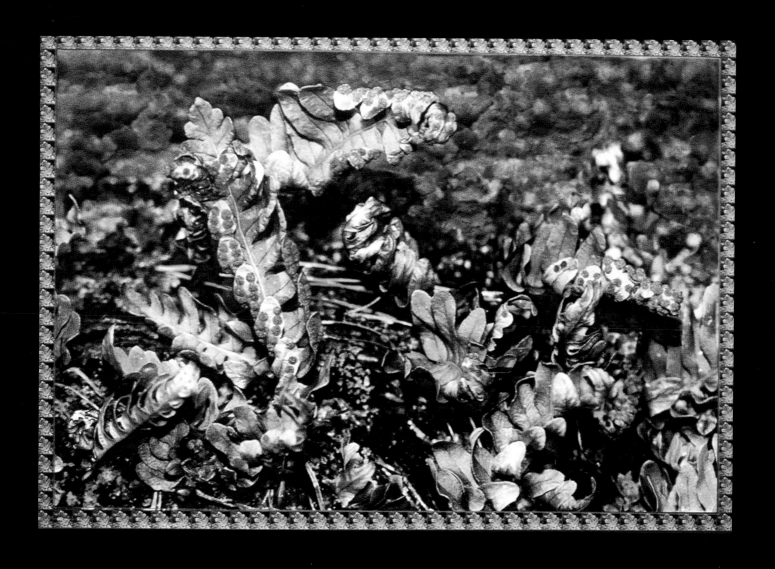

Peter Campus, Wild Leaves, 1995

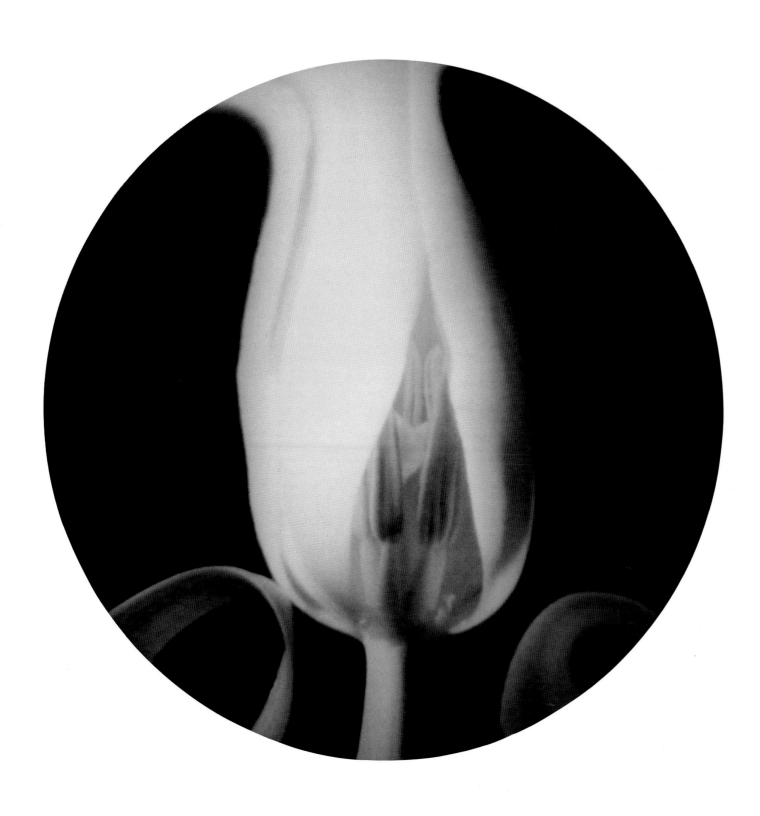

Marianne Engberg, Floral, 1996
COURTESY STALEY-WISE GALLLERY, NEW YORK, NY

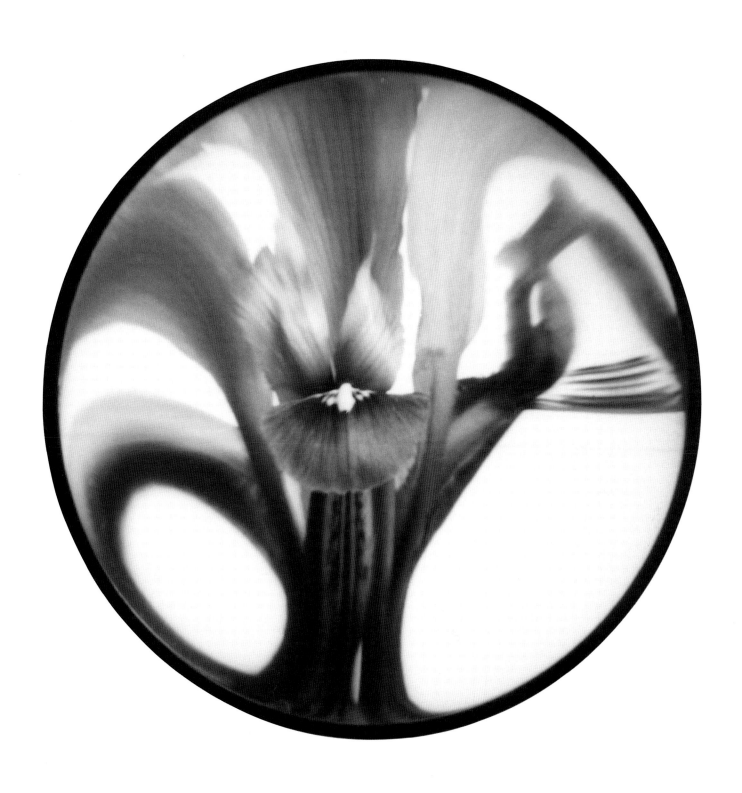

Marianne Engberg, Floral, 1996
COURTESY STALEY-WISE GALLERY, NEW YORK, NY

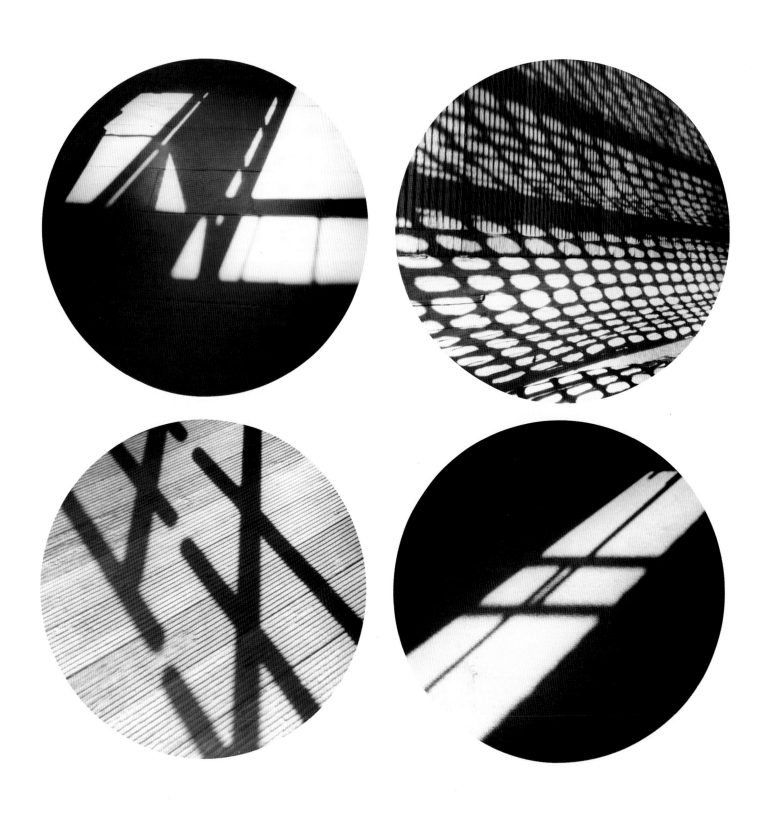

Marianne Engberg, Shadow, NY, 1996

COURTESY STALEY-WISE GALLERY, NEW YORK, NY

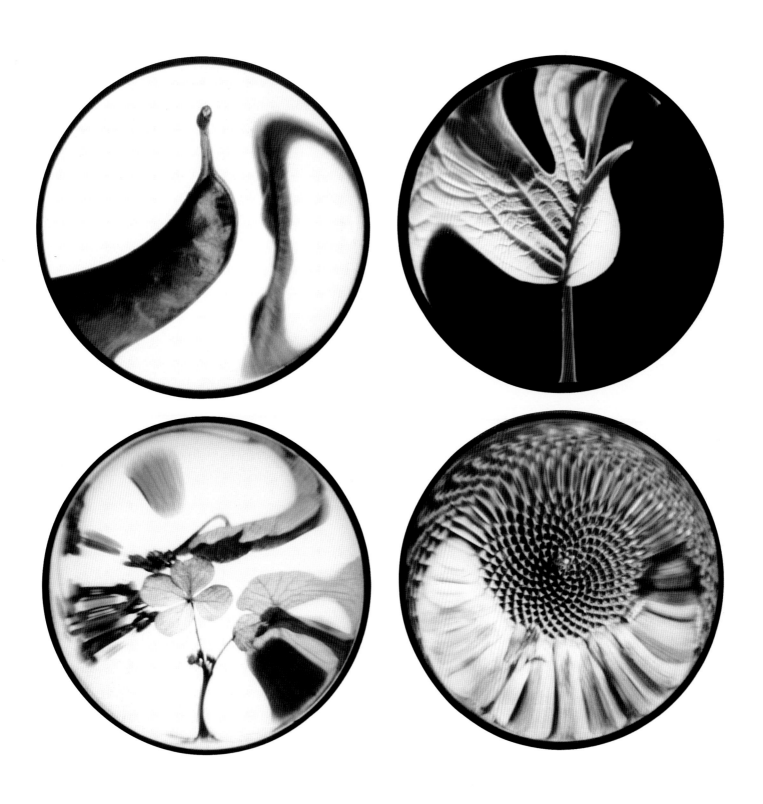

Marianne Engberg, Floral, 1996
COURTESY STALEY-WISE GALLERY, NEW YORK, NY

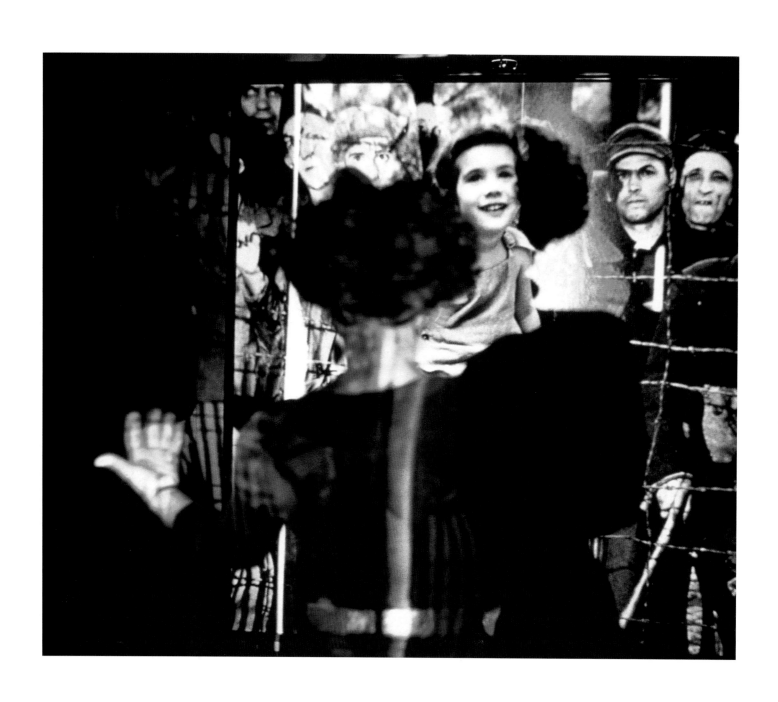

Dorit Cypis, The Body in the Picture: Isabella Stewart Gardner, 1995

COURTESY JAYNE H. BAUM, NEW YORK, NY

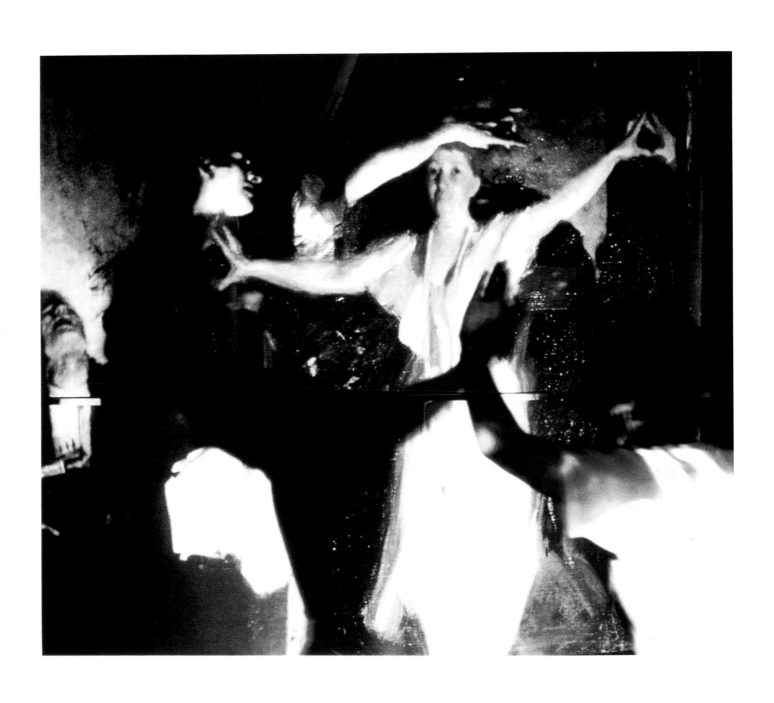

Dorit Cypis, The Body in the Picture: Malka Michaelson, 1995

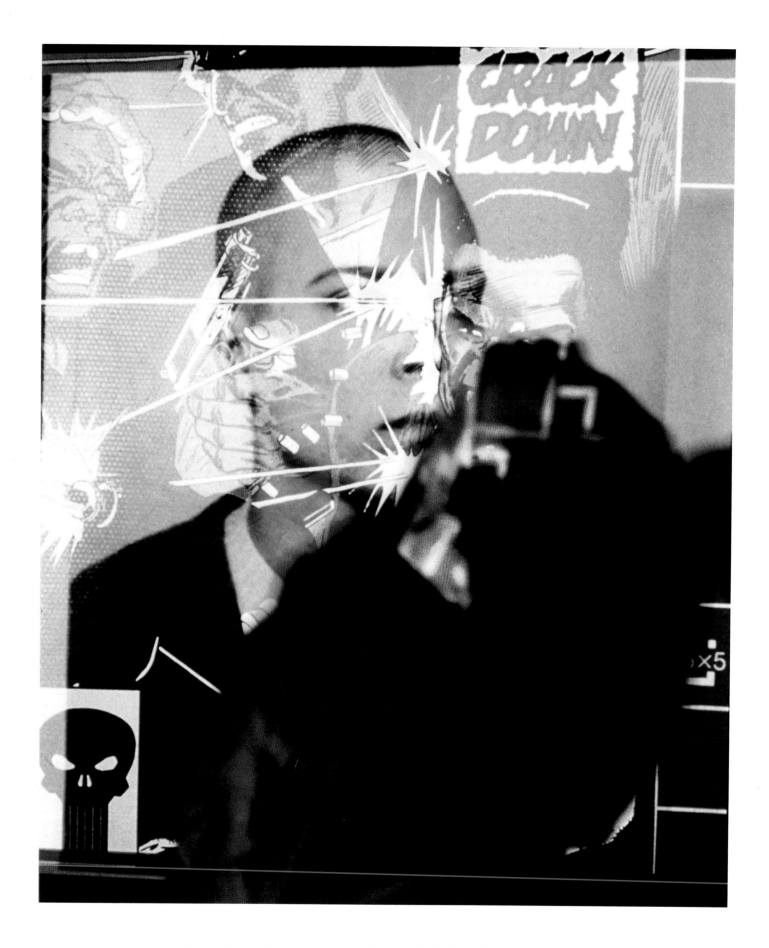

Dorit Cypis, The Body in the Picture: Kelly Rae Hemenway, 1995

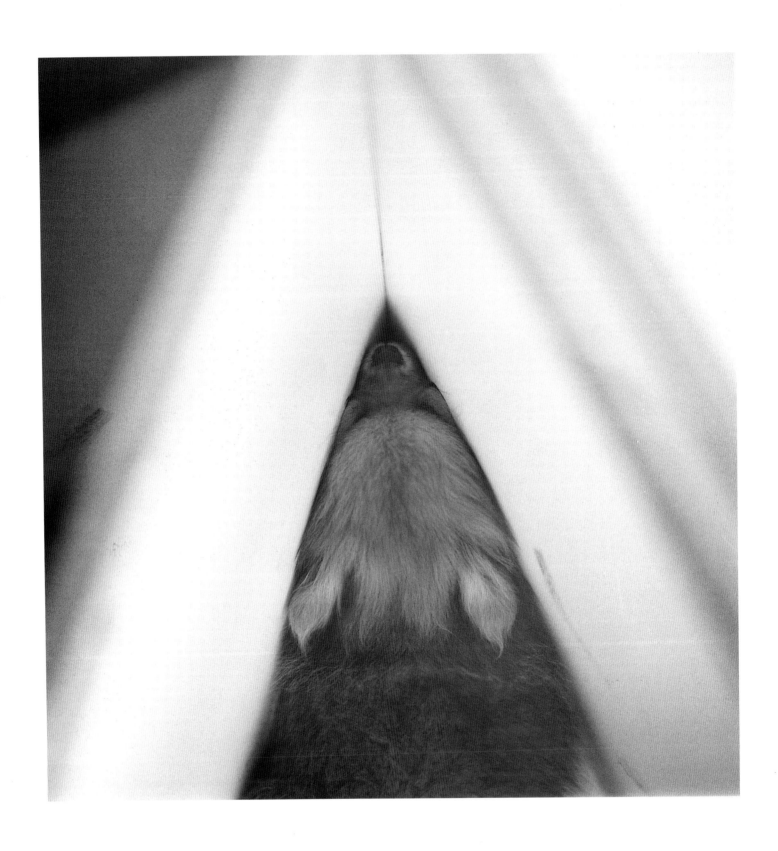

Jayne Hinds Bidaut, Pomeranian, from the Animalerie series, 1996

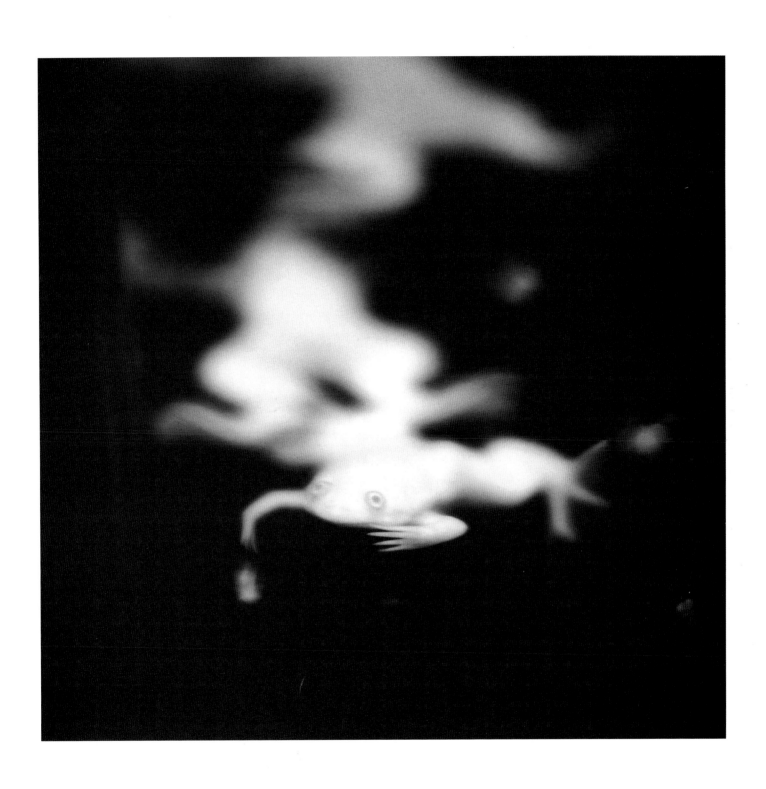

Jayne Hinds Bidaut, Albino Frogs, from the Animalerie series, 1996

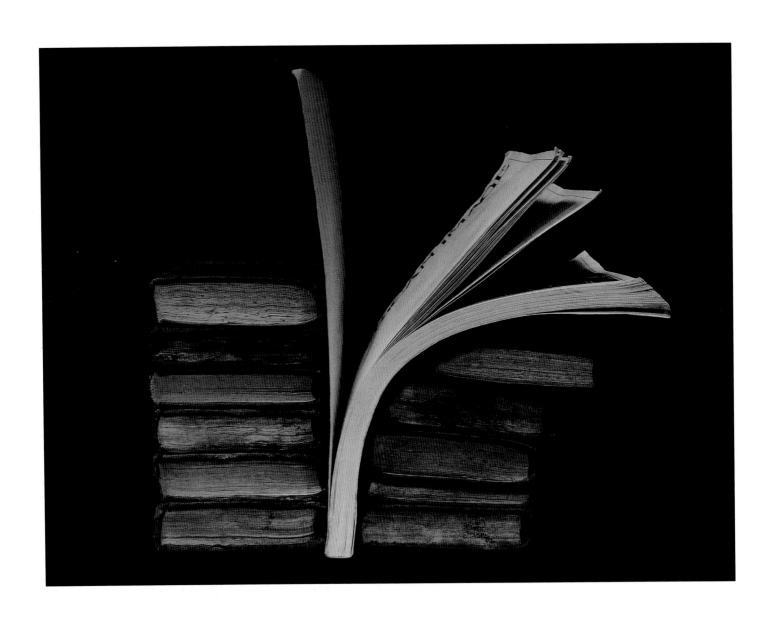

Fawn Potash, Bouquet and Pile of Books, 1995

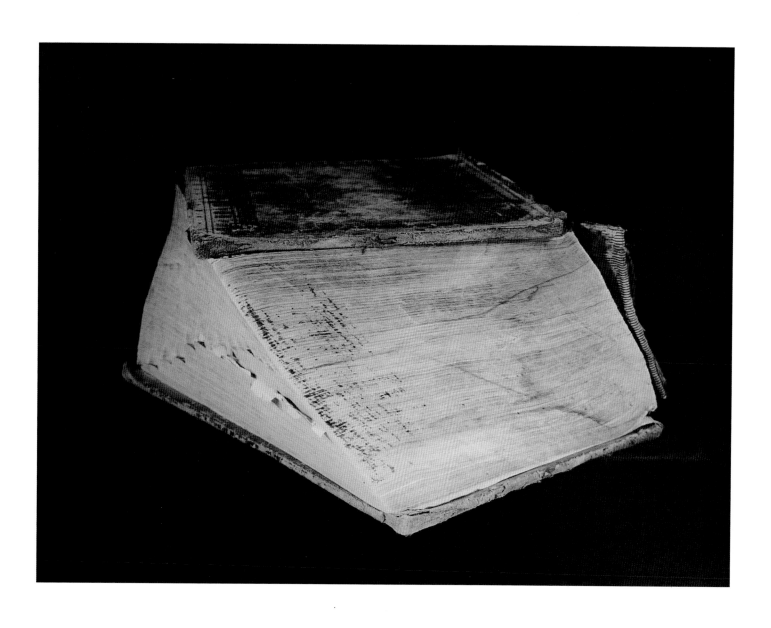

Fawn Potash, Big Dictionary #2, 1995
COURTESY GALLERY 292, NEW YORK, NY

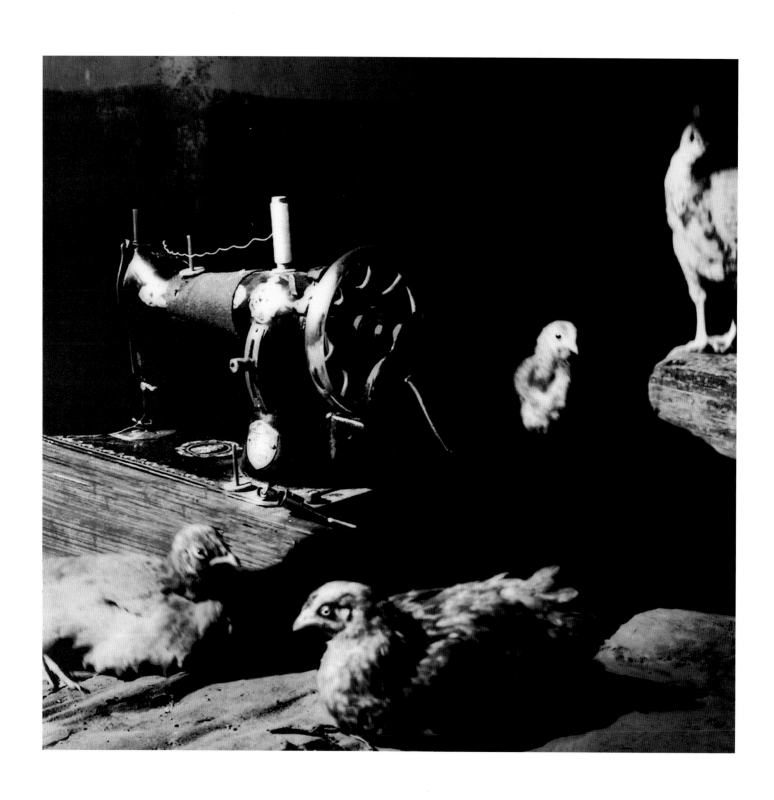

Stuart Hawkins, Untitled from the Tremor Series, 1995-96

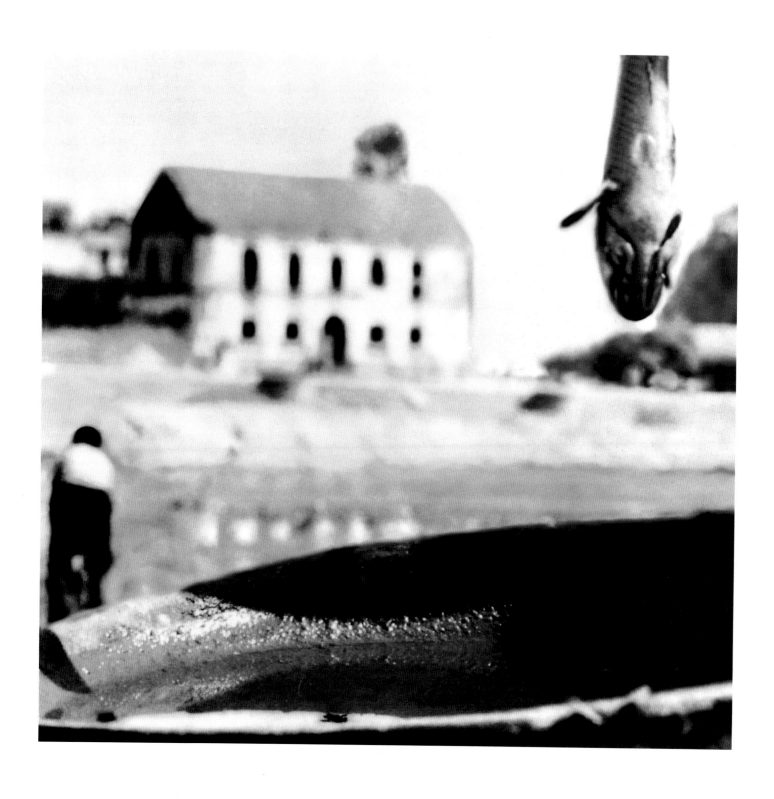

Stuart Hawkins, Untitled from the Tremor Series, 1995-96

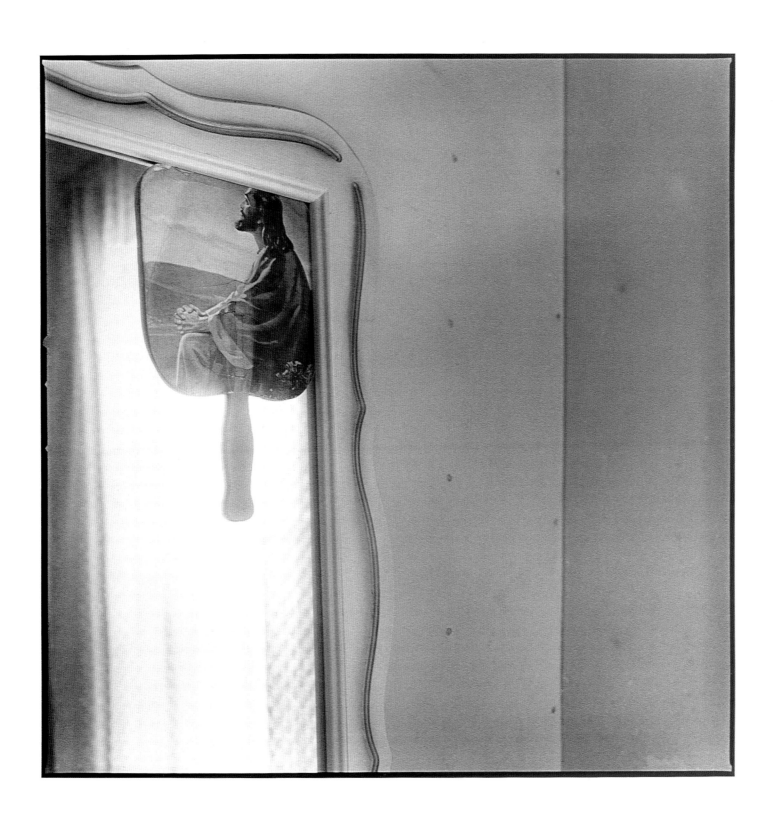

Susan Lipper, Untitled from the Grapevine II series, 1995

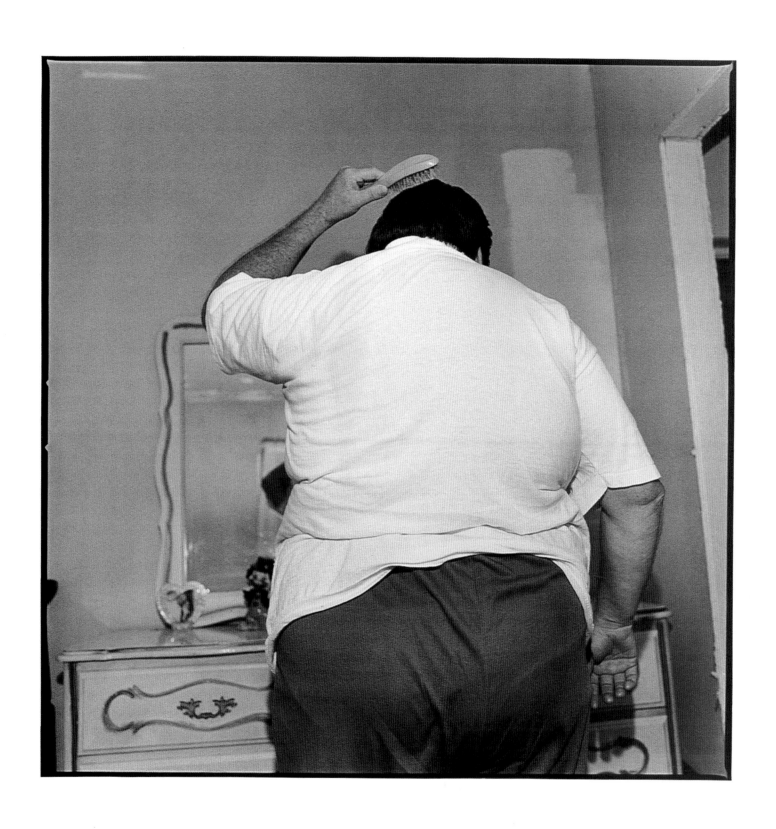

Susan Lipper, Untitled from the Grapevine II series, 1996

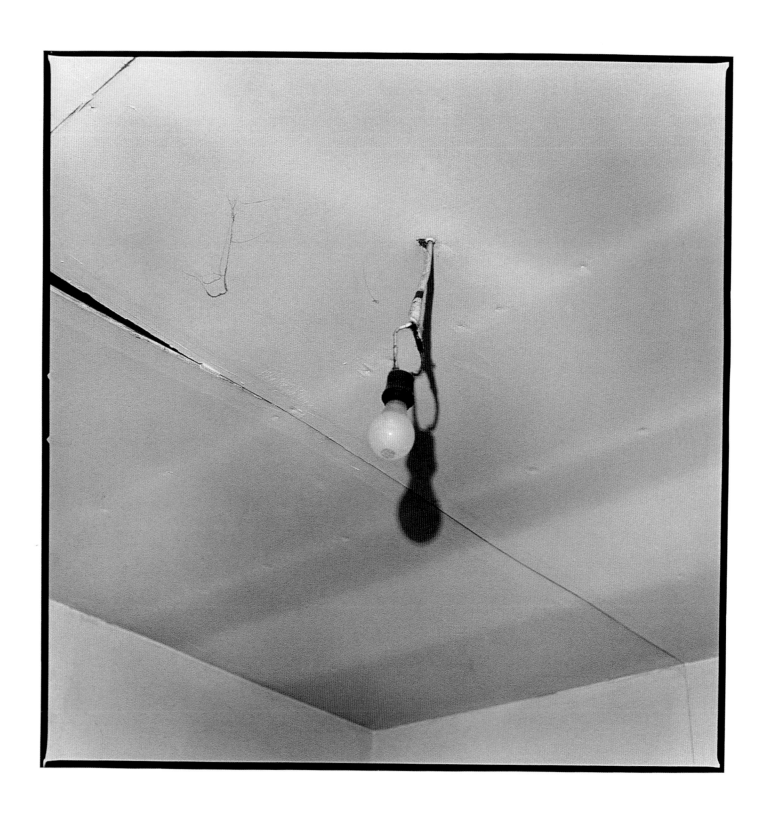

Susan Lipper, Untitled from the Grapevine II series, 1995

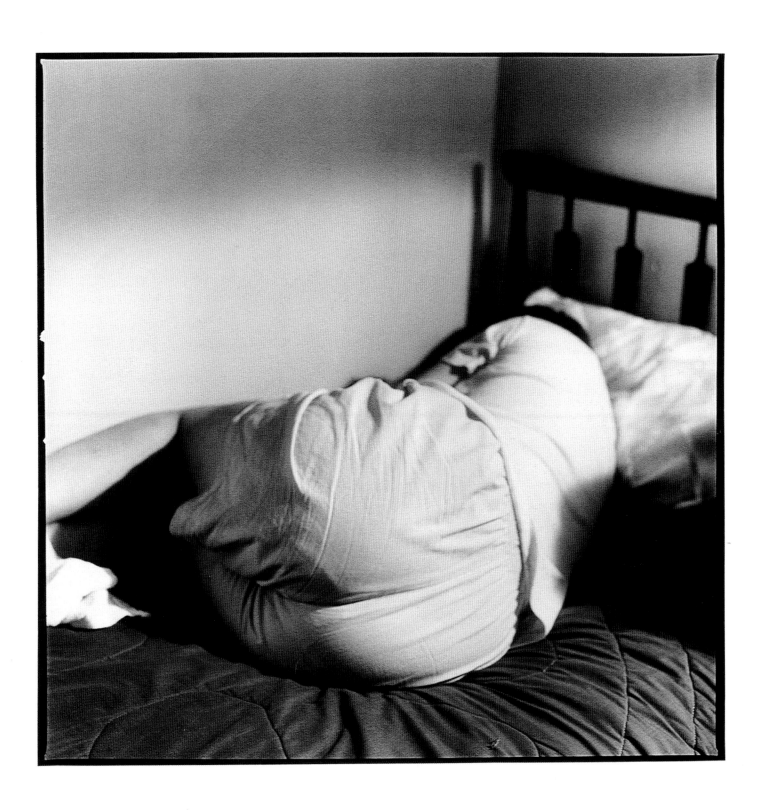

Susan Lipper, Untitled from the Grapevine II series, 1995

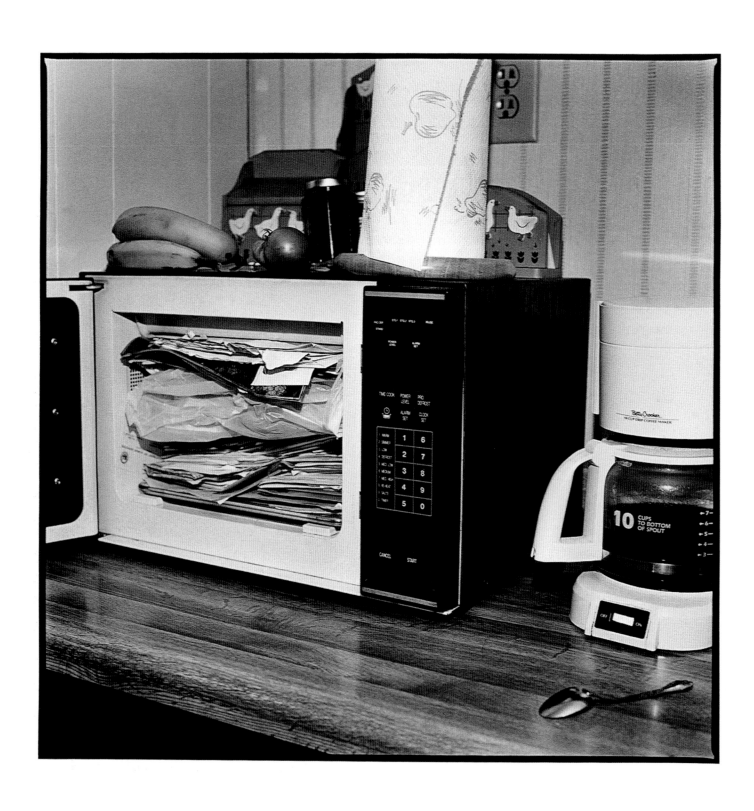

Susan Lipper, Untitled from the Grapevine II series, 1996

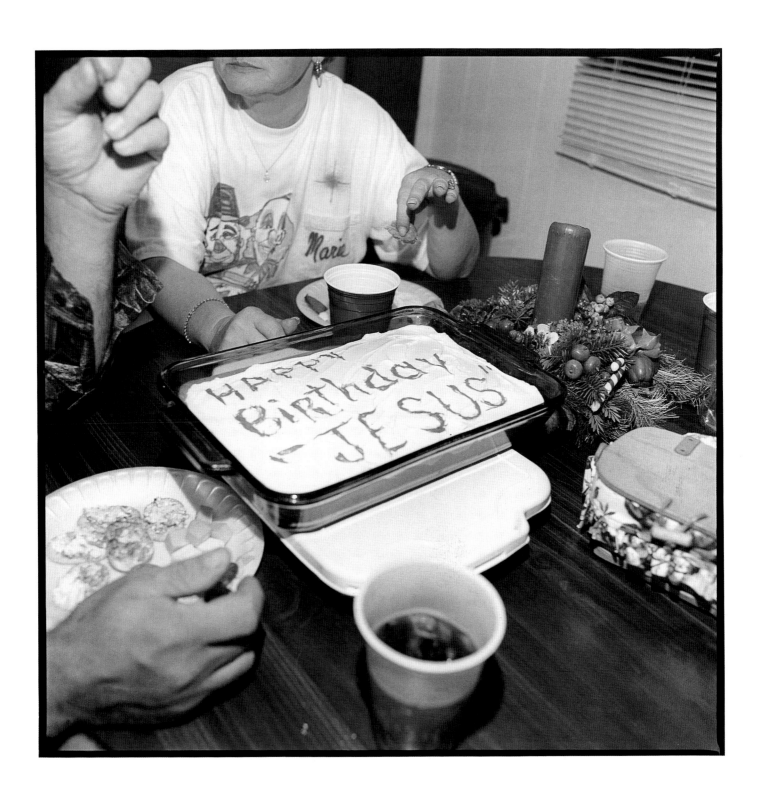

Susan Lipper, Untitled from the Grapevine II series, 1996

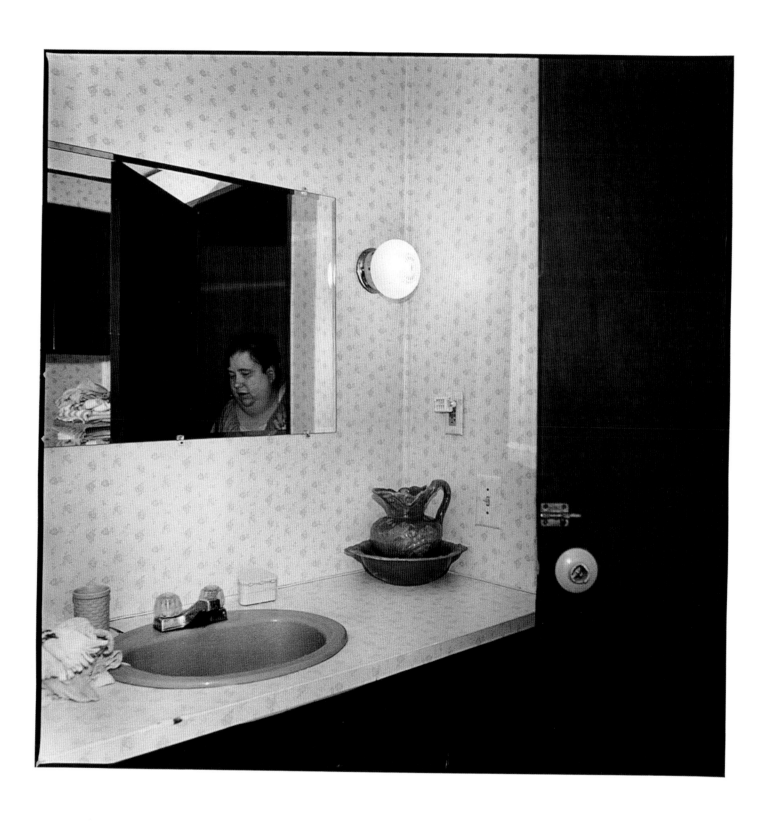

Susan Lipper, Untitled from the Grapevine II series, 1996

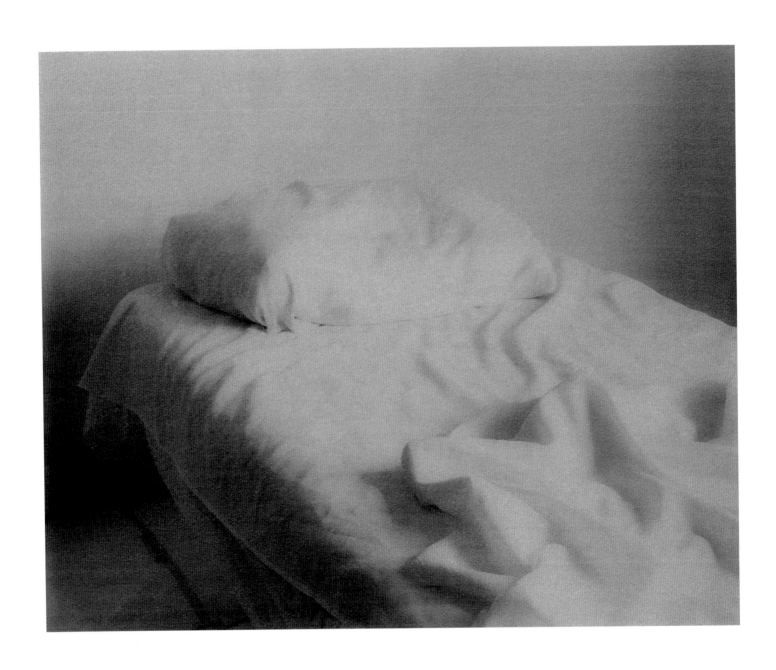

Hiromitsu Morimoto, Untitled, 1995

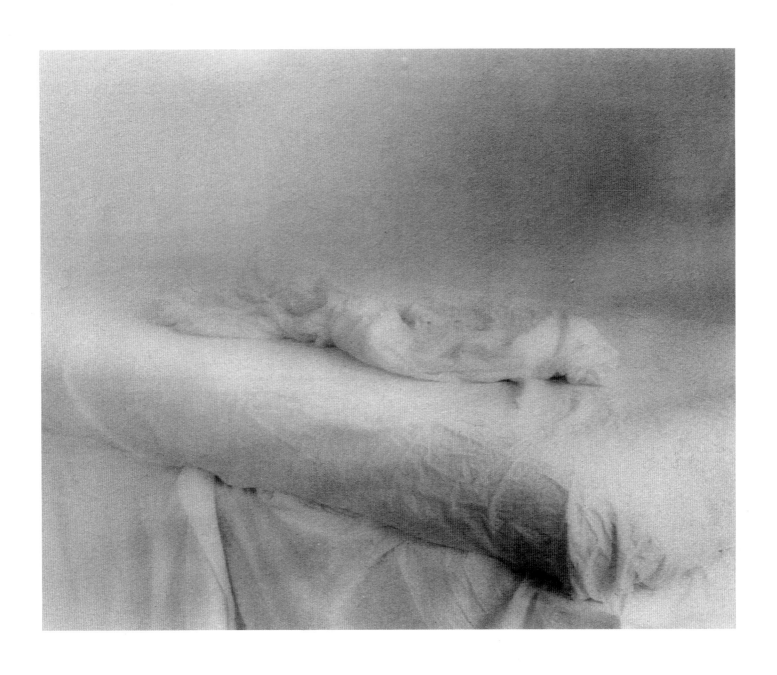

Hiromitsu Morimoto, Untitled, 1995

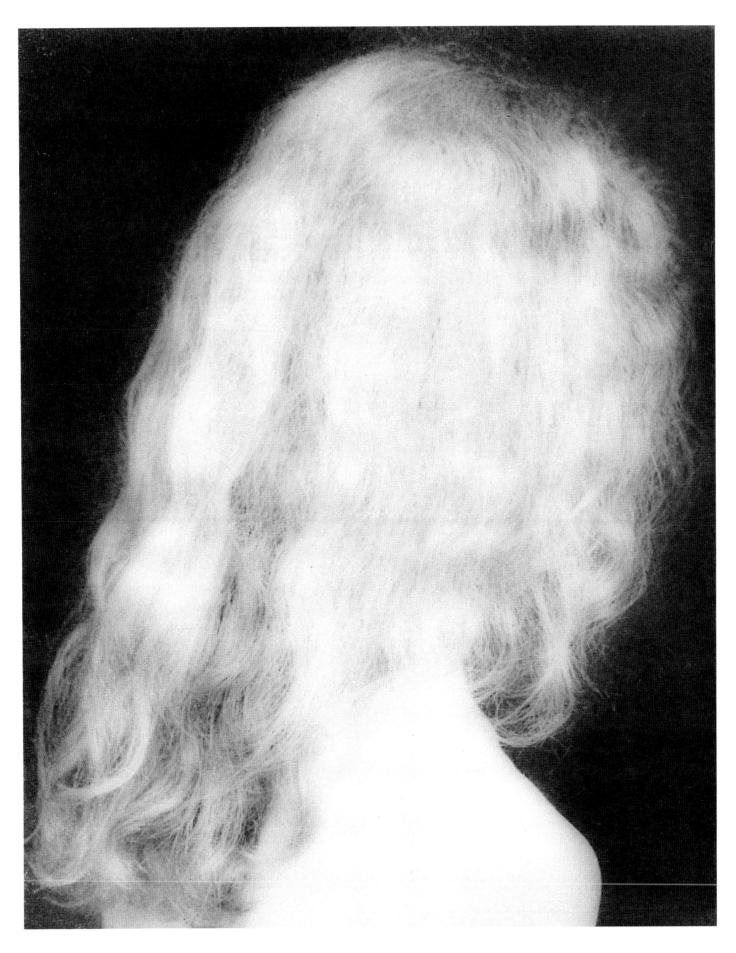

Hiromitsu Morimoto, Untitled, 1995

COURTESY JAYNE H. BAUM, NEW YORK, NY

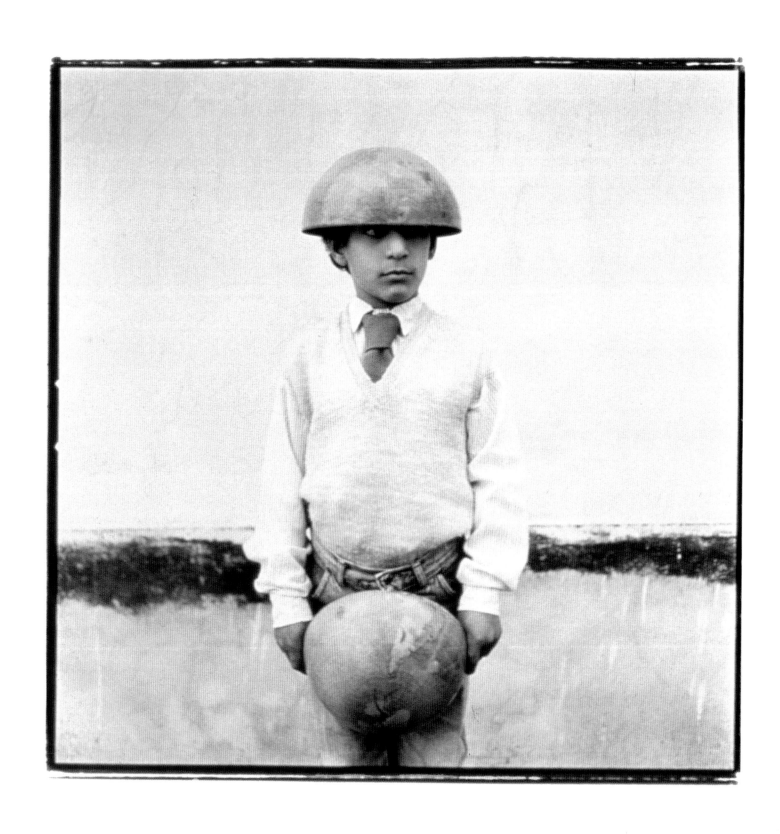

Keith Carter, Ezekiel, 1995

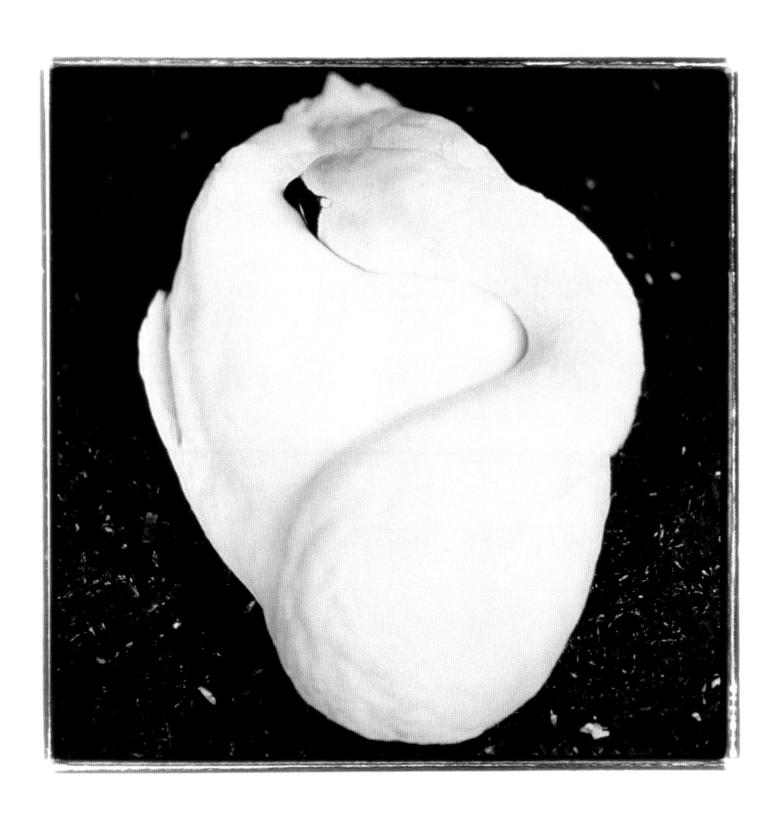

Keith Carter, Sleeping Swan, 1995

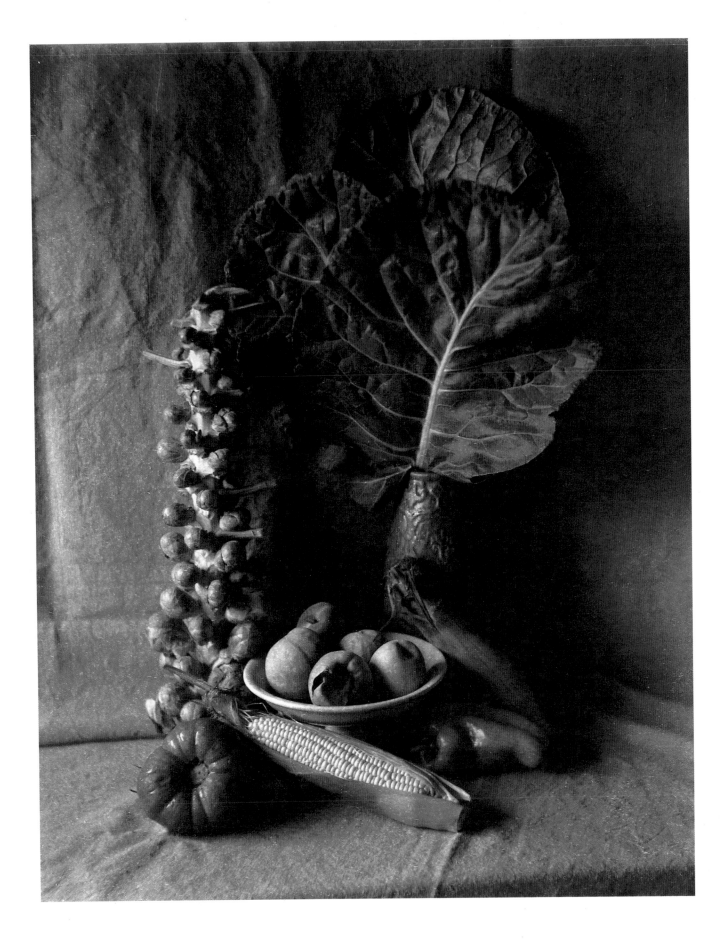

John Dugdale, Fruits of Summer, 1996
COURTESY WESSEL + O'CONNOR GALLERY, NEW YORK, NY

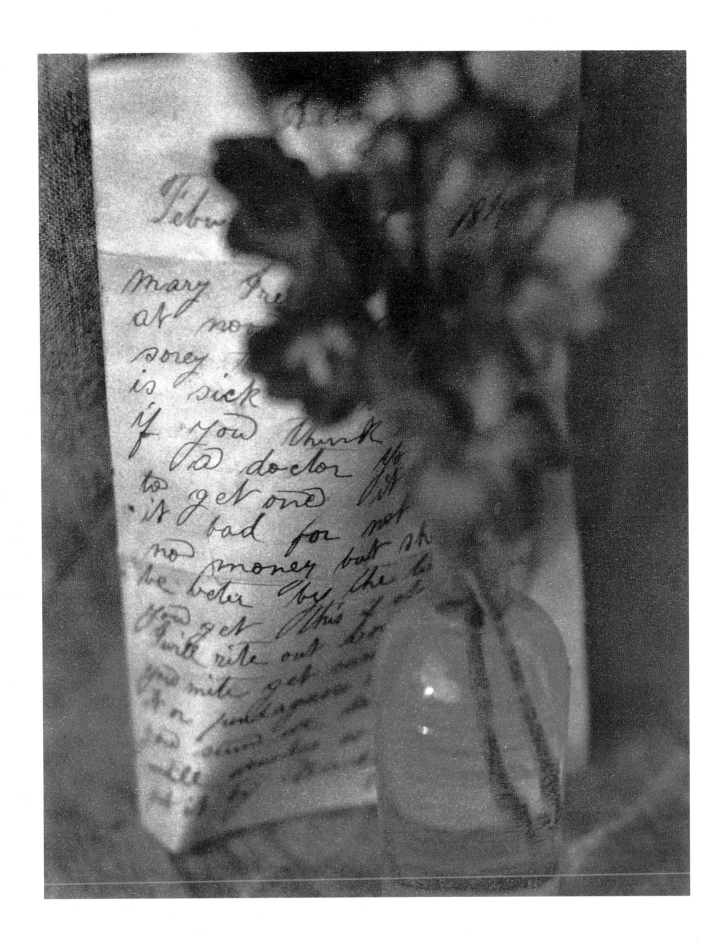

John Dugdale, Dear Mary, 1996

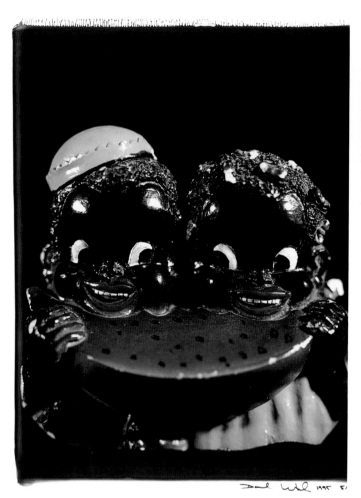 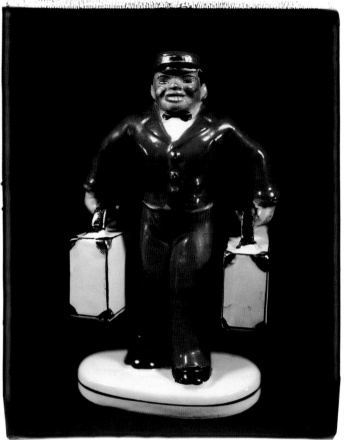

David Levinthal, Untitled from the Blackface Series, 1995

COURTESY JANET BORDEN, INC., NEW YORK, NY

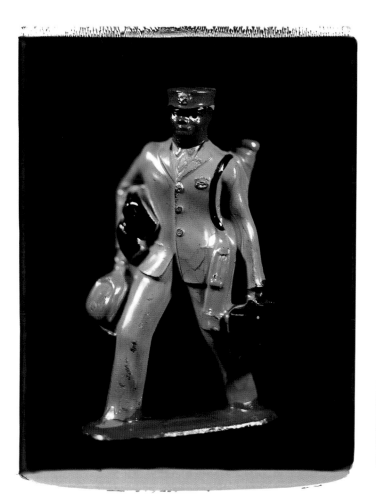 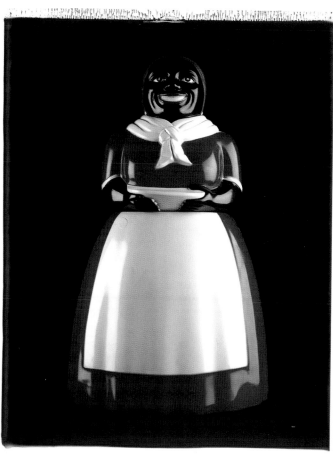

David Levinthal, Untitled from the Blackface Series, 1995

COURTESY JANET BORDEN, INC., NEW YORK, NY

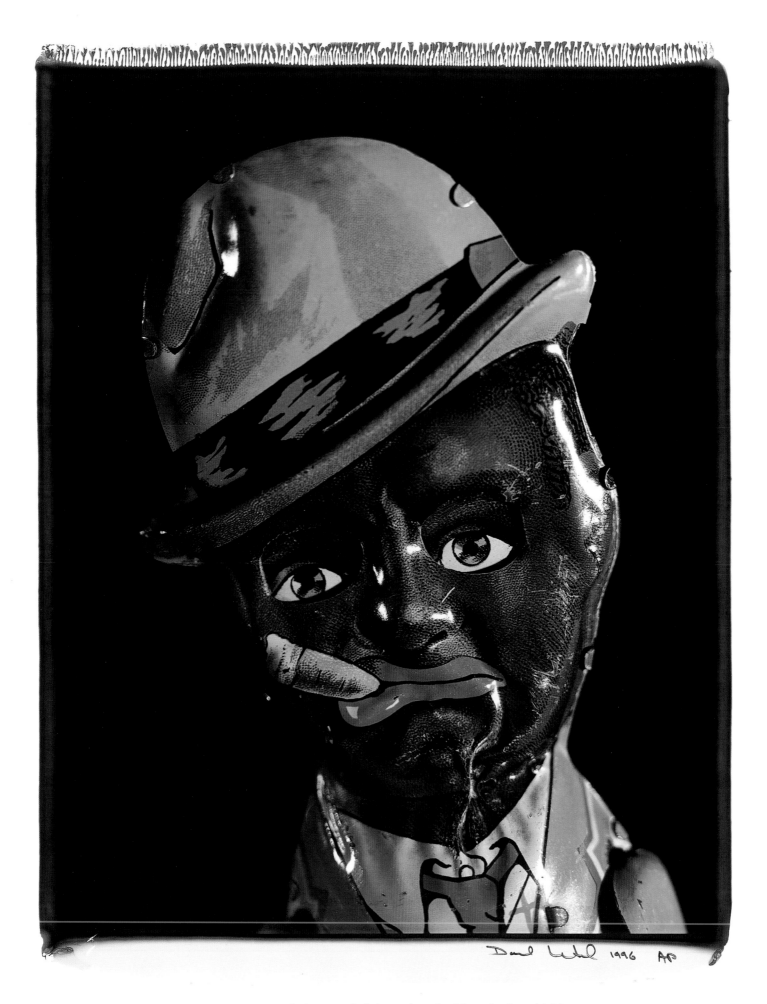

David Levinthal, Untitled from the Blackface Series, 1995

COURTESY JANET BORDEN, INC., NEW YORK, NY

73

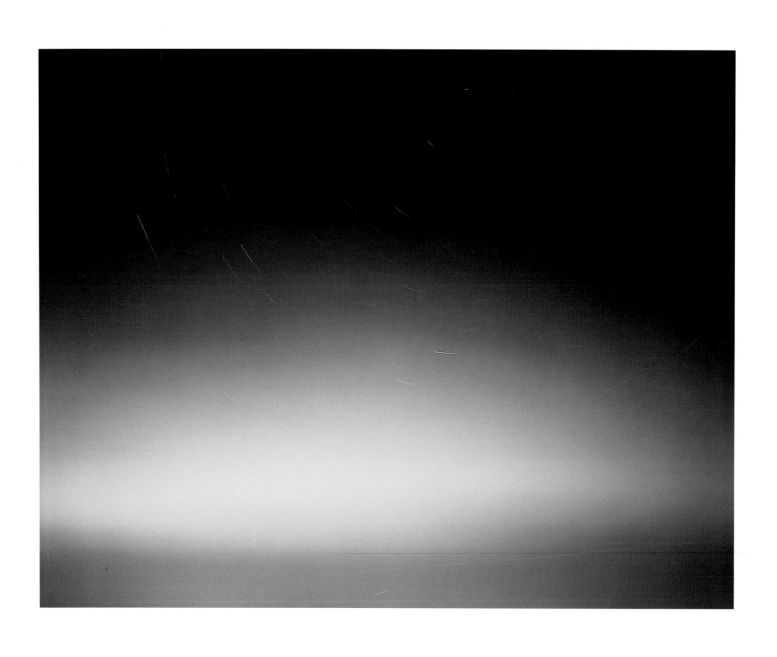

Richard Misrach, Polaris Over Ak-Chin, 11.5.96-11.6.96, 11:42 p.m.-12:31 a.m.

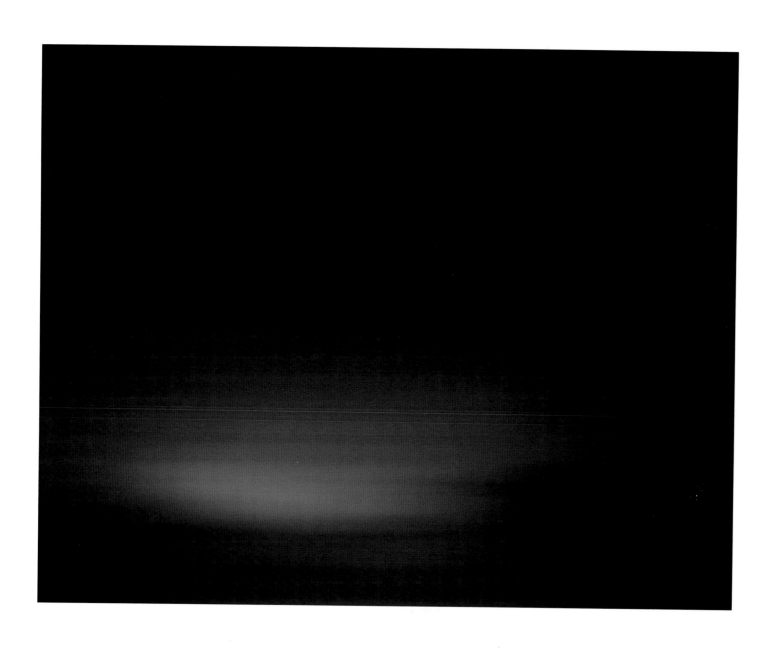

Richard Misrach, Clouds, Las Vegas, 10.29.95, 4:47 a.m.
COURTESY ROBERT MANN GALLERY, NEW YORK, NY

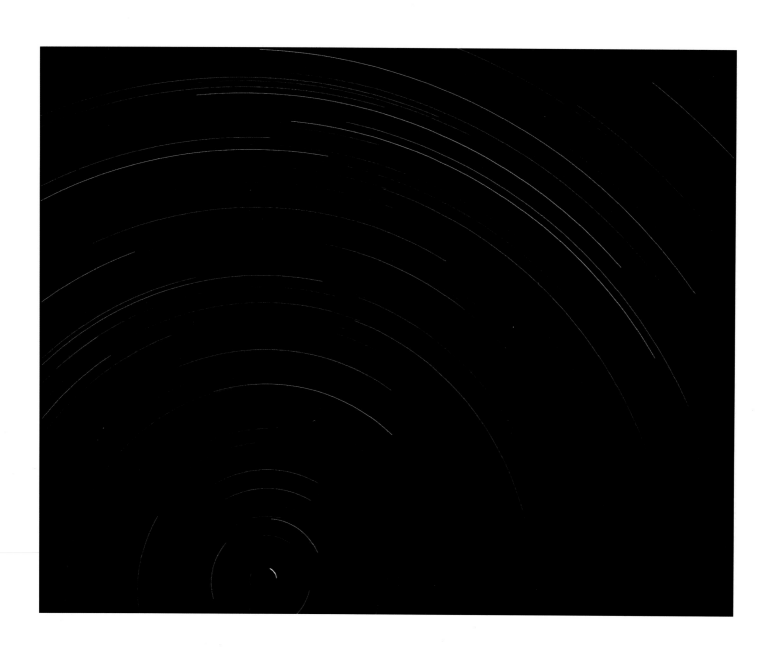

Richard Misrach, Cassiopeia and Polaris Over Hassayampa Plain, 10.31.96, 6:58-10:58 p.m.

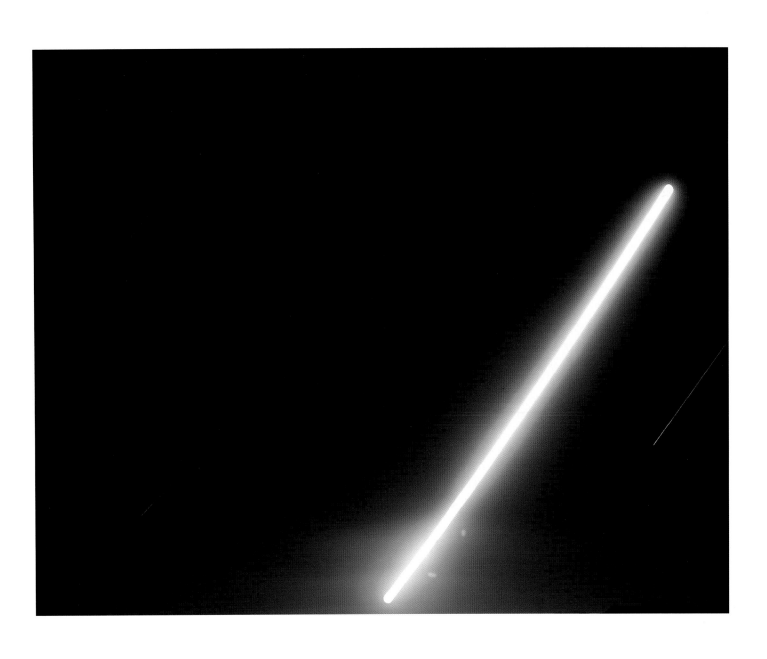

Richard Misrach, Moon Over Black Rock Desert, 8.31.96, 9:35 p.m.-11:51 p.m.

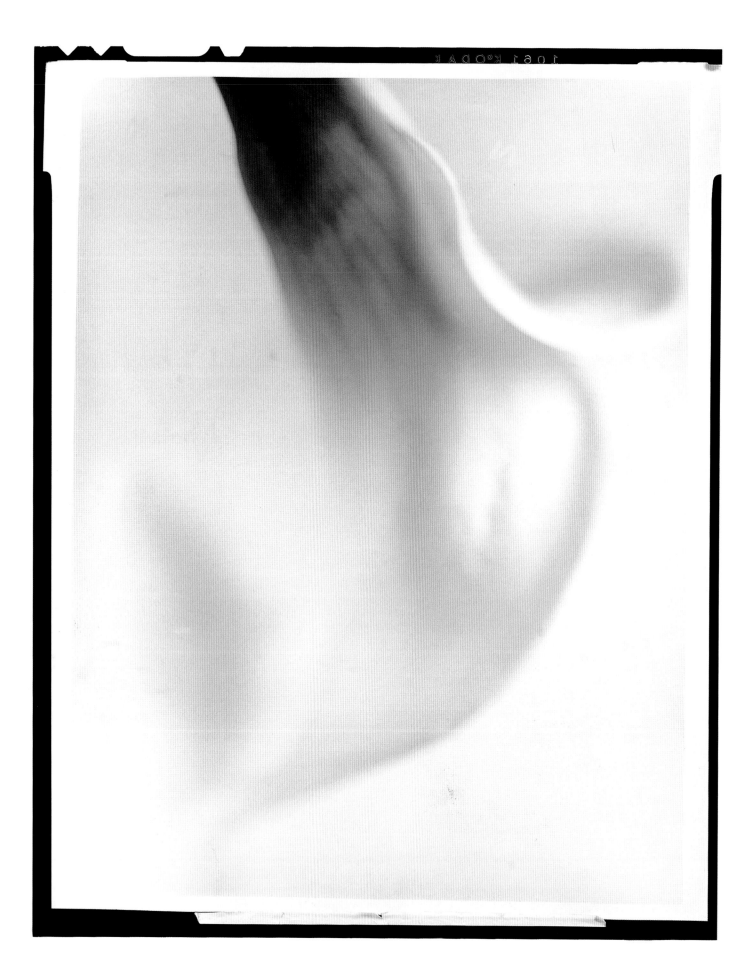

Sandi Fellman, Calla Lily II, 1996

COURTESY HOUK FRIEDMAN GALLERY, NEW YORK, NY

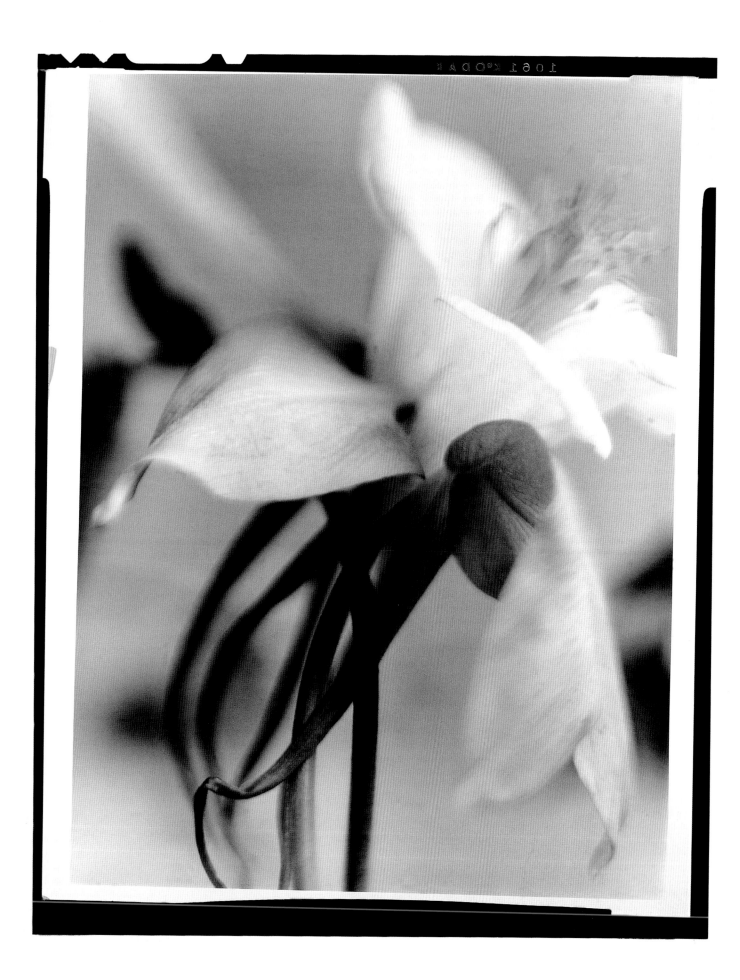

Sandi Fellman, Columbine, 1996
COURTESY HOUK FRIEDMAN GALLERY, NEW YORK, NY

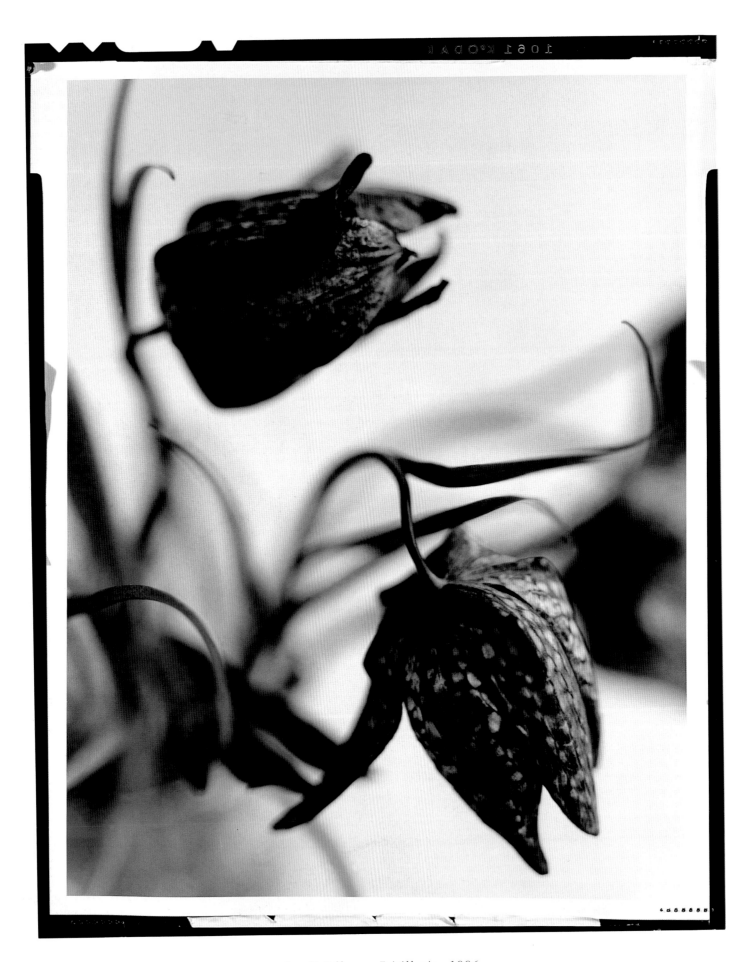

Sandi Fellman, Fritillaria, 1996

COURTESY HOUK FRIEDMAN GALLERY, NEW YORK, NY

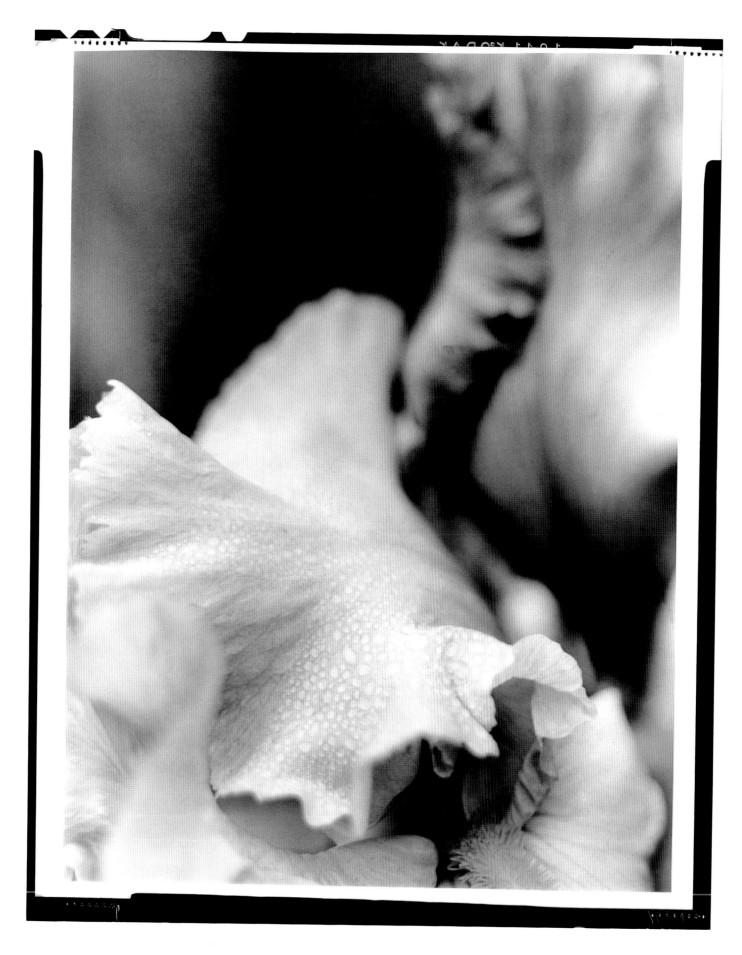

Sandi Fellman, Garden Iris, 1996

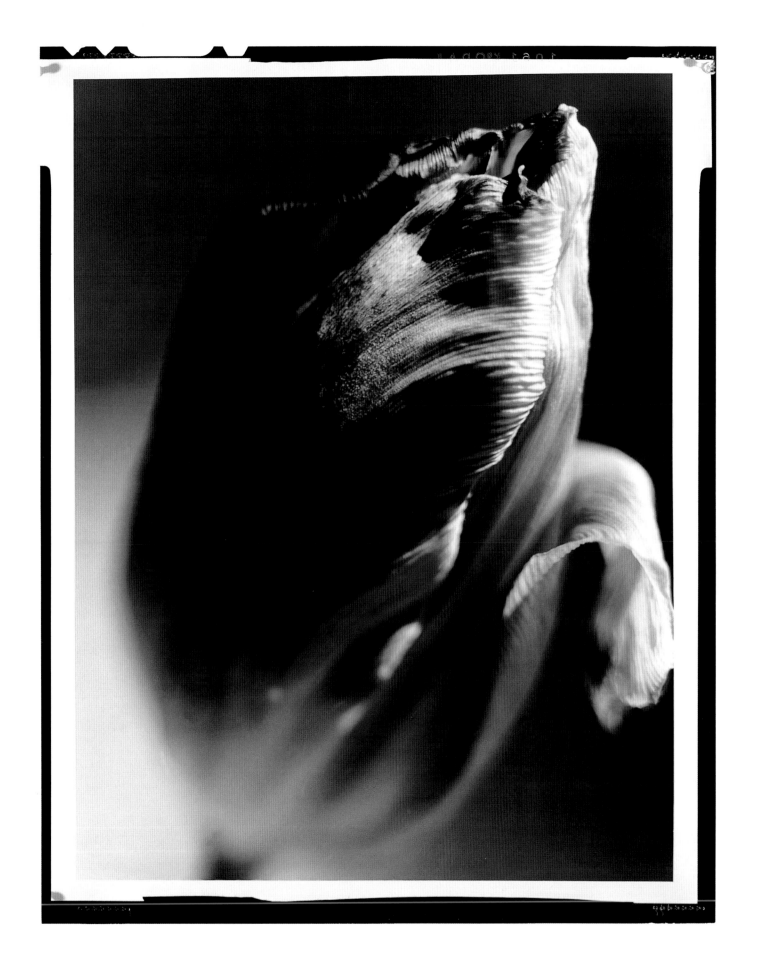

Sandi Fellman, Single Dark Tulip, 1996

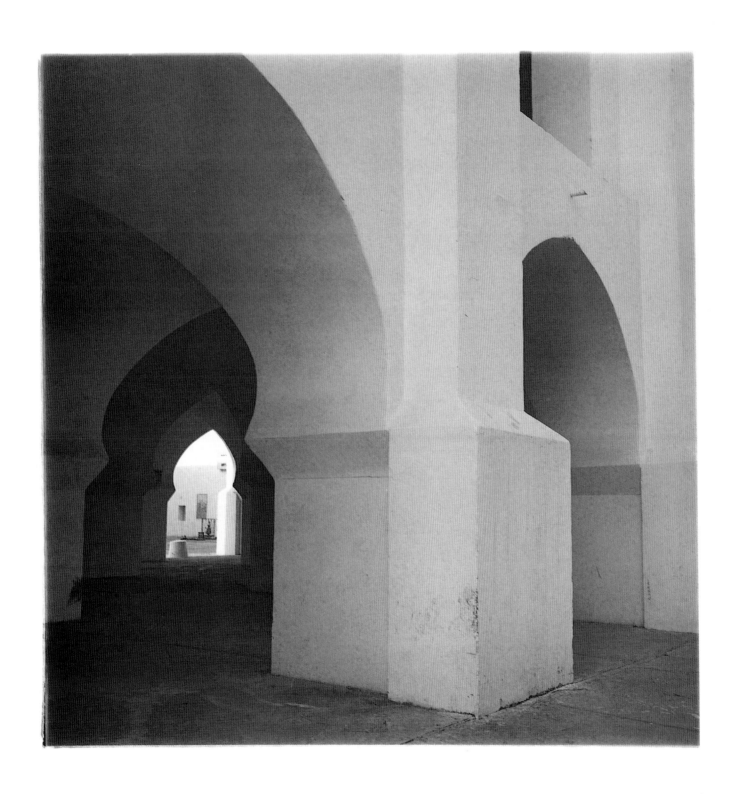

Jayne Hinds Bidaut, Algeria, 1995

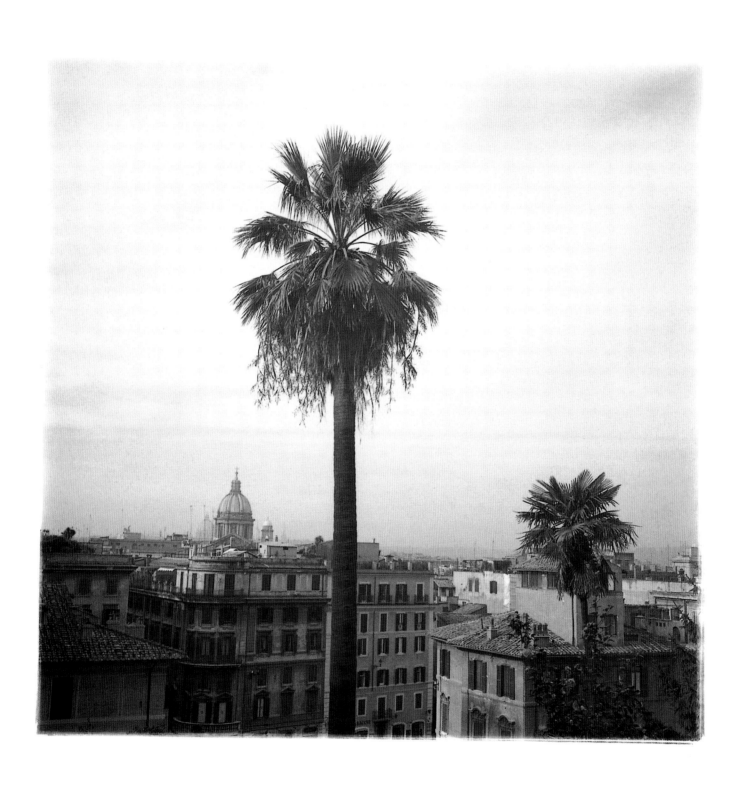

Jayne Hinds Bidaut, Rome, 1995

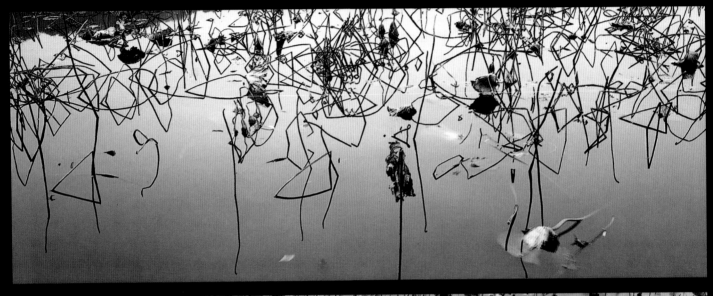

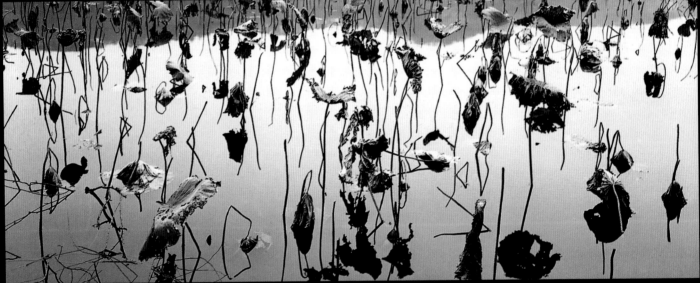

Lois Conner, Lotus, China, 1995

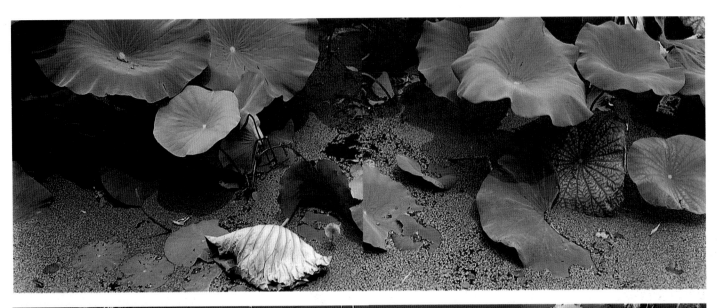

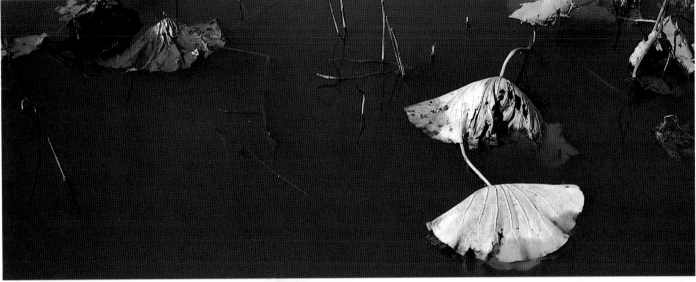

Lois Conner, Lotus, China, 1995

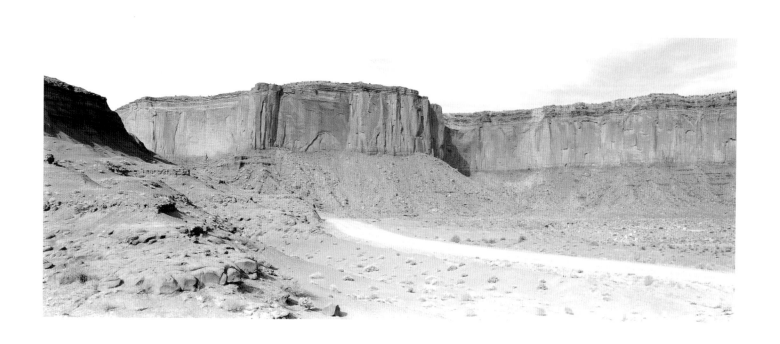

Lois Conner, Monument Valley, Arizona

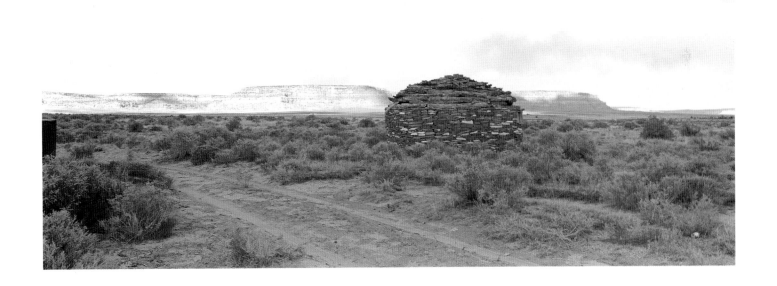

Lois Conner, Whitehorse, New Mexico, 1995

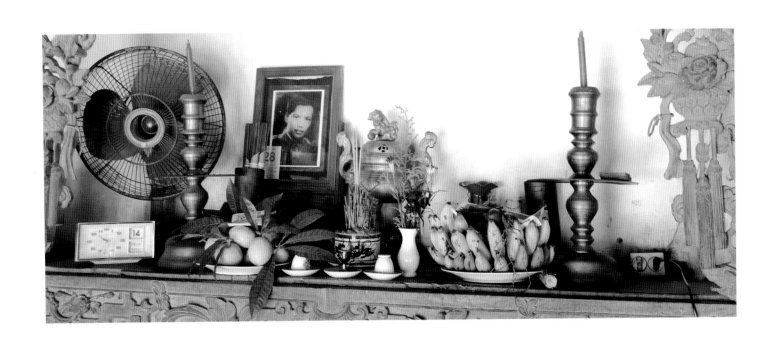

Lois Conner, Vietnam, 1995

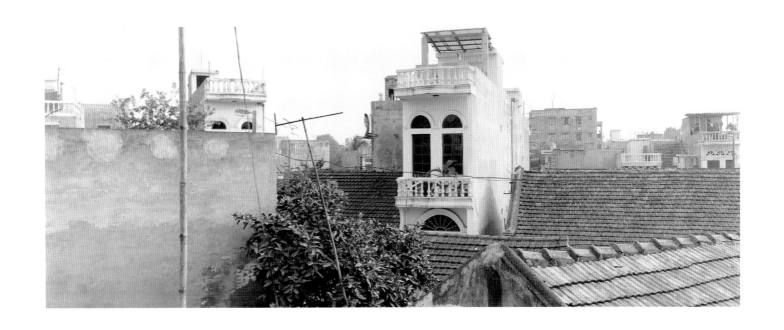

Lois Conner, Hanoi, Vietnam, 1995

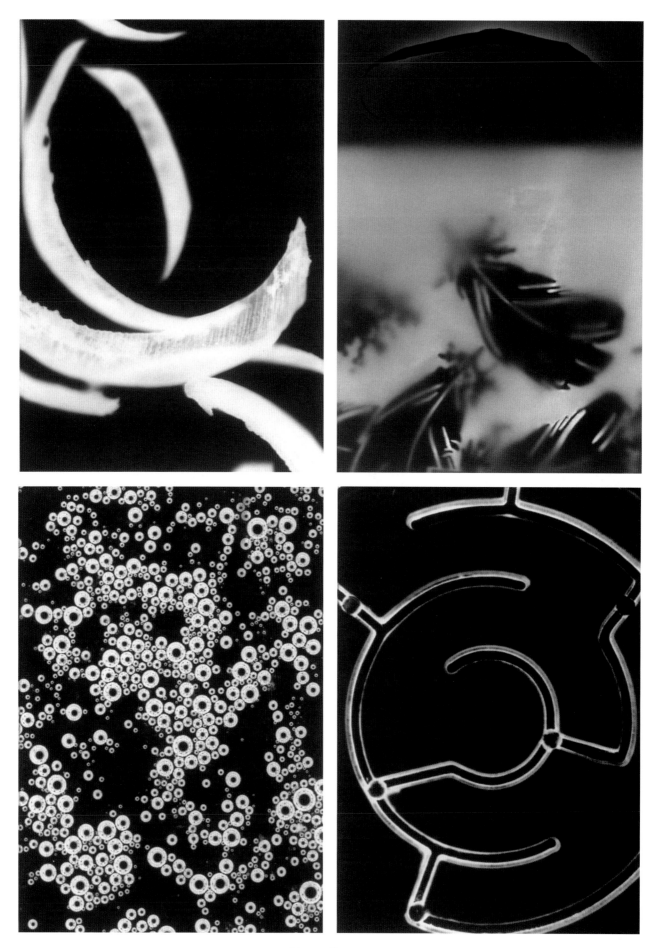

Marco Breuer
(TOP LEFT) *A/Z (Nails), 1996* (TOP RIGHT) *A/Z (Bag I), 1996* (BOTTOM LEFT) *A/Z (Spit), 1996* (BOTTOM RIGHT) *A/Z (Maze), 1996*

COURTESY JAYNE H. BAUM, NEW YORK, NY

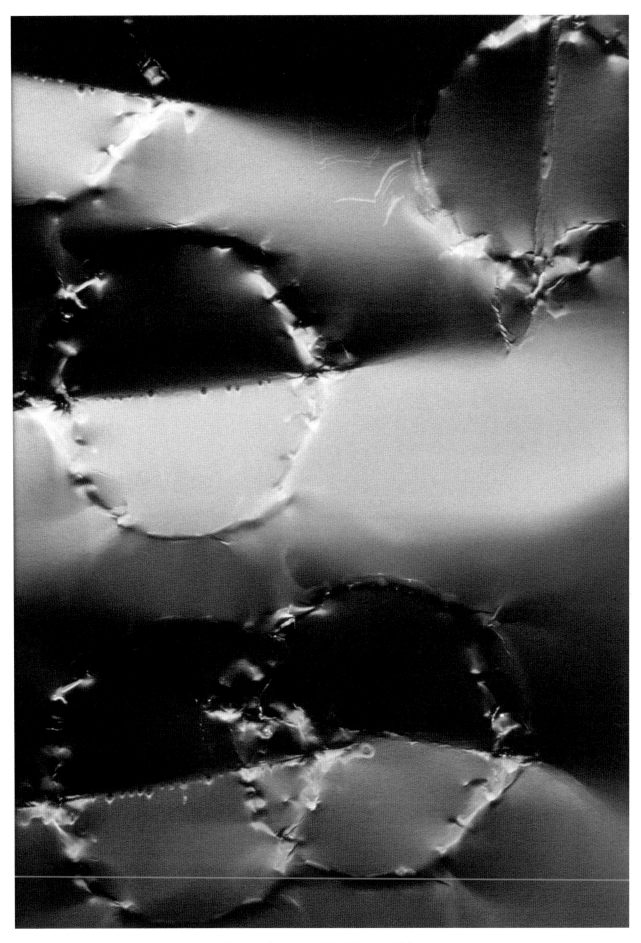

Marco Breuer, A/Z (Bites), 1996

COURTESY JAYNE H. BAUM, NEW YORK, NY

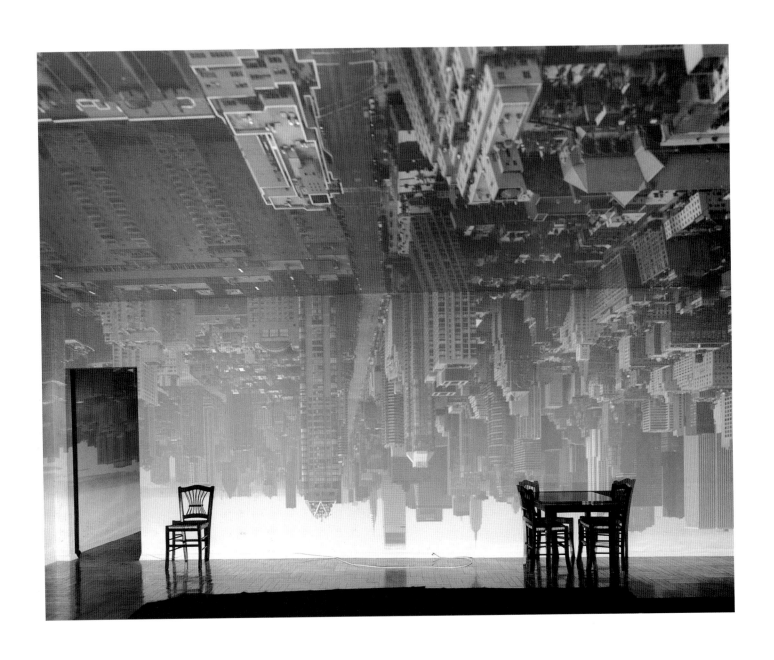

Abelardo Morell, Camera Obscura Image of Manhattan View Looking South in Large Room, 1997

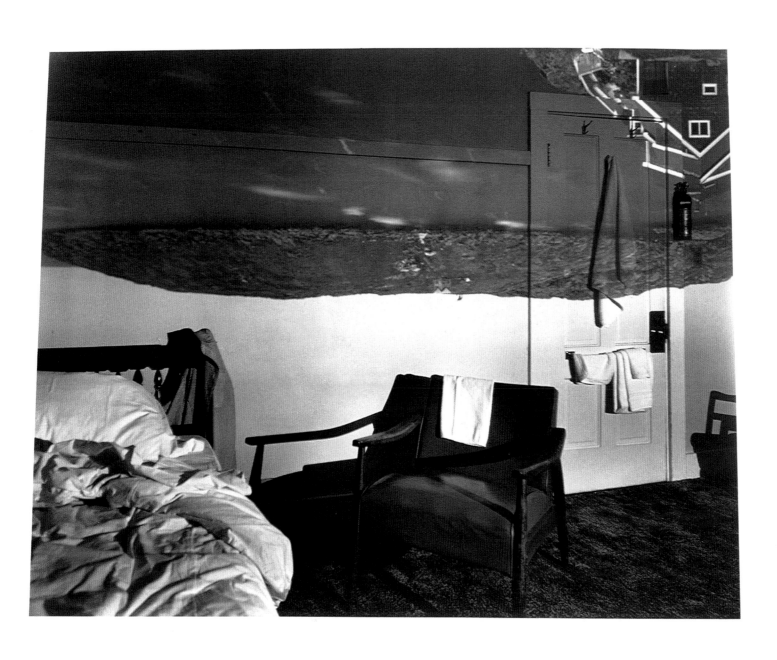

Abelardo Morell, Camera Obscura Image of Manana in Monhegan Inn, 1996

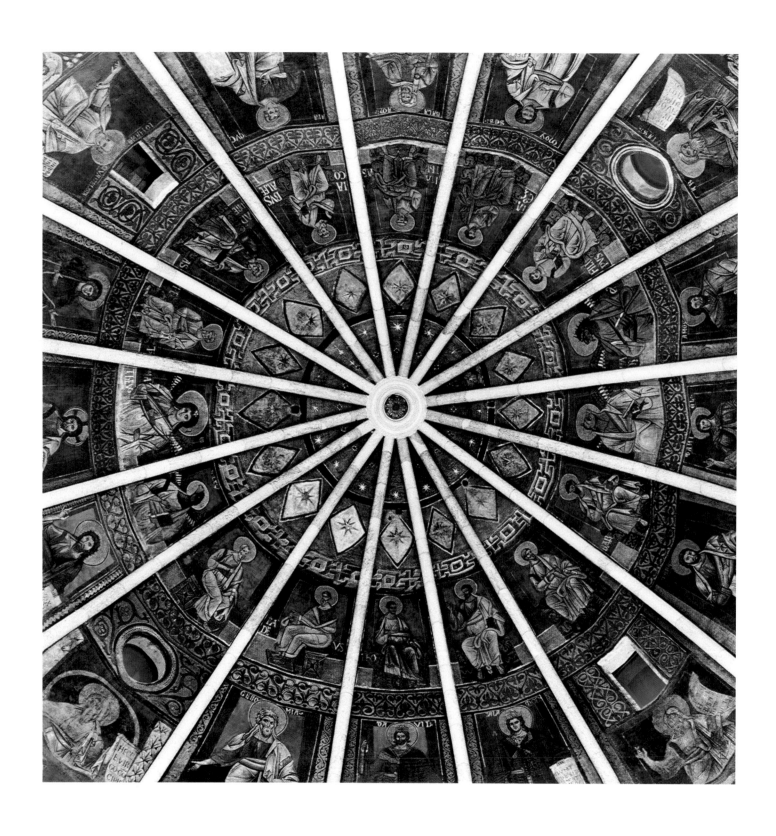

David Stephenson, Transfigurations #8904, Battistero, Parma, 1993

COURTESY JULIE SAUL GALLERY, NEW YORK, NY

David Stephenson, Transfigurations #8005, 1993

David Stephenson, Transfigurations #4106, Sant' Eufemia, Milano, 1993

David Stephenson, Transfigurations #9709, 1993
COURTESY JULIE SAUL GALLERY, NEW YORK, NY

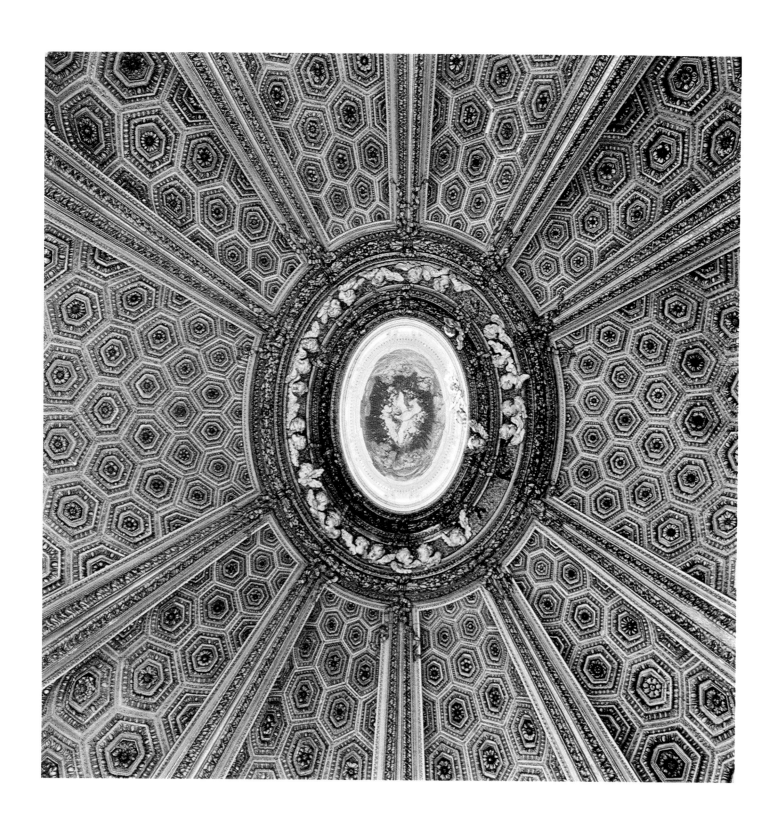

David Stephenson, Transfigurations #10105, Sant' Andrea al Quirnale, Roma, 1993

COURTESY JULIE SAUL GALLERY, NEW YORK, NY

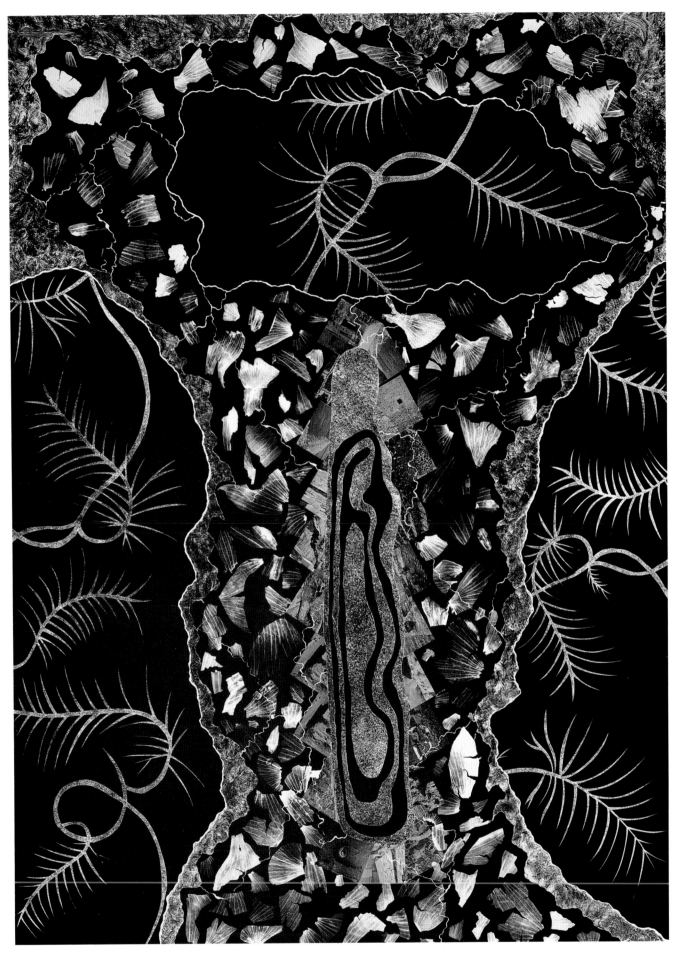

Maria Martinez-Cañas, Piedras: Destinos, 1996

COURTESY JULIE SAUL GALLERY, NEW YORK, NY

Stephen Sack, Natural History, 1996

COURTESY JAMES DANZIGER GALLERY, NEW YORK, NY

Stephen Sack, Natural History, 1996

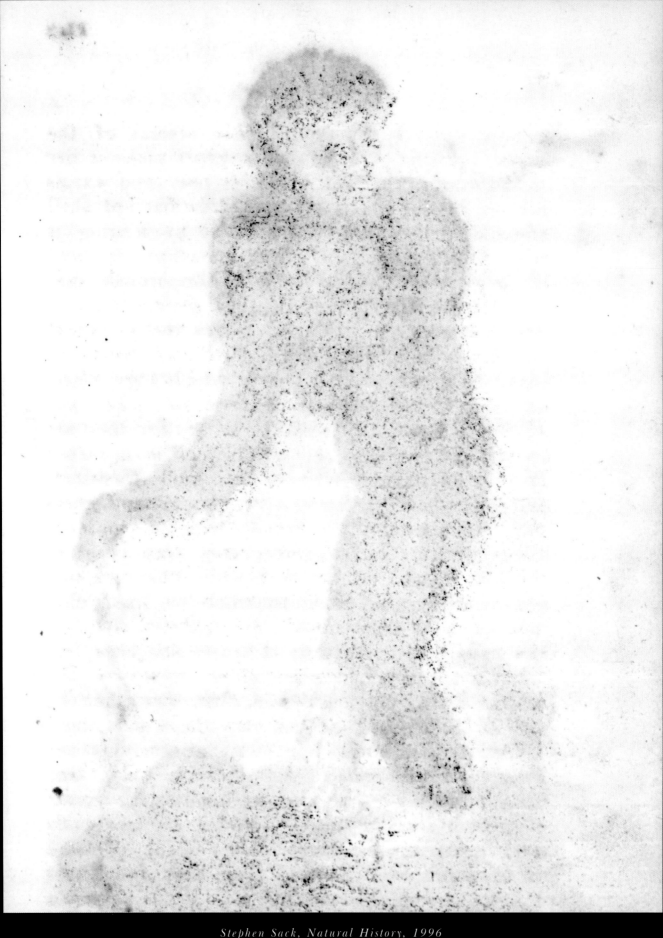

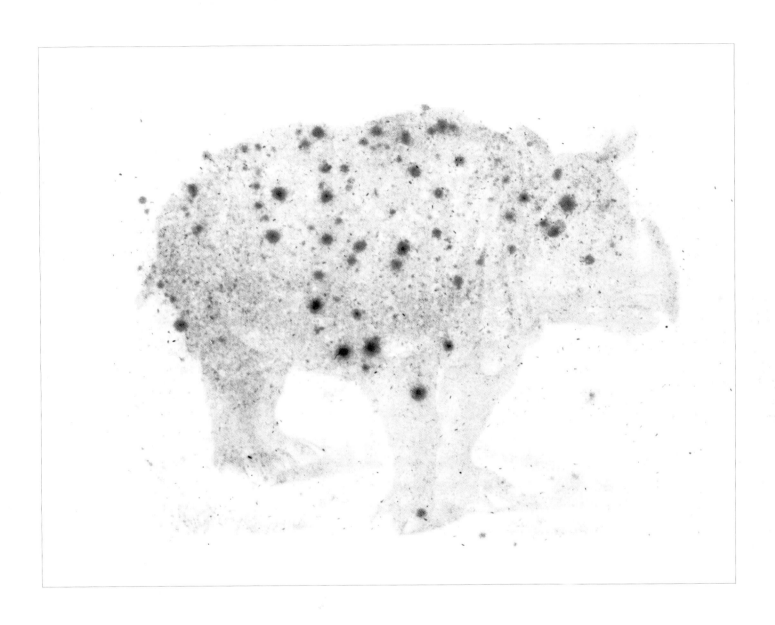

Stephen Sack, Natural History, 1996

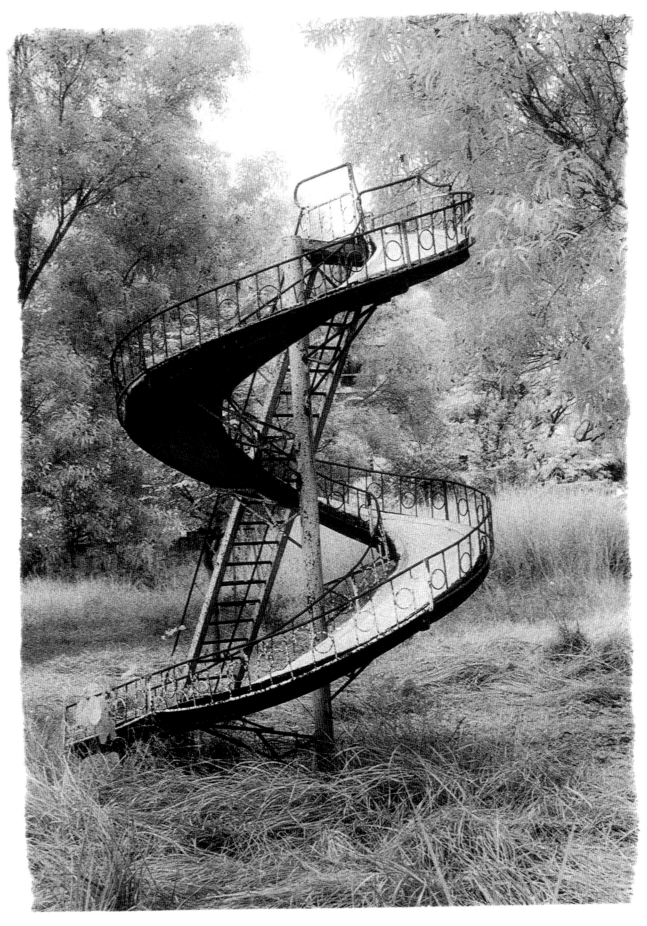

Marcia Lippman, Ventienne, Laos, 1996

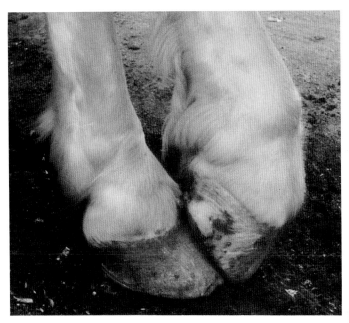
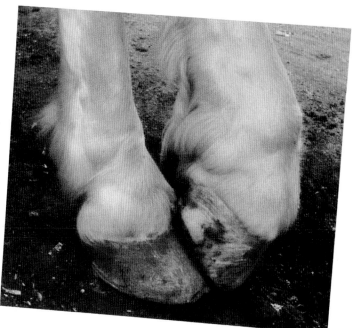

Marcia Lippman, Horse, 1996

COURTESY STALEY-WISE GALLERY, NEW YORK, NY

111

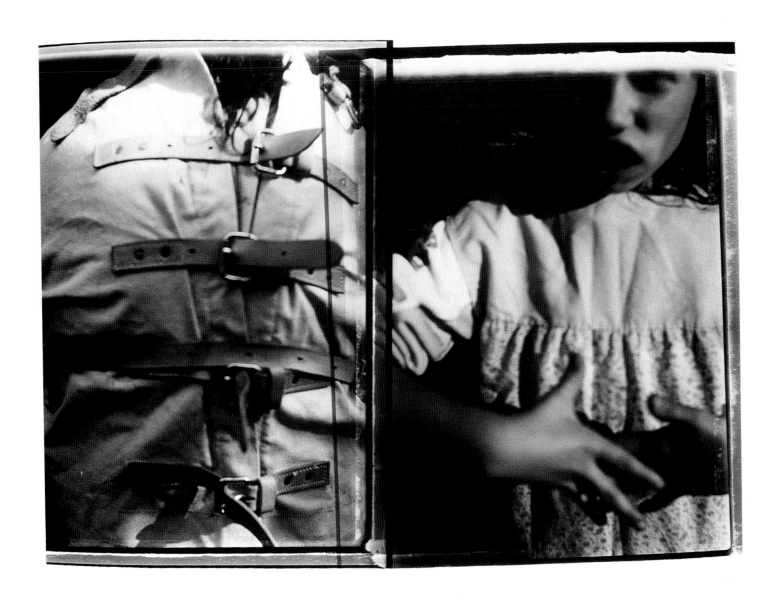

Gerald Slota, Untitled, 1993

COURTESY RICCO/MARESCA GALLERY, NEW YORK, NY

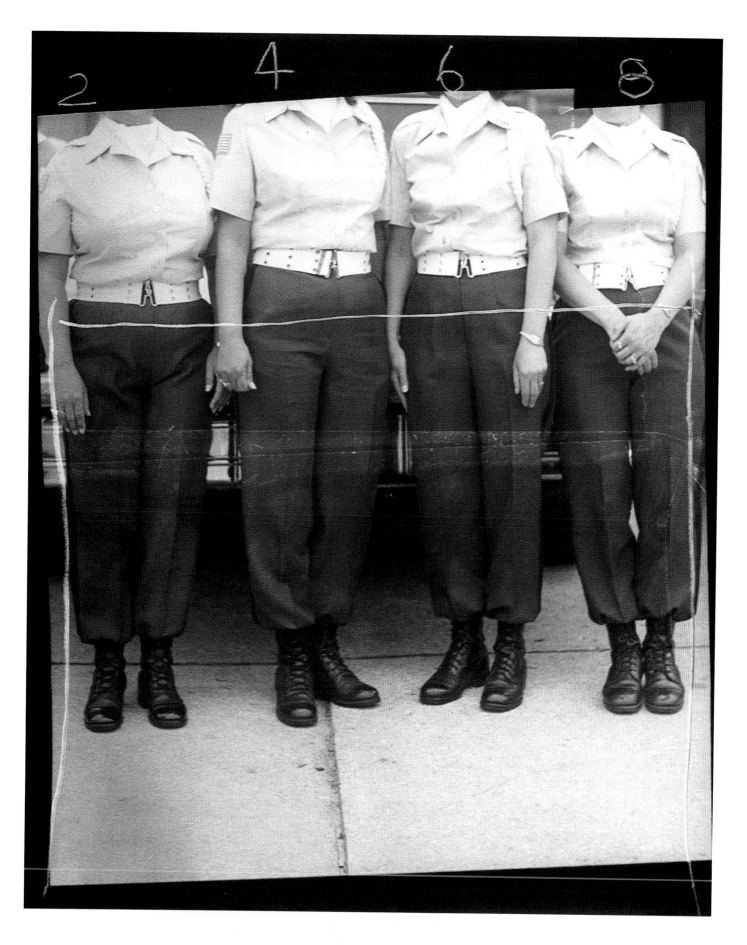

Gerald Slota, Untitled, 1995
COURTESY RICCO/MARESCA GALLERY, NEW YORK, NY

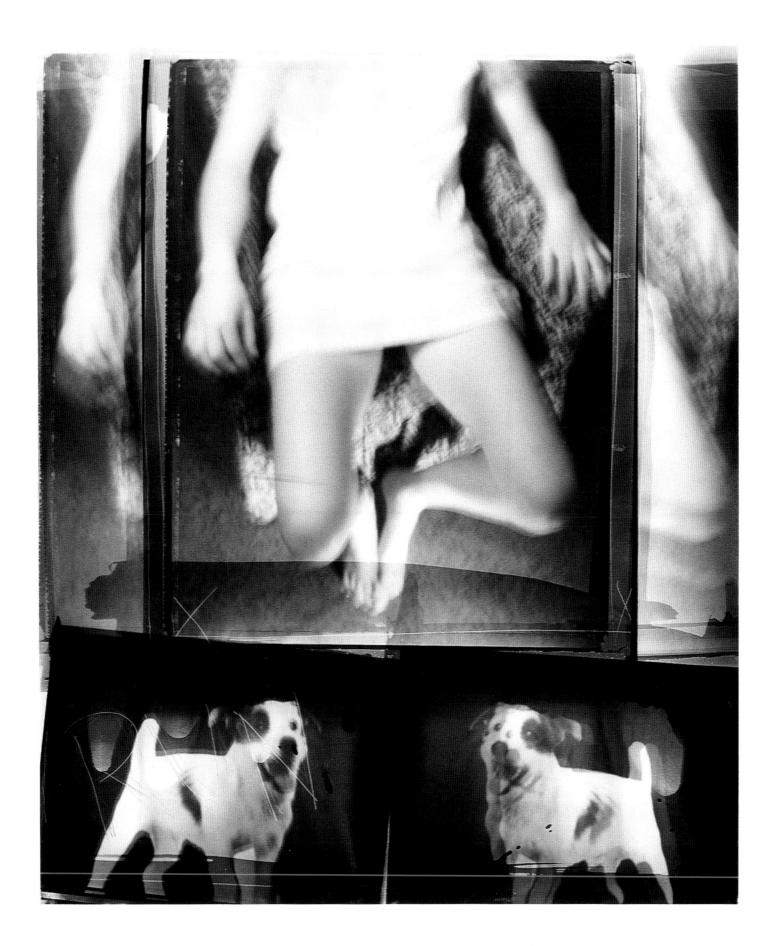

Gerald Slota, Run, 1993

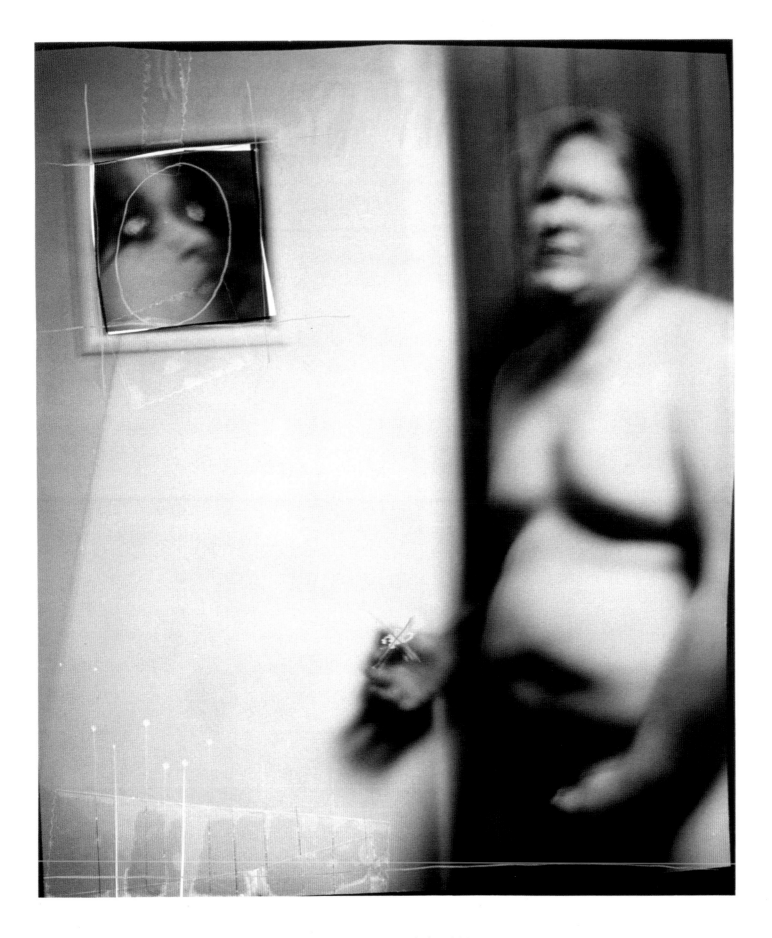

Gerald Slota, Untitled, 1995

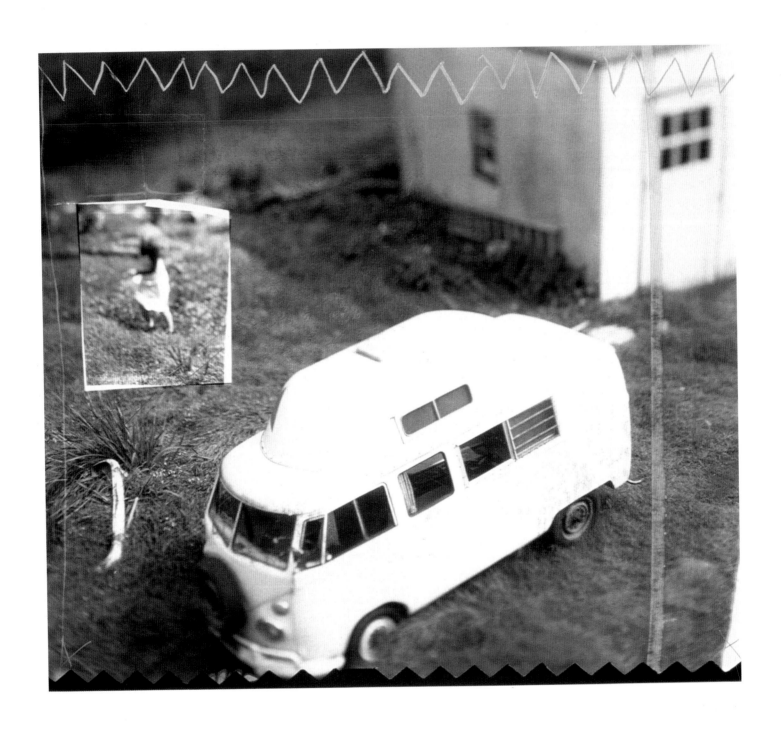

Gerald Slota, Untitled, 1996

COURTESY RICCO/MARESCA GALLERY, NEW YORK, NY

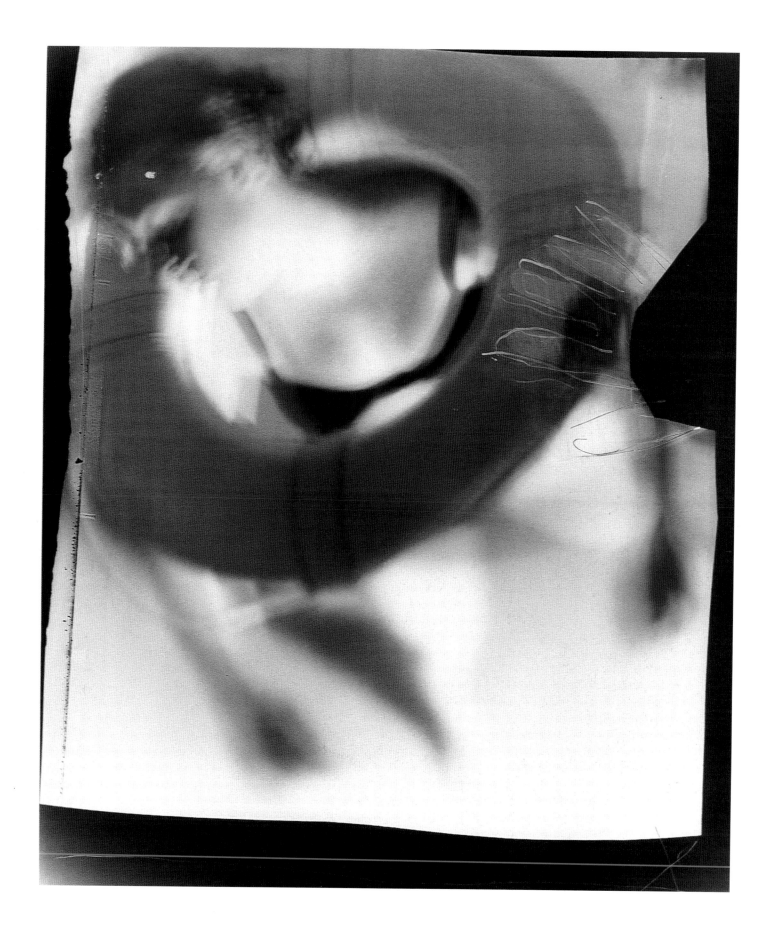

Gerald Slota, Untitled, 1995

COURTESY RICCO/MARESCA GALLERY, NEW YORK, NY

Hiroshi Sugimoto, Bass Strait, Table Mountain, 1996

Hiroshi Sugimoto, Bay of Sagami, Atami, 1996

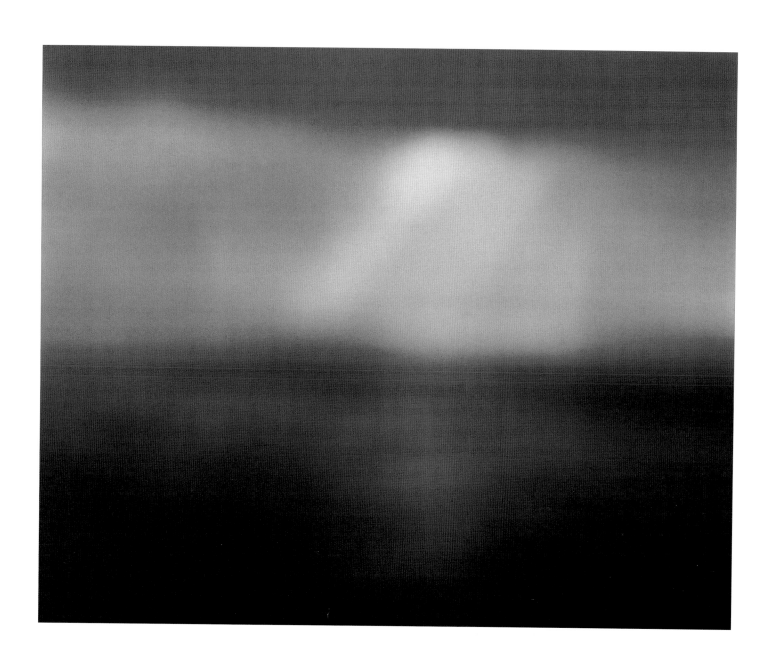

Hiroshi Sugimoto, Bay of Sagami, Atami, 1997

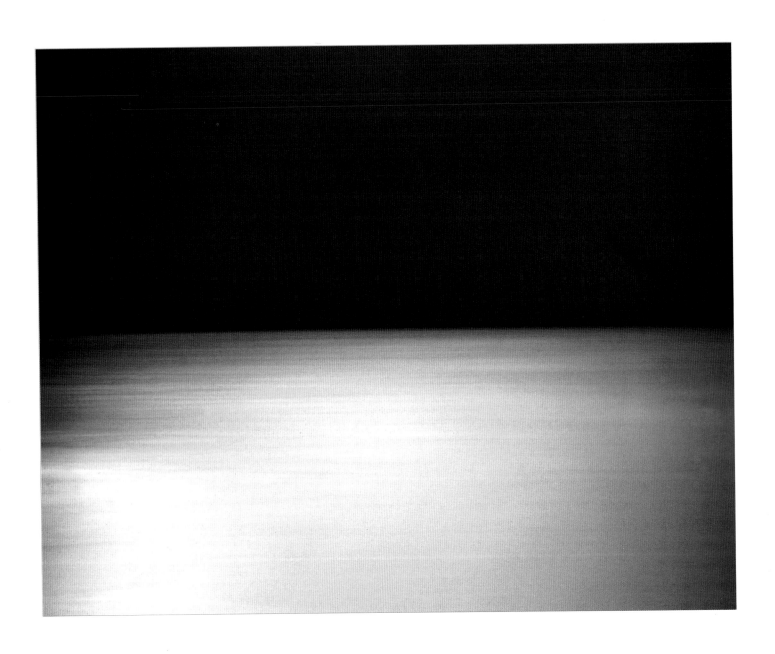

Hiroshi Sugimoto, Bay of Sagami, Atami, 1996

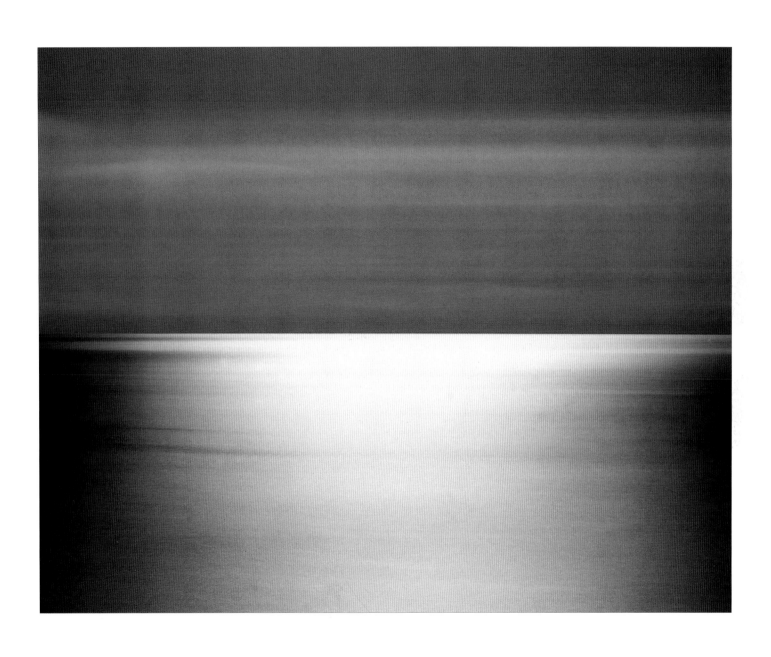

Hiroshi Sugimoto, N. Atlantic Ocean, Cape Breton Island, 1996

Arne Svenson, Las Vegas, 1994

COURTESY JULIE SAUL GALLERY, NEW YORK, NY

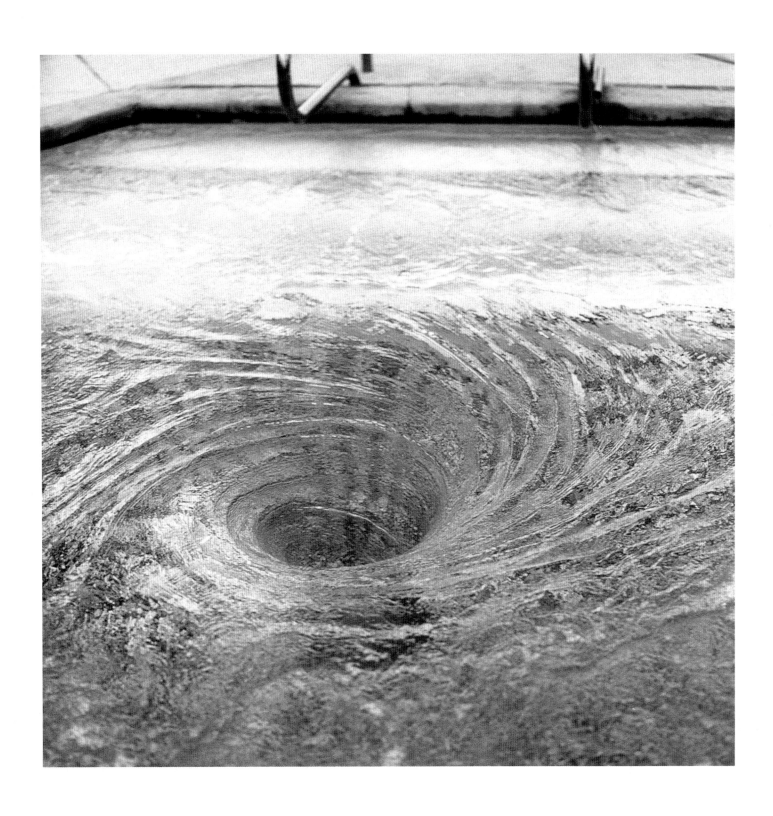

Arne Svenson, Las Vegas, 1995

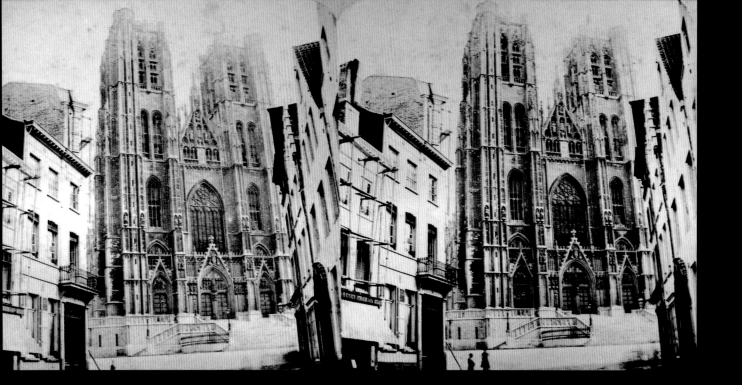

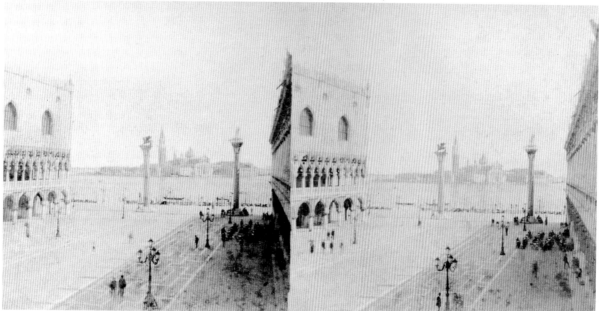

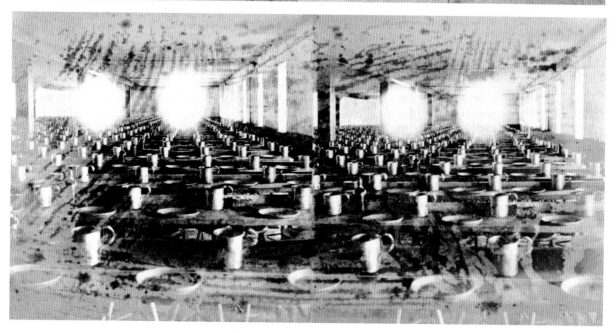

Stephen Sack, Landscapes, 1995-1997

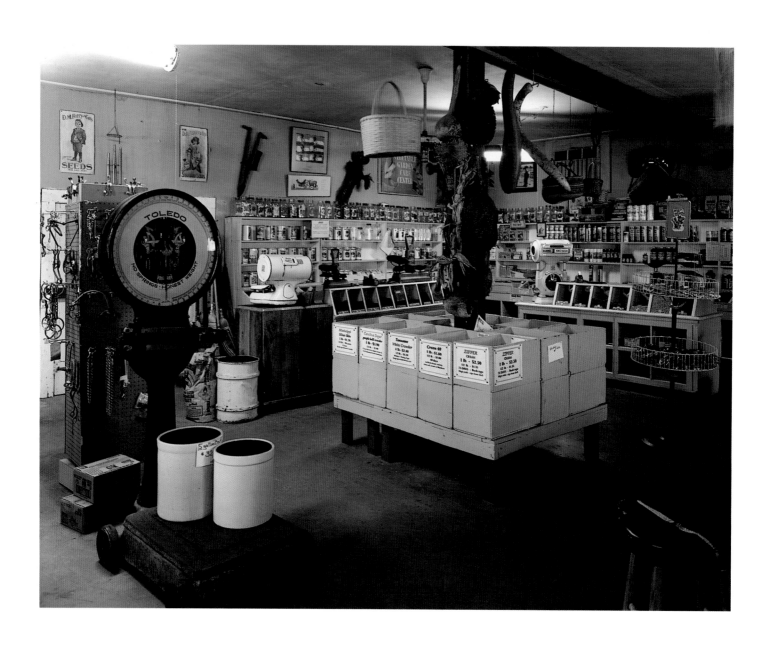

Jim Dow, Interior, Hollingsworth's Feed & Seed Store, El Dorado, AR, 1995

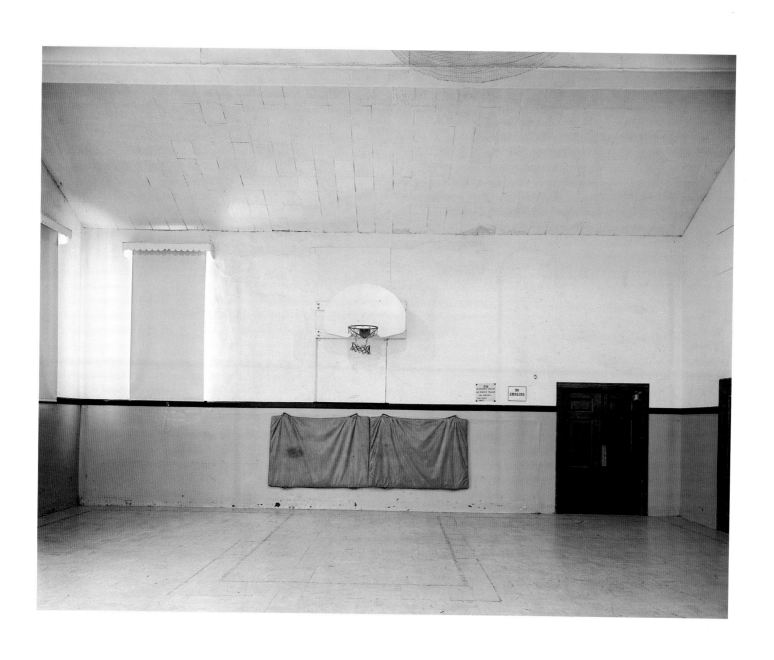

Jim Dow, Gymnasium, Woodhull, NY, 1996

COURTESY JANET BORDEN, INC., NEW YORK, NY

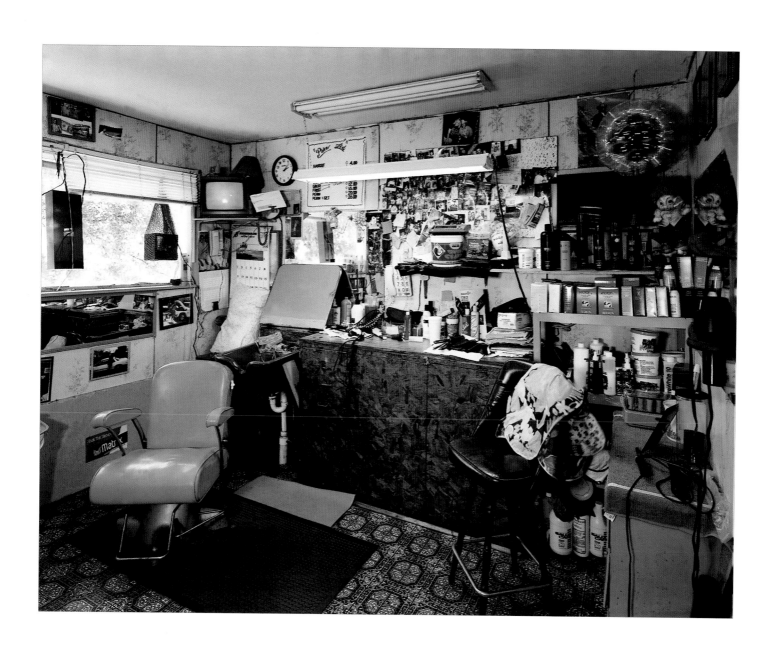

Jim Dow, Deb's Hot Kutz, US 64, Coal Hill, AR, 1995

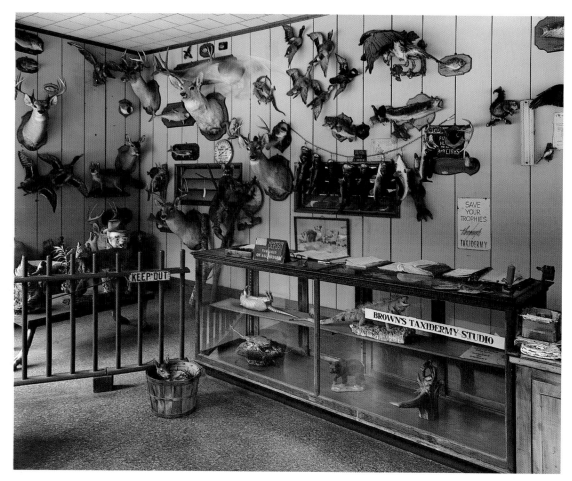

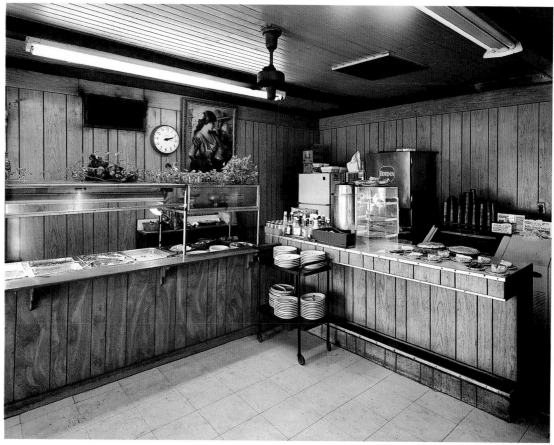

Jim Dow
(TOP) *Brown's Taxidermy Studio, US 82, El Dorado, AR, 1995*
(BOTTOM) *Lunch Buffet, Davis Cafe, US 67, Prescott, AR, 1995*

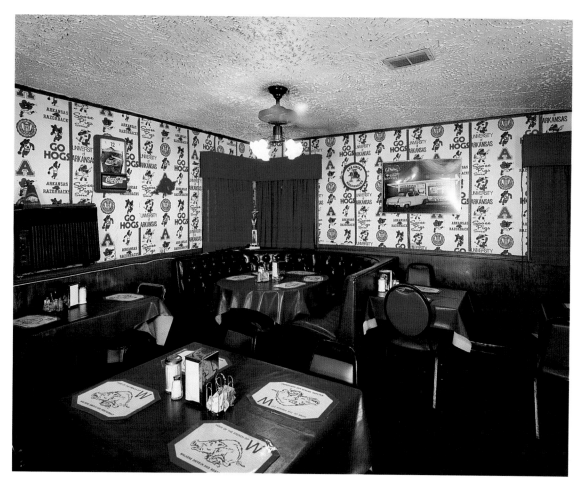

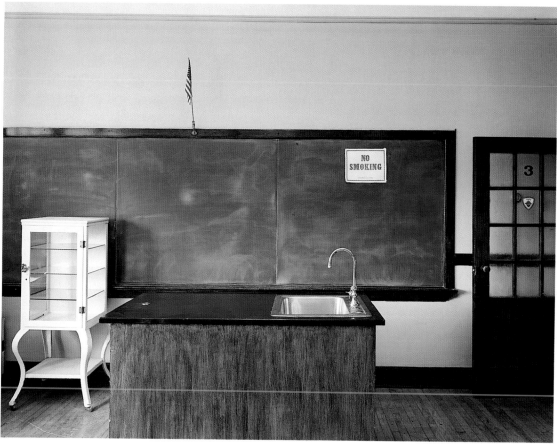

Jim Dow
(TOP) *Razorback Room, Walker's Drive In, US 71, Ft. Smith, AR, 1995*
(BOTTOM) *Chemistry Lab in High School, Woodhull, NY, 1995*

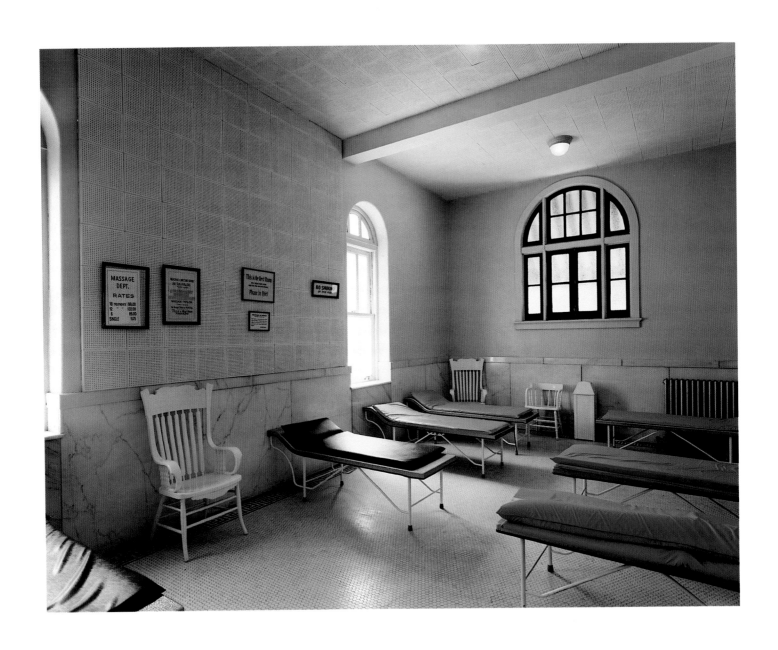

Jim Dow, Men's Drying Room, Buckstaff Baths, Hot Springs, AR, 1995

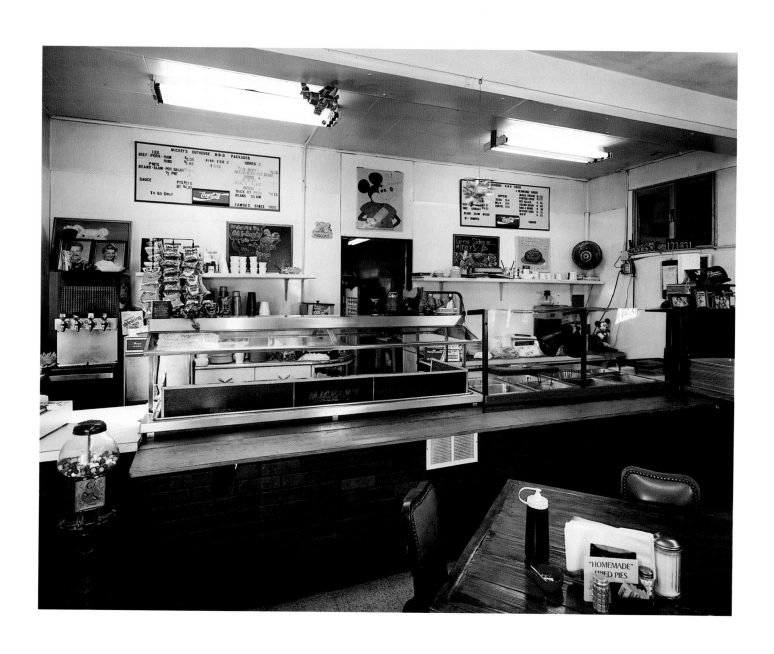

Jim Dow, Mickey's Bar-B-Que, US 70, Hot Springs, AR, 1995

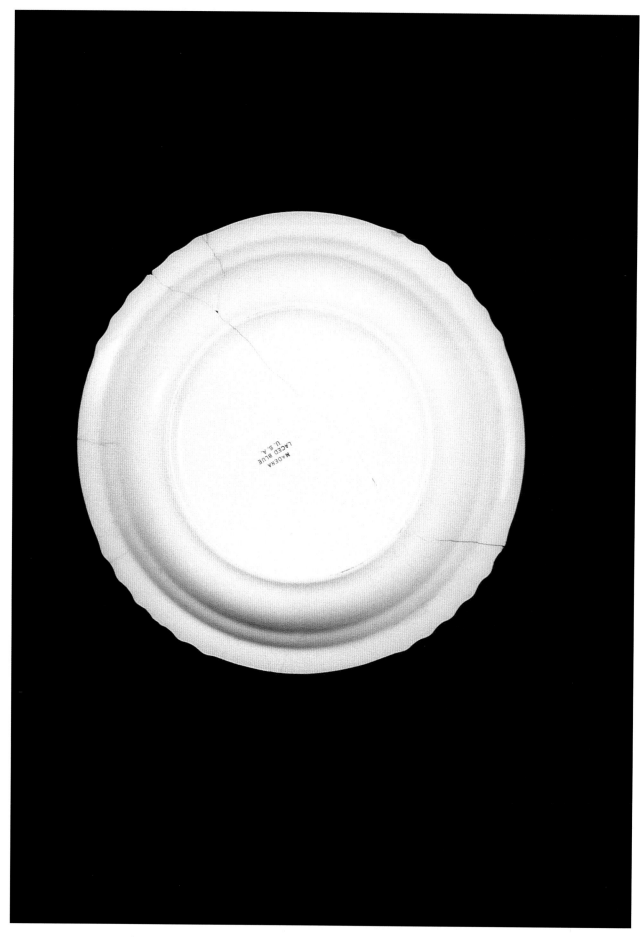

J. John Priola, Dish, 1995
COURTESY FRAENKEL GALLERY, SAN FRANCISCO, CA

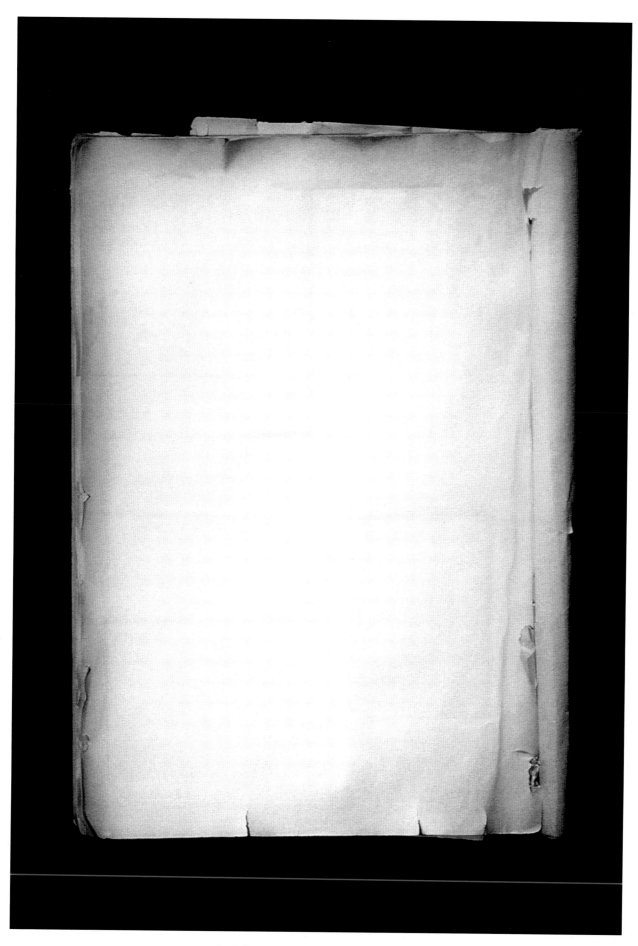

J. John Priola, Scrap Book, 1995

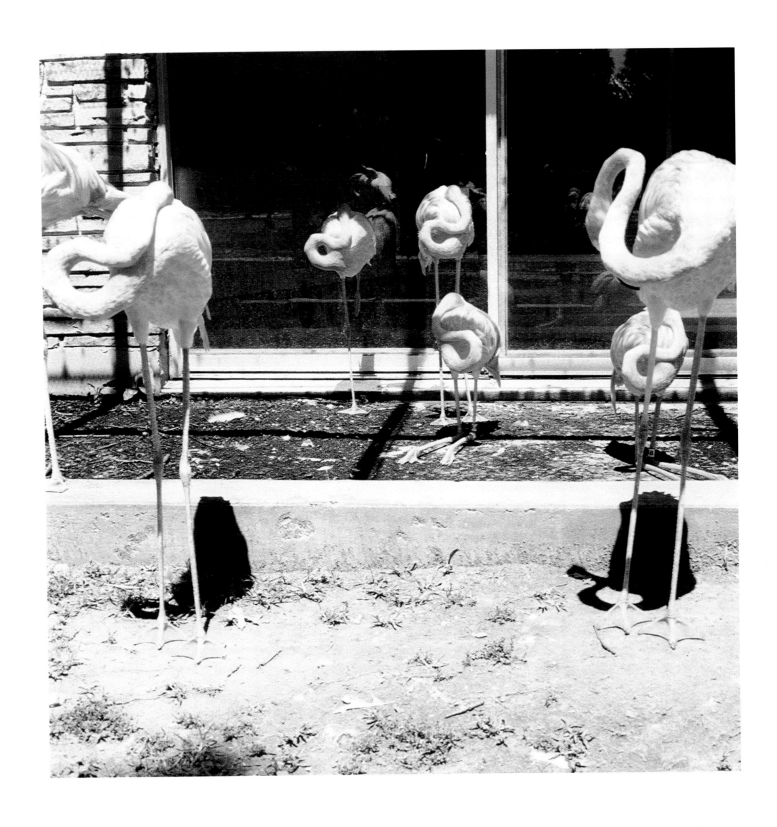

Deborah Brackenbury, Peaceable Kingdom, 1996

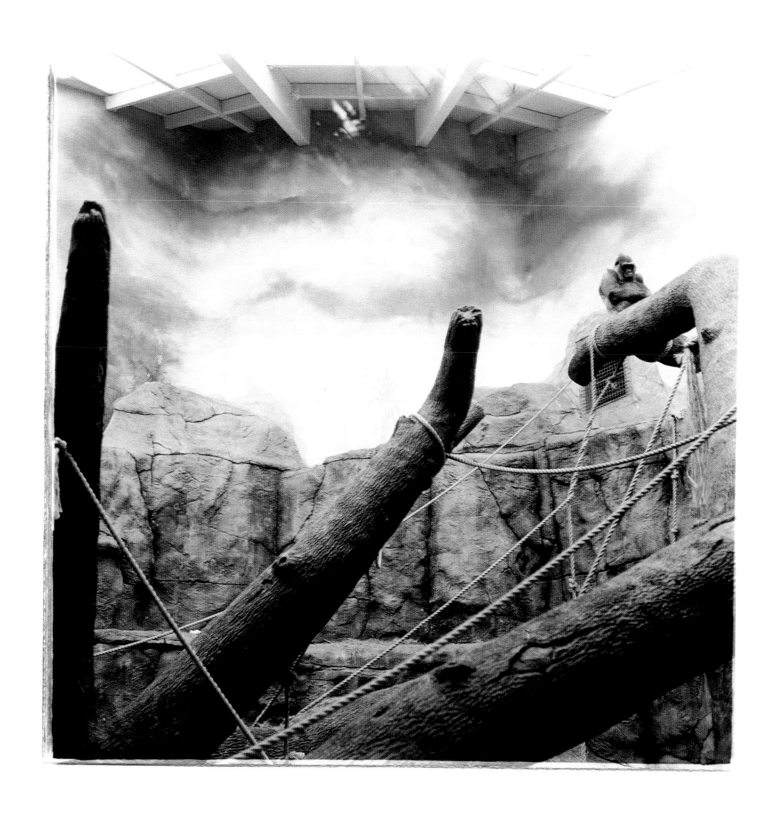

Deborah Brackenbury, Peaceable Kingdom, 1996

John D. Monteith, Untitled, 1995

COURTESY RICCO/MARESCA GALLERY, NEW YORK, NY

John D. Monteith, Untitled, 1995

COURTESY RICCO/MARESCA GALLERY, NEW YORK, NY

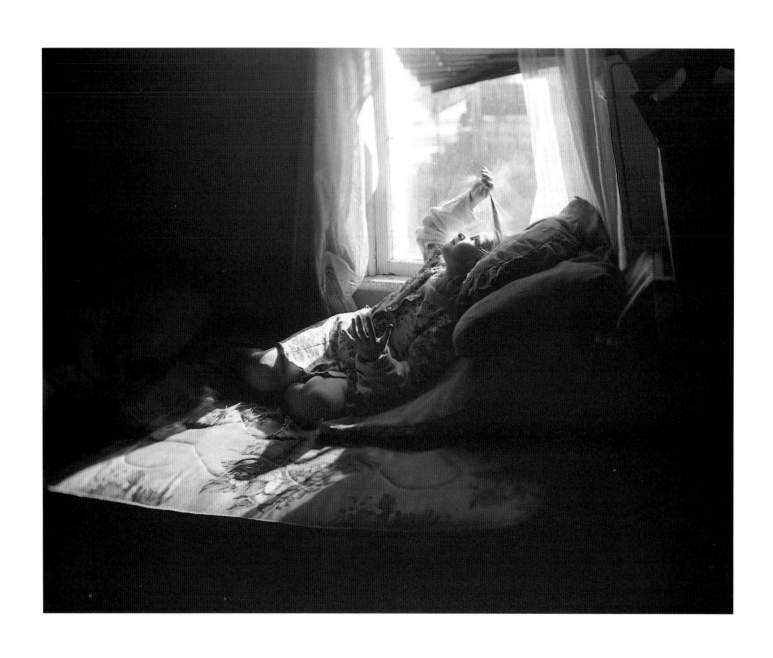

Andrea Modica, Treadwell, NY, 1996

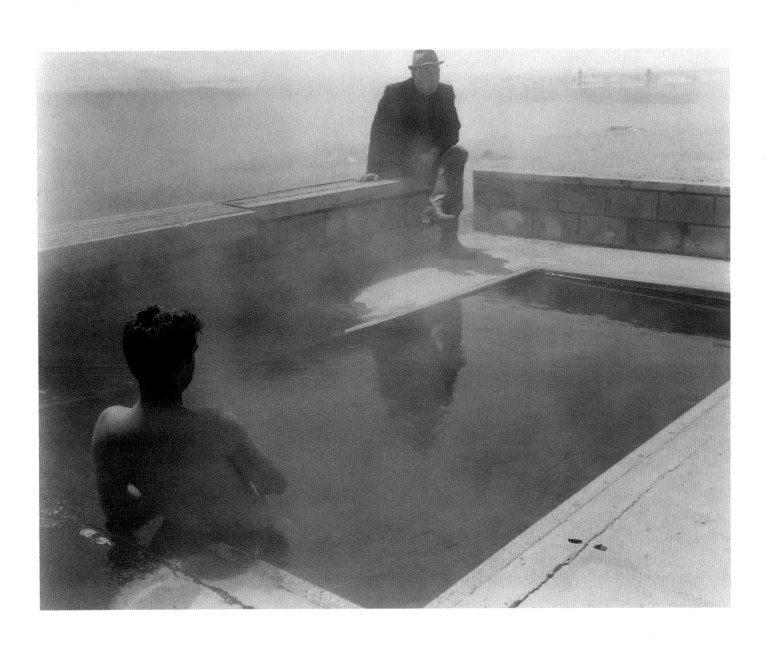

Andrea Modica, Tonopah, NV, 1995

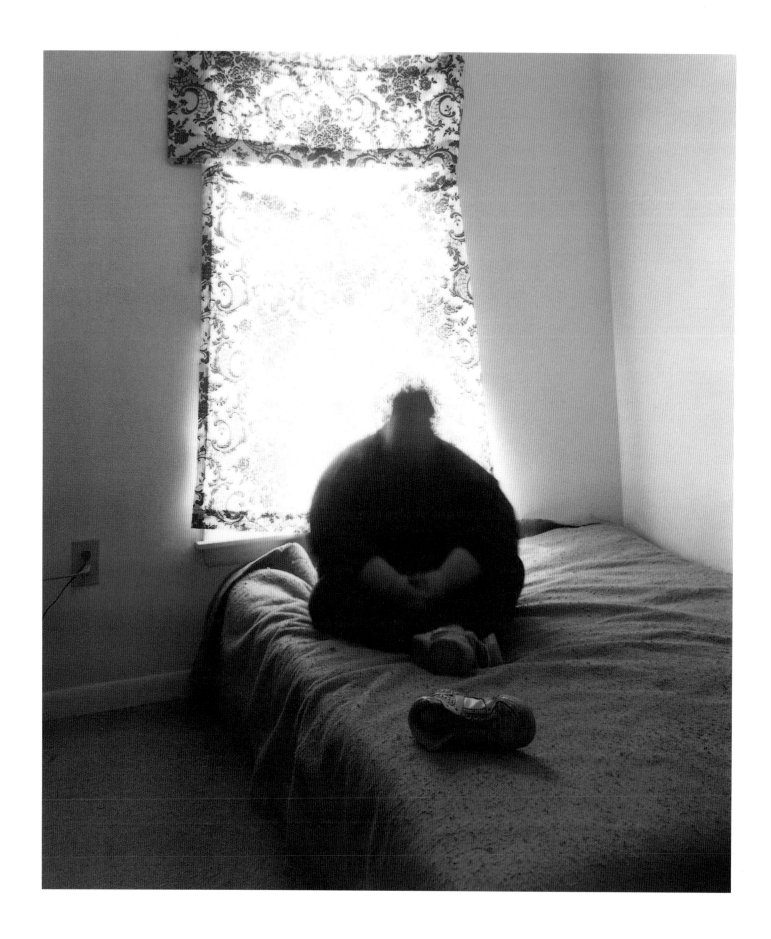

Andrea Modica, Treadwell, NY, 1997

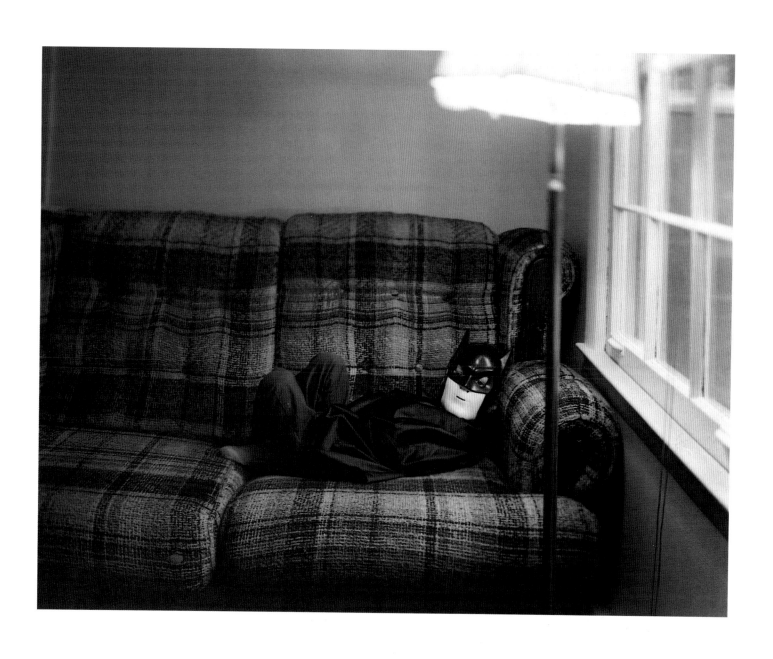

Andrea Modica, Charlotte, NC, 1996

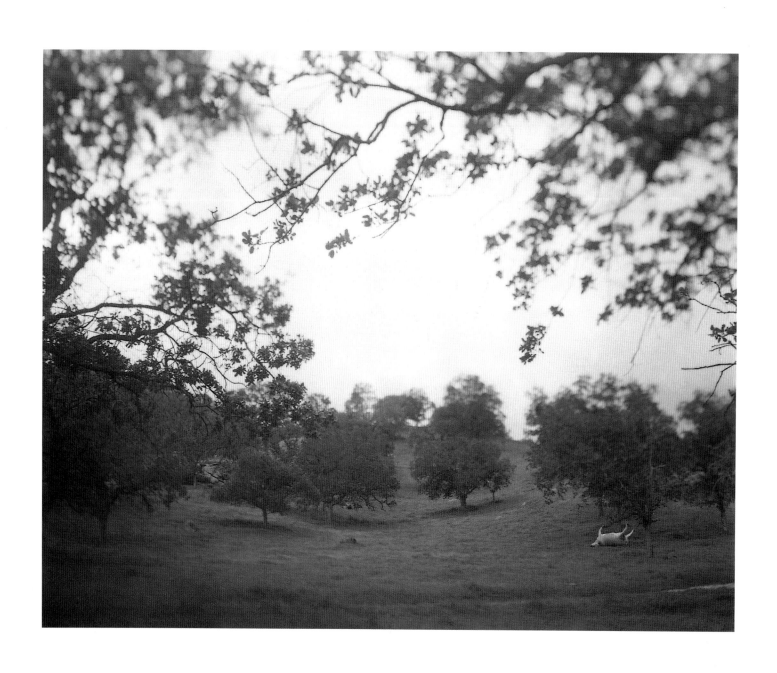

Andrea Modica, Caliente, CA, 1995

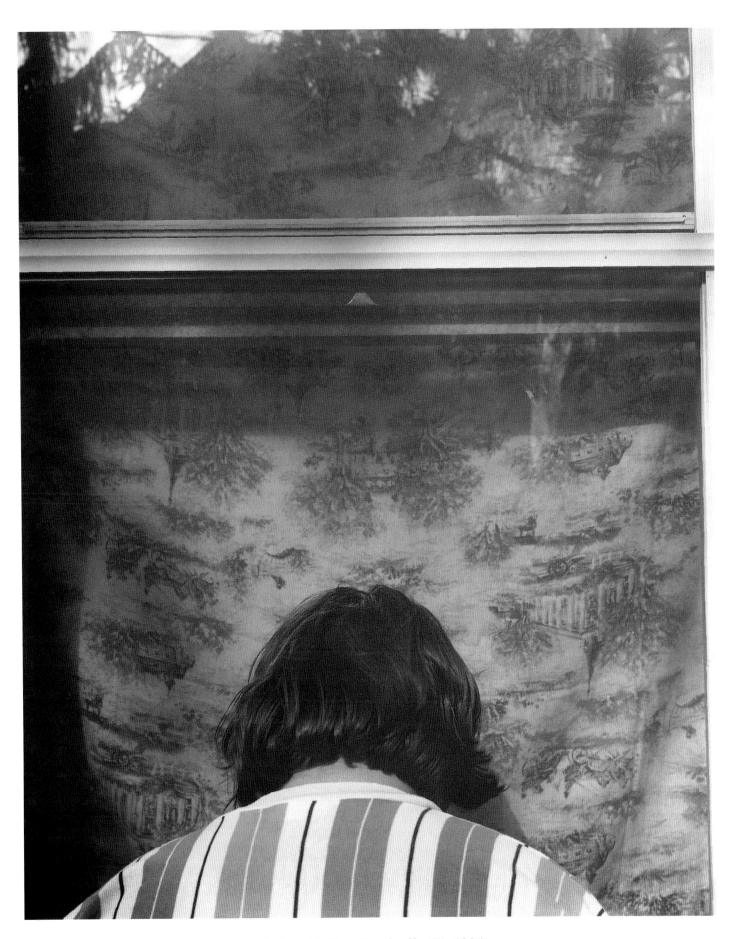

Andrea Modica, Treadwell, NY, 1996
COURTESY HOUK FRIEDMAN GALLERY, NEW YORK, NY

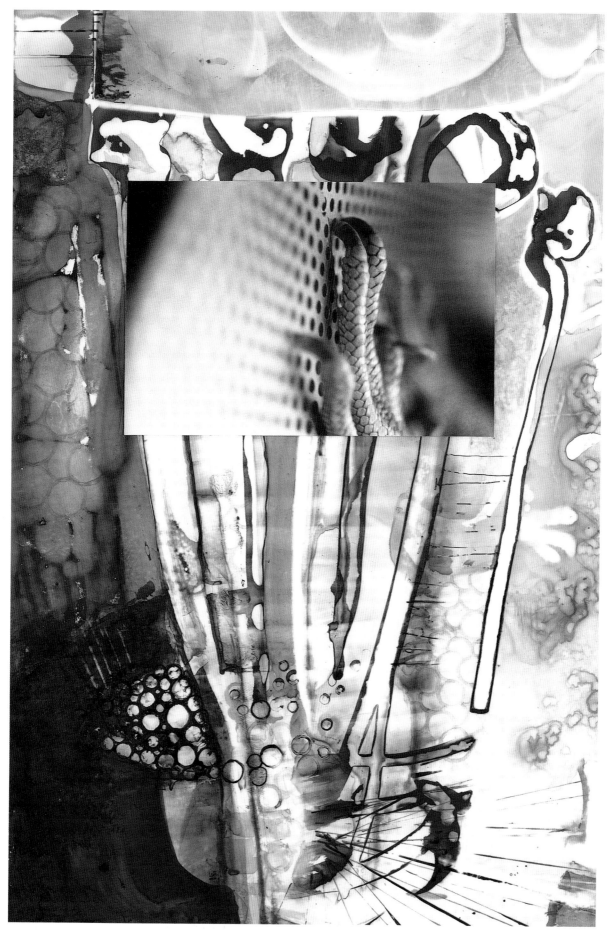

Brian Wood, Untitled, 1996

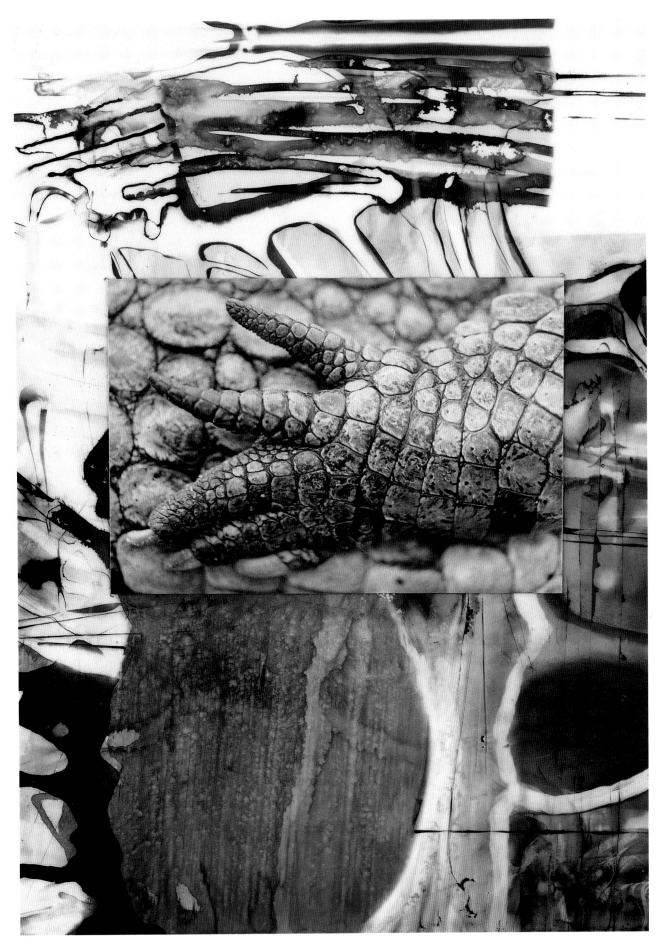

Brian Wood, Untitled, 1994

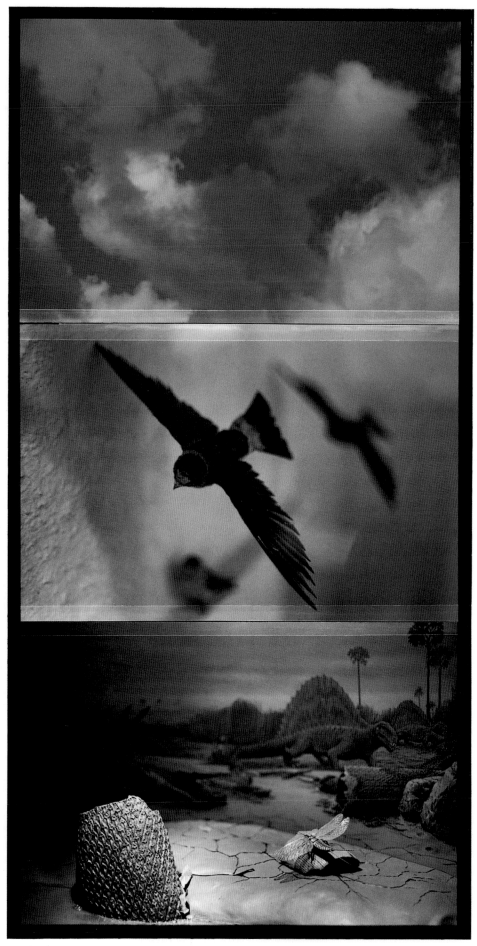

Han Nguyen, Strange Day, 1996
COURTESY STEPHEN COHEN GALLERY, LOS ANGELES, CA

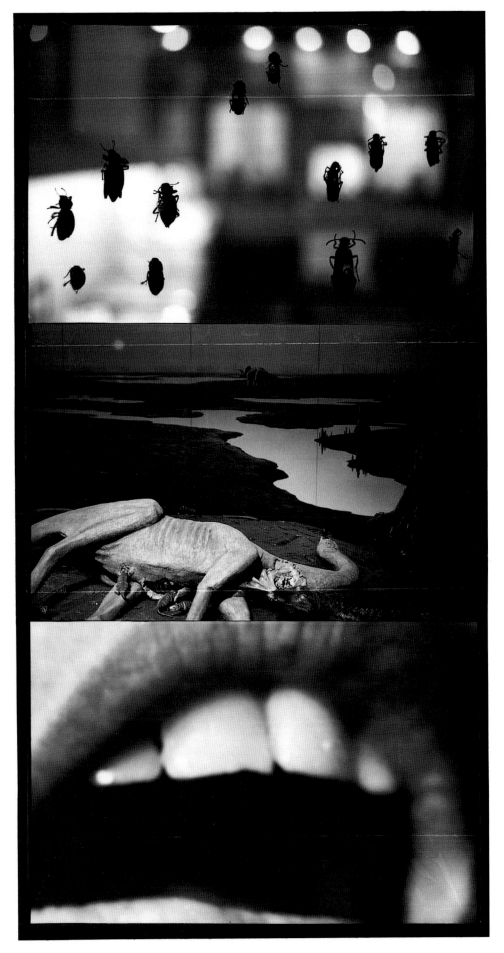

Han Nguyen, Dream, 1996

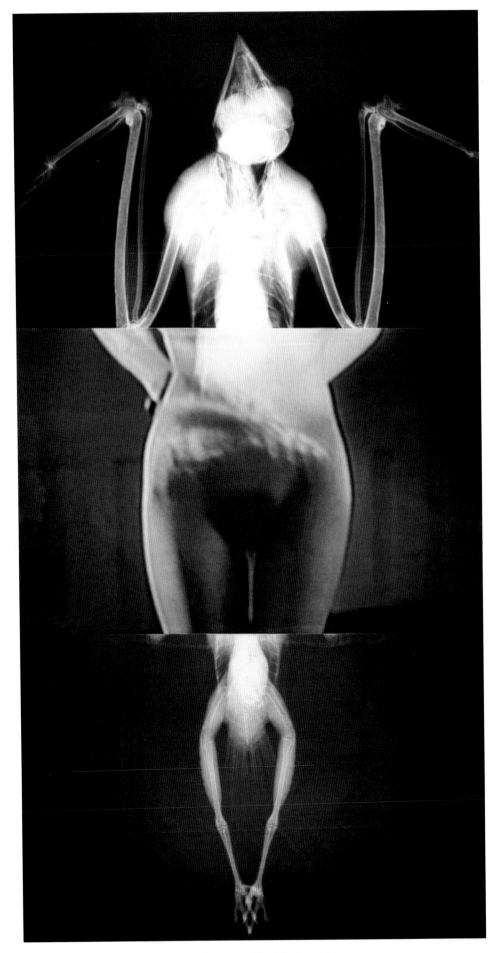

Han Nguyen, Untitled, 1996
COURTESY STEPHEN COHEN GALLERY, LOS ANGELES, CA

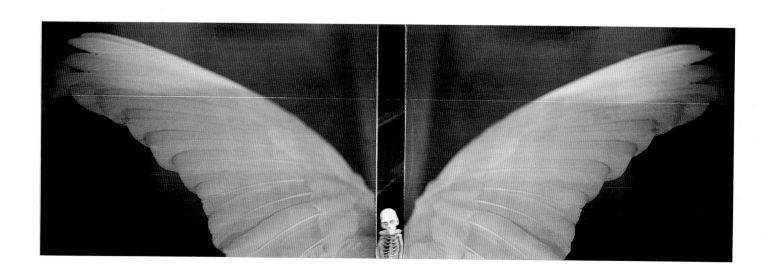

Han Nguyen, Dead Angel (Butterfly), 1996

COURTESY STEPHEN COHEN GALLERY, LOS ANGELES, CA

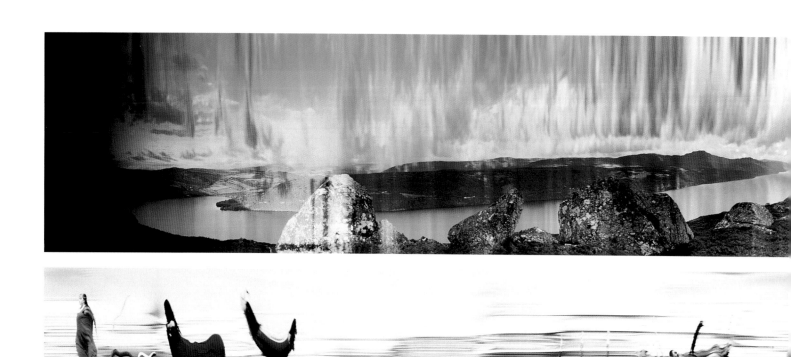

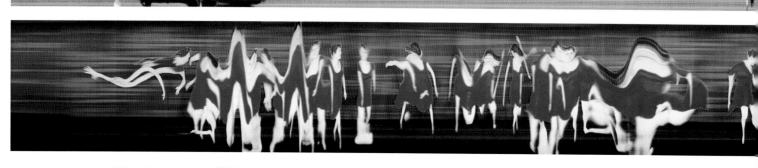

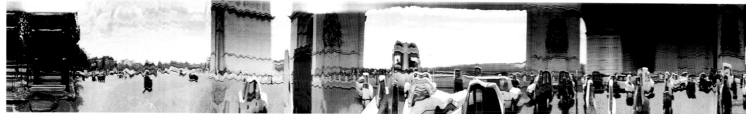

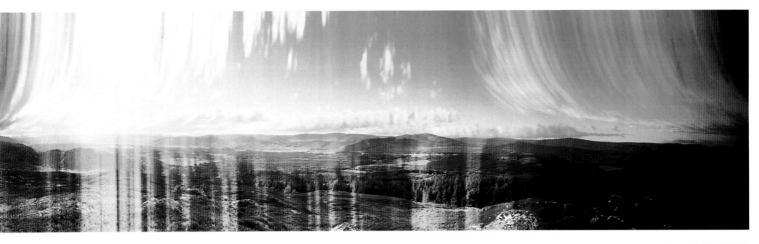

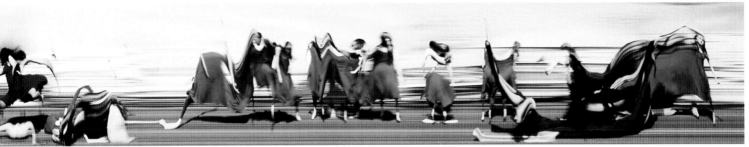

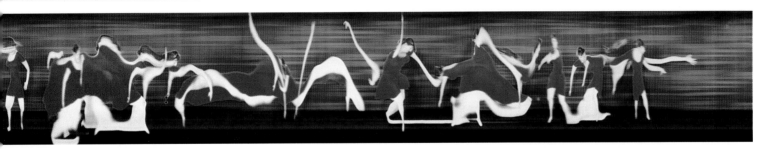

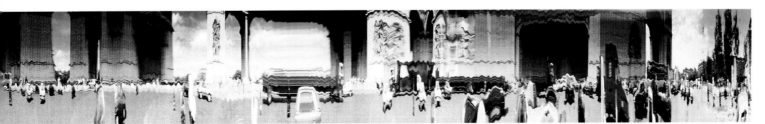

Stephen Lawson
(TOP) *Sun on the Strath, 1995* (SECOND) *Arabesque in Red & Blue, 1995* (THIRD) *Desirée's Red Dress Dance, 1995*
(FOURTH) *Circumference-Making a Circuit of the Arc de Triomphe, 1995*

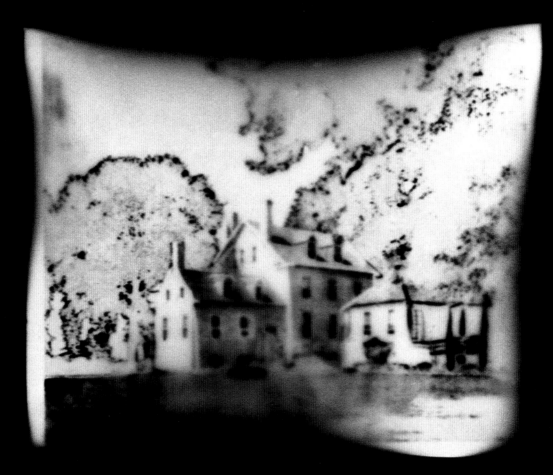

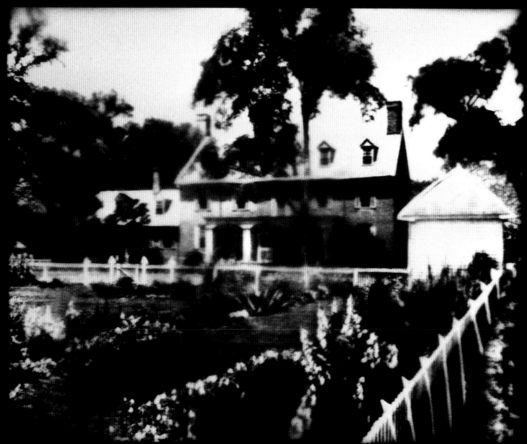

Lorna Bieber
(TOP) *White Farmhouse, 1995-96*
(BOTTOM) *Fence, 1995-96*

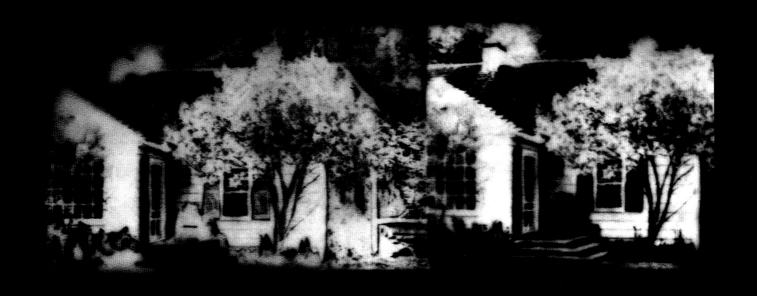

Lorna Bieber, Double Cherry Tree, 1995-96

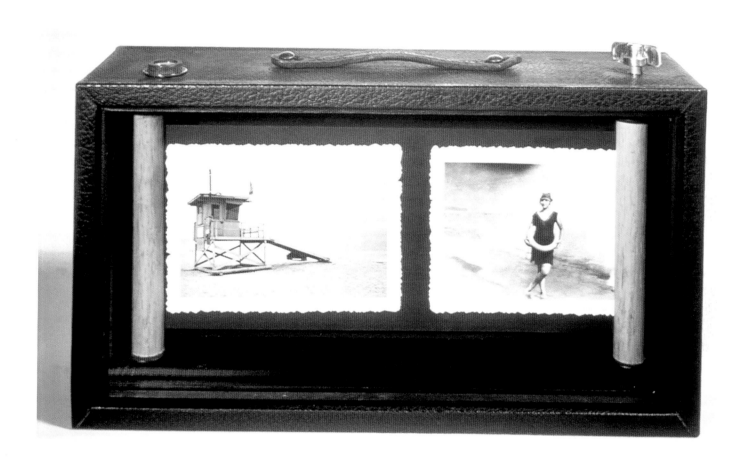

M. Elizabeth Ernst, Brownie 2A, 1995
COURTESY CATHERINE EDELMAN GALLERY, CHICAGO, IL

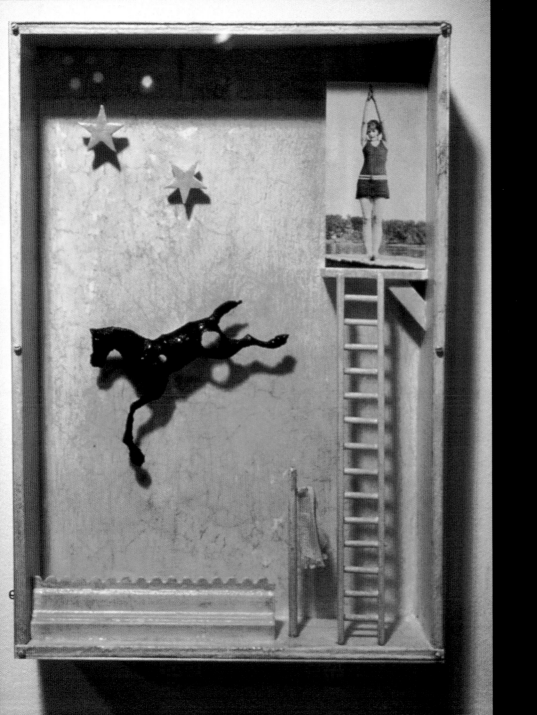

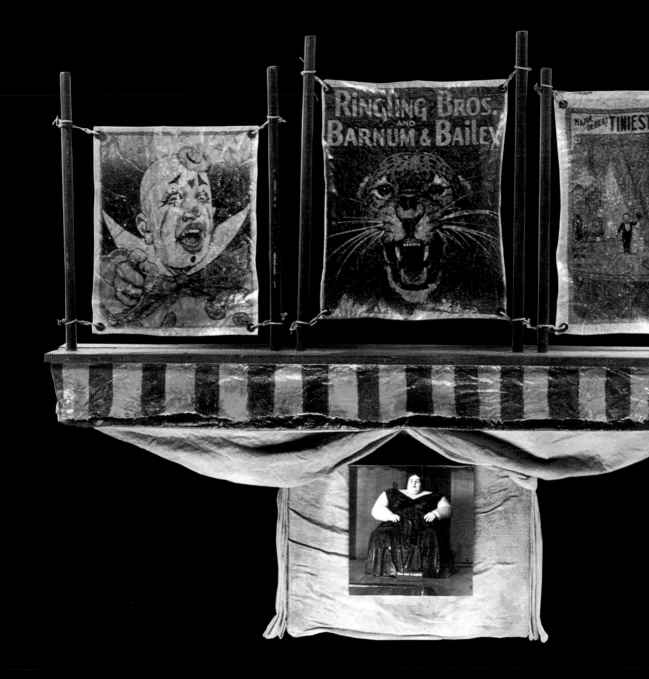

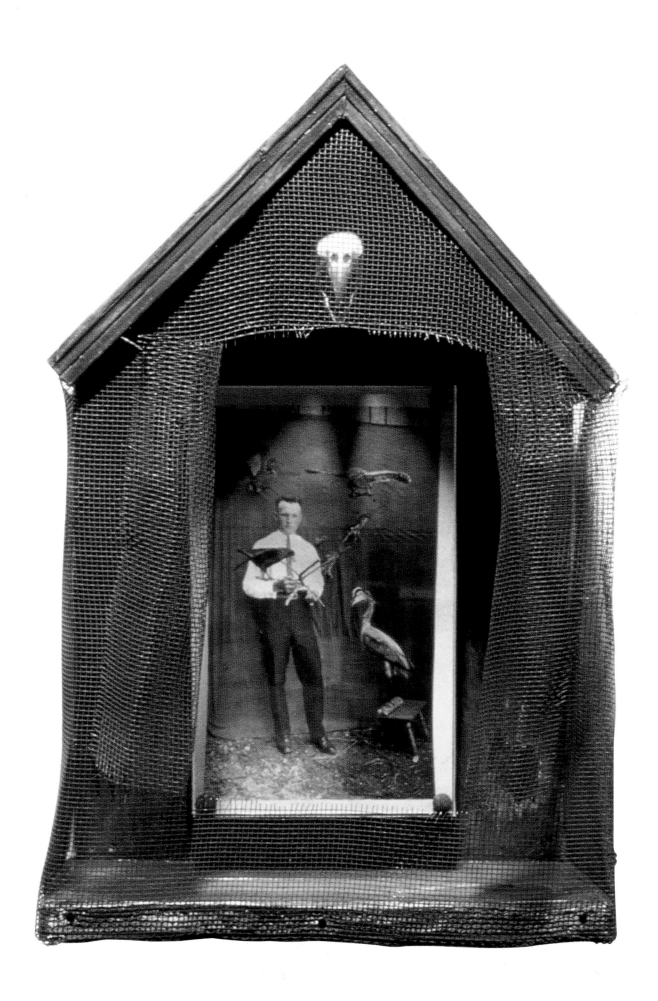

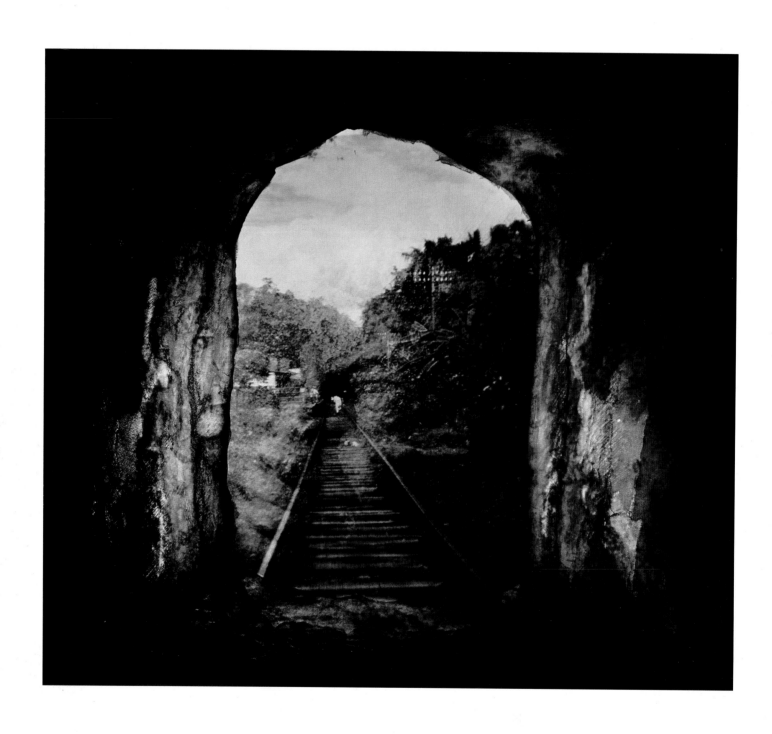

Nancy Goldring, Tunnel Visions: Maidens (Guard), 1996

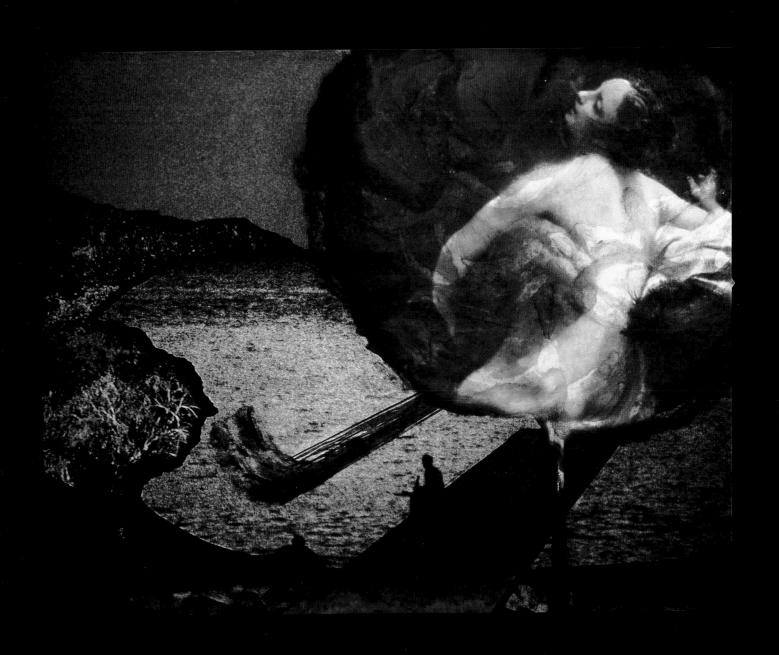

Nancy Goldring, At Sea: 10, 1995

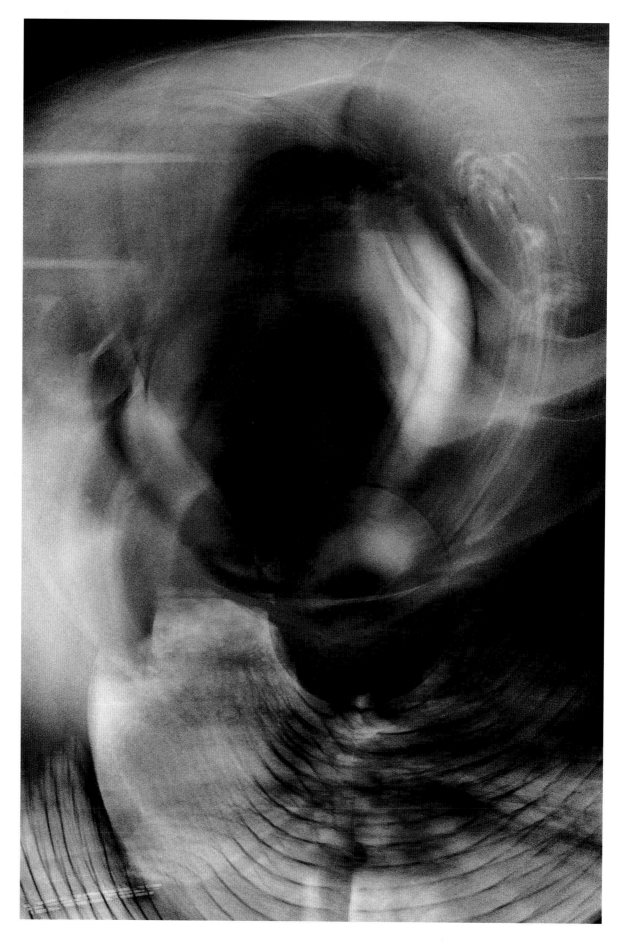

Petah Coyne, Untitled #833, 1995

COURTESY LAURENCE MILLER GALLERY, NEW YORK, NY

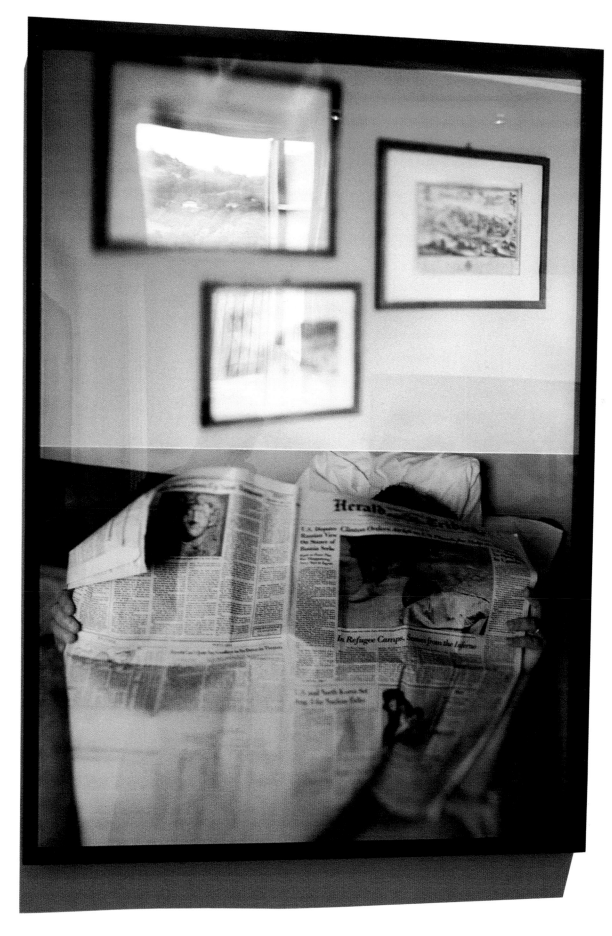

Jo Ann Verburg, Half Life (Scenes from the Inferno), 1995

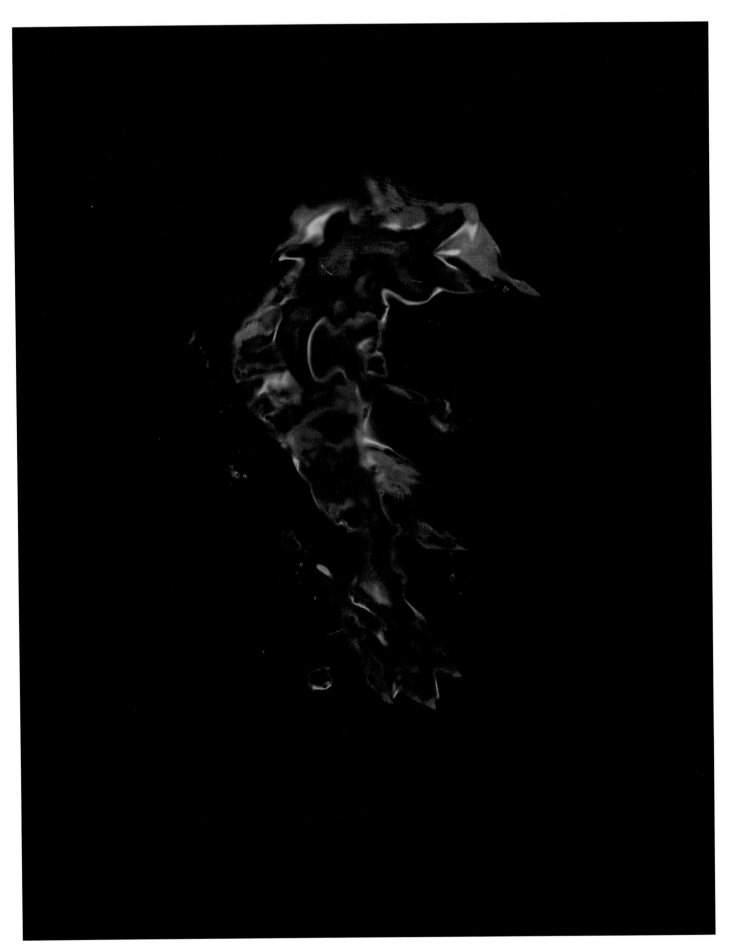

Marco Breuer, Untitled (Cloth), 1996

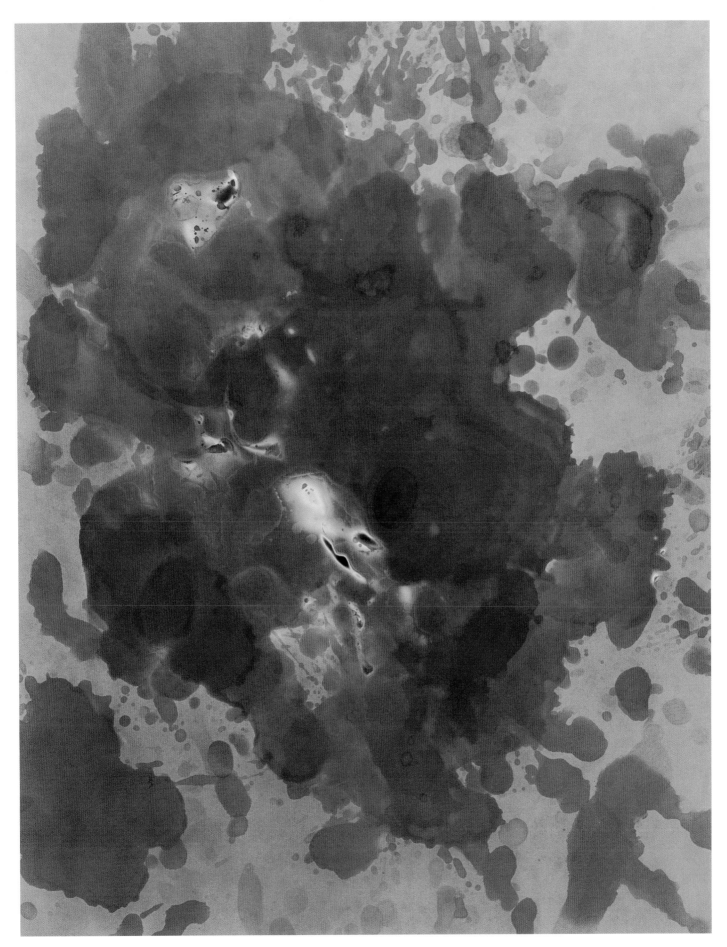

Marco Breuer, Untitled (Vodka), 1996

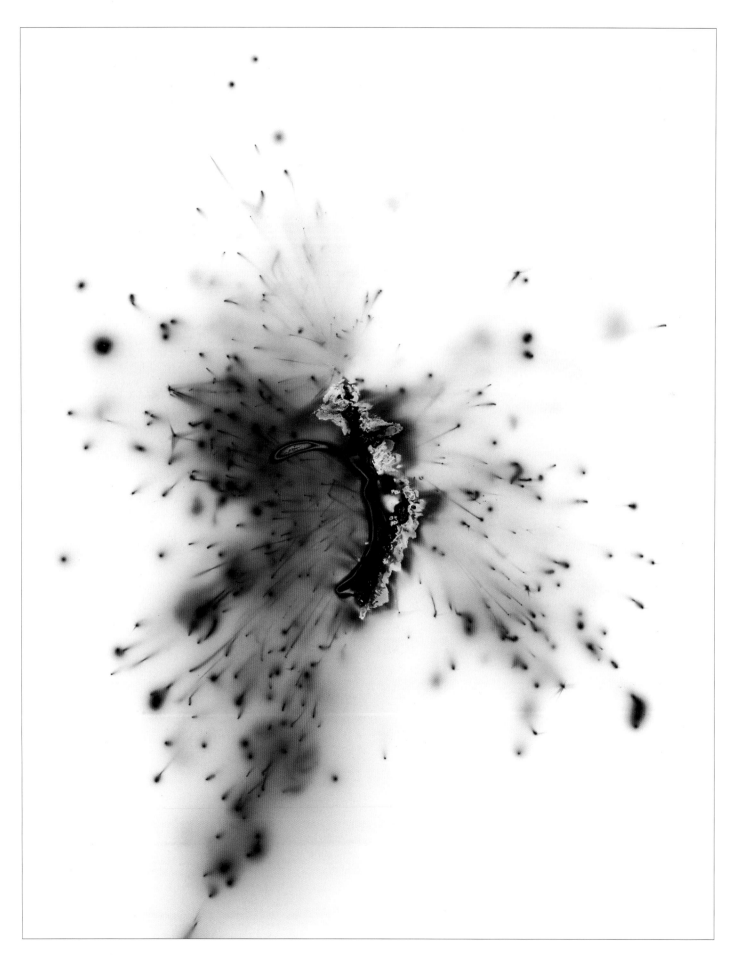

Marco Breuer, Untitled (Fuse), 1995

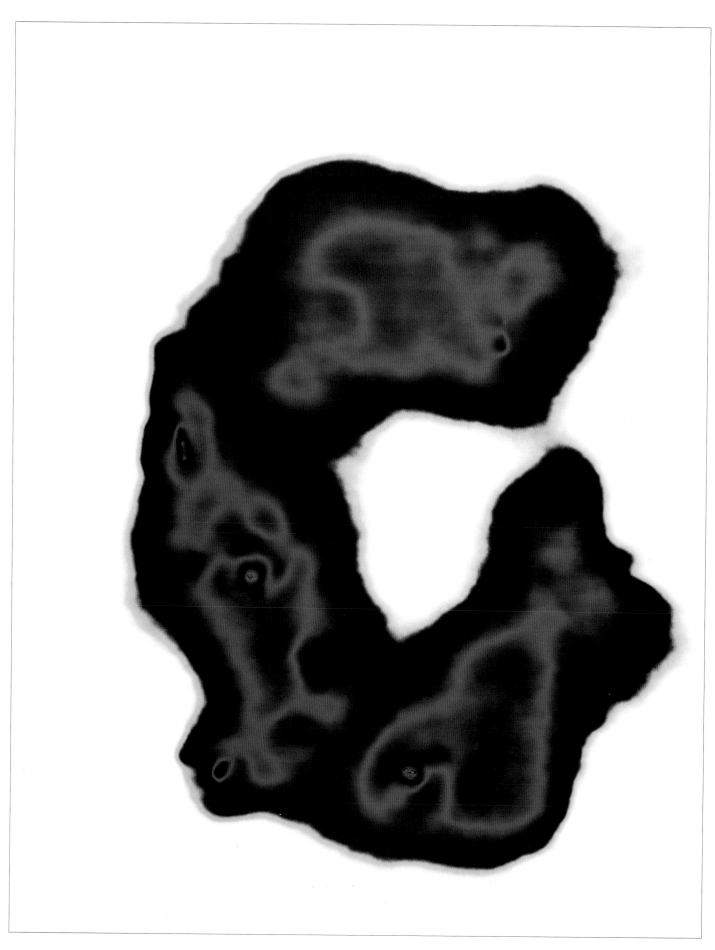

Marco Breuer, Untitled (Coals), 1995

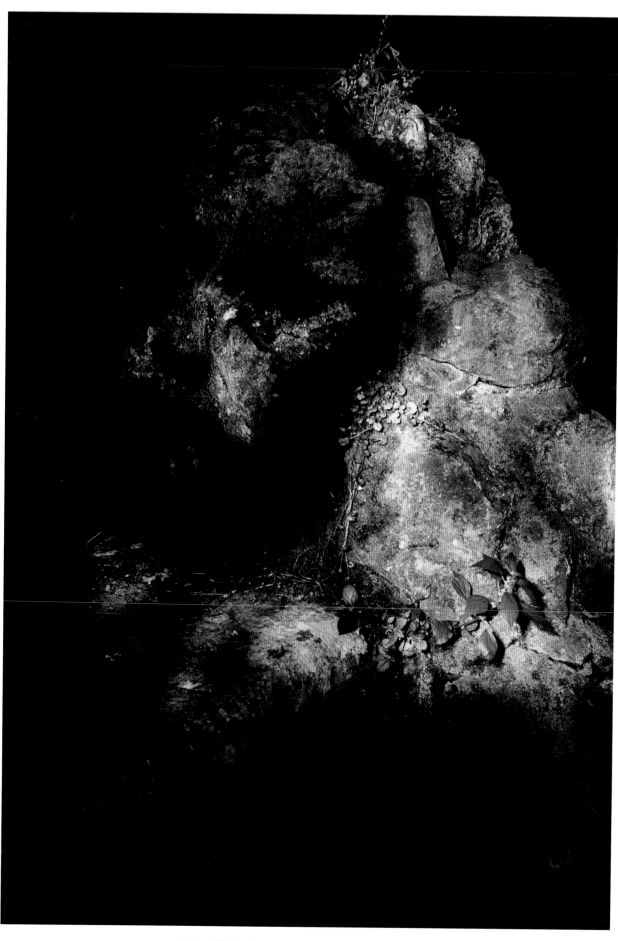

Alain Fleischer, La Nuit des Visages, 1995

COURTESY JAYNE H. BAUM , NEW YORK , NY

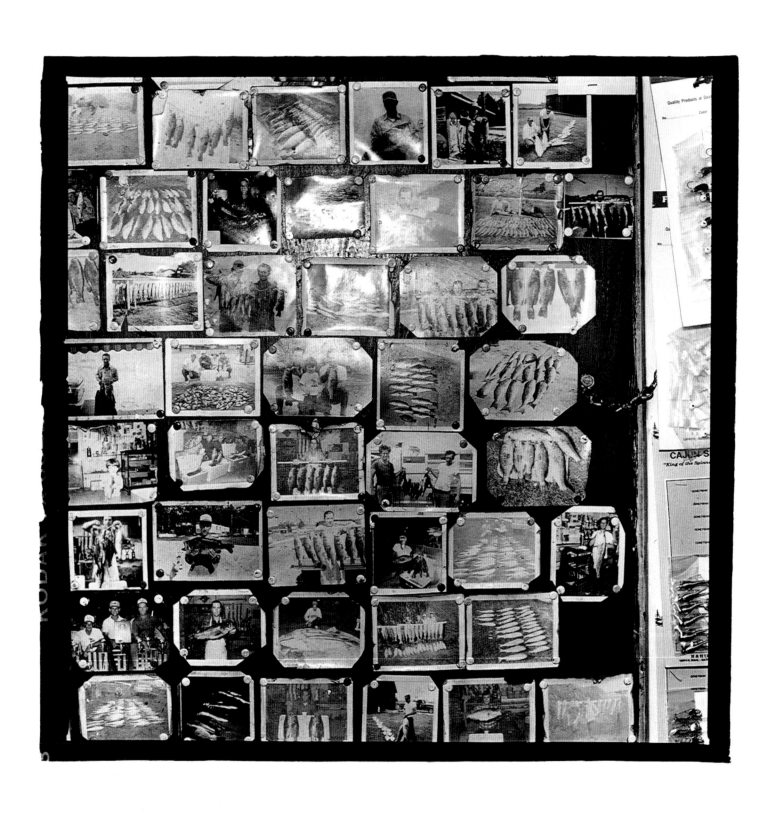

Susan Lipper, Untitled from the Louisiana series, 1995
COURTESY DEBRA HEIMERDINGER, SAN FRANCISCO, CA

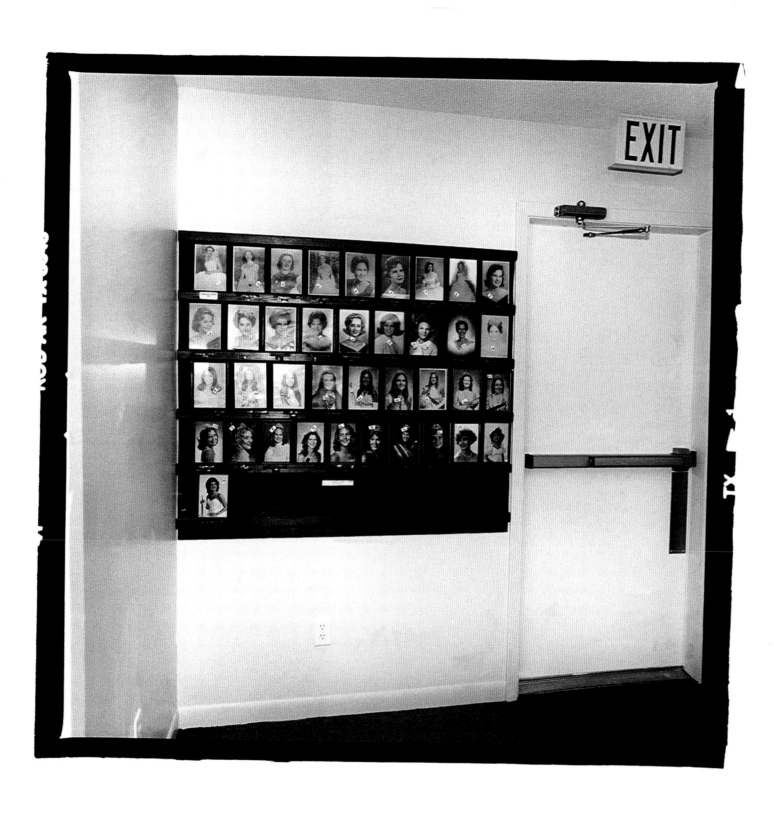

Susan Lipper, Untitled from the Louisiana series, 1996

COURTESY DEBRA HEIMERDINGER, SAN FRANCISCO, CA

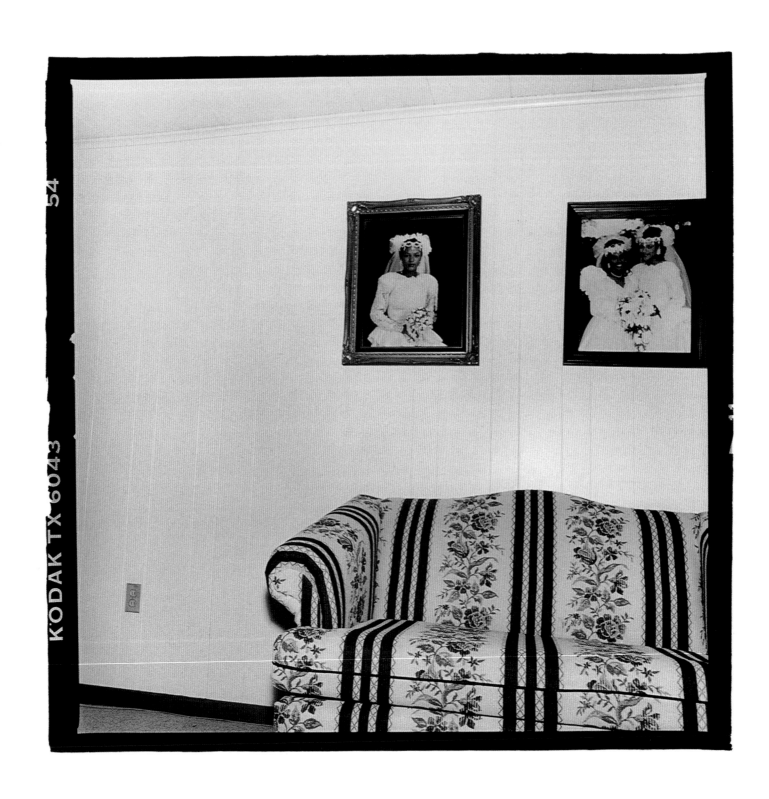

Susan Lipper, Untitled from the Louisiana series, 1996

COURTESY DEBRA HEIMERDINGER, SAN FRANCISCO, CA

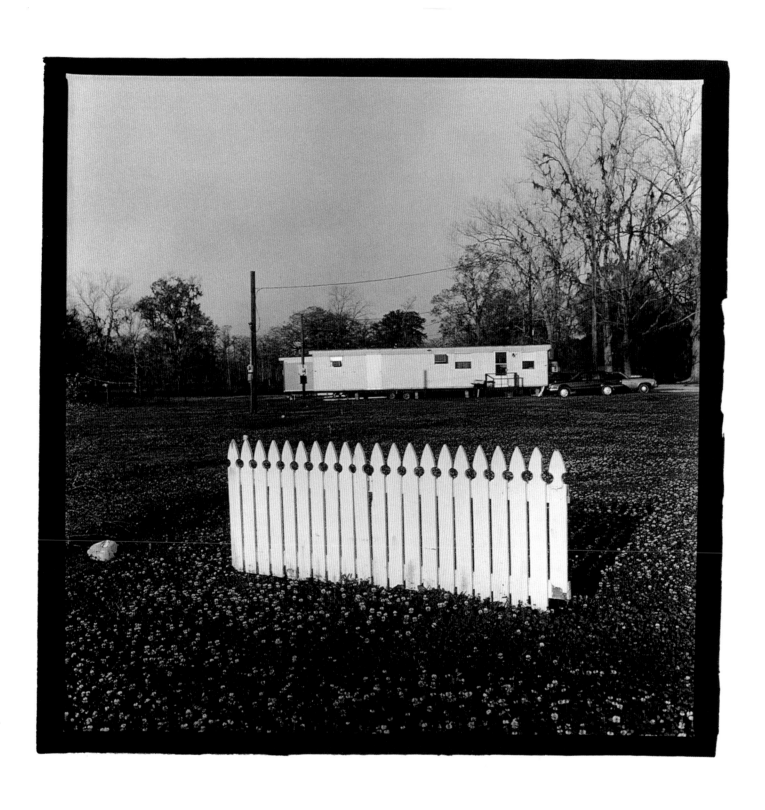

Susan Lipper, Untitled from the Louisiana series, 1995

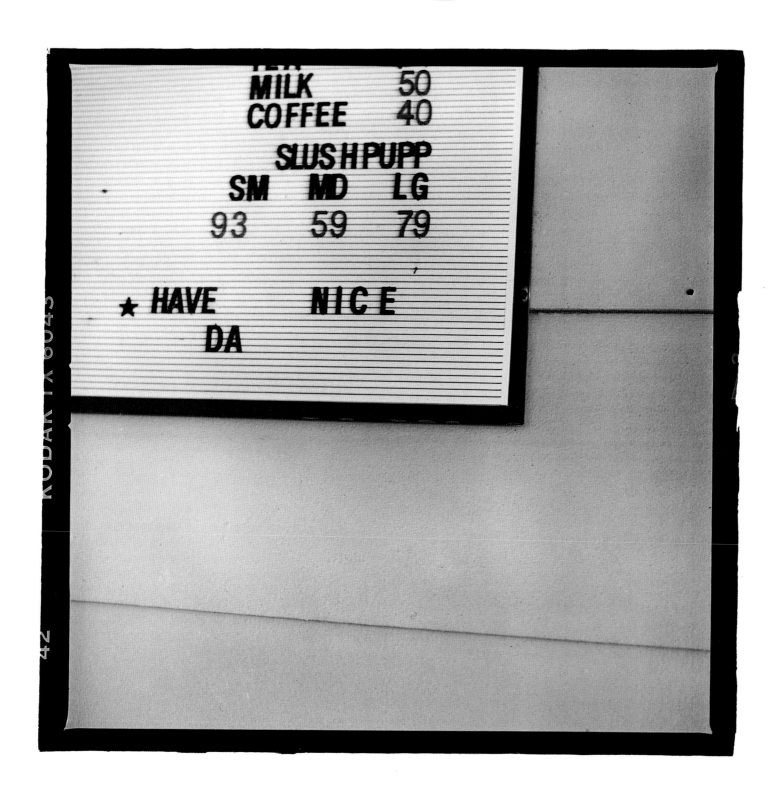

Susan Lipper, Untitled from the Louisiana series, 1995

COURTESY DEBRA HEIMERDINGER, SAN FRANCISCO, CA

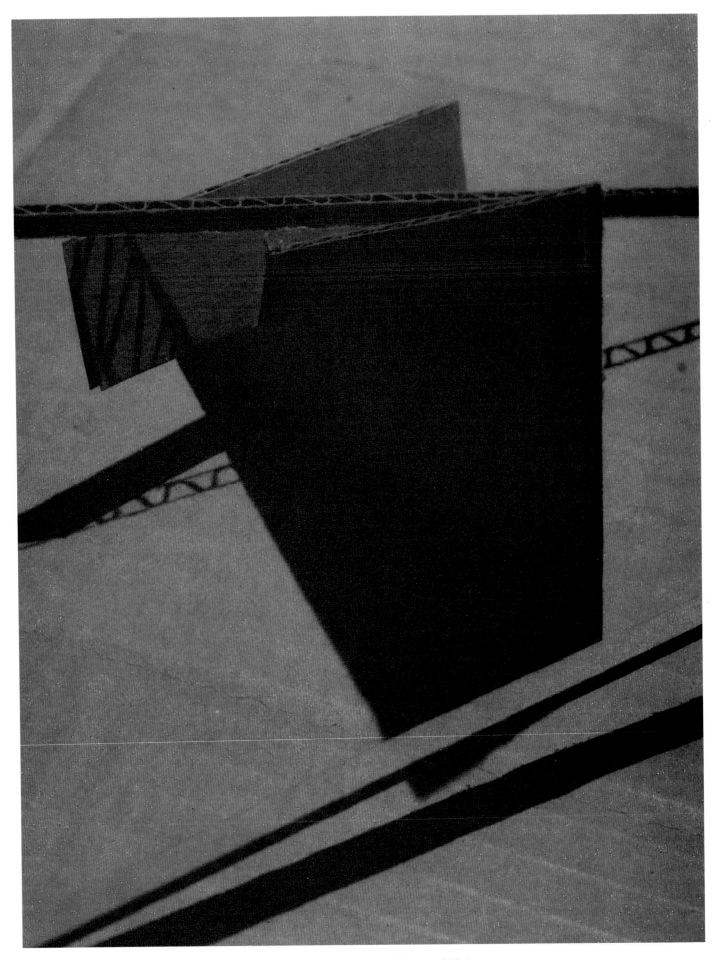

James Wojcik, Elongated Box, 1996

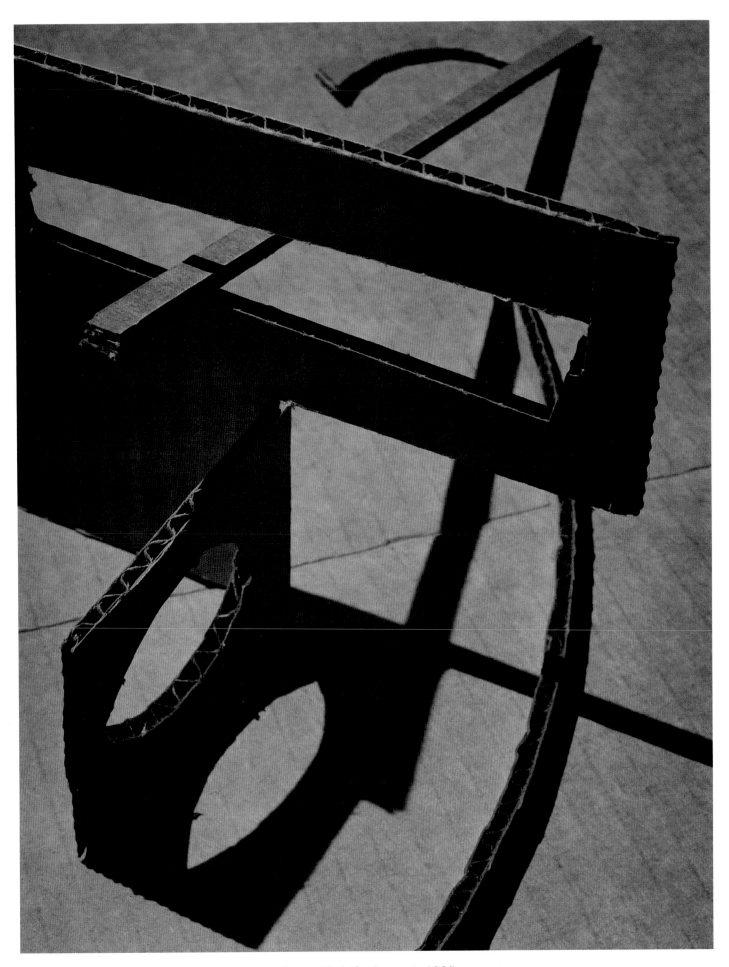

James Wojcik, Sextant, 1995

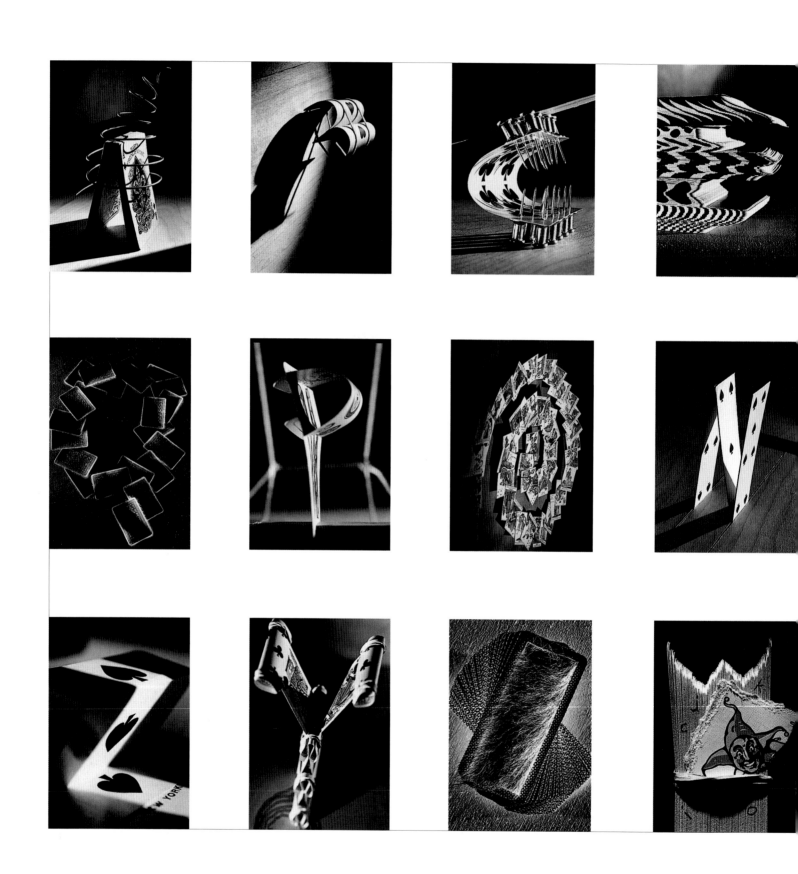

James Wojcik, Alphabet Series, 1995
COURTESY JAYNE H. BAUM, NEW YORK, NY

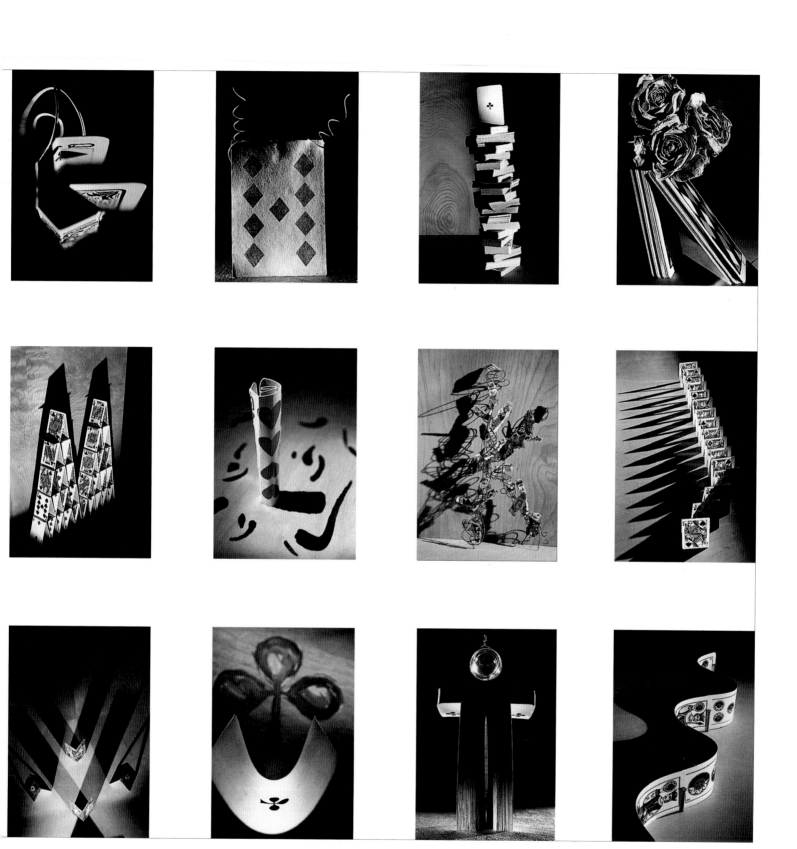

James Wojcik, Alphabet Series, 1995

COURTESY JAYNE H. BAUM GALLERY, NEW YORK, NY

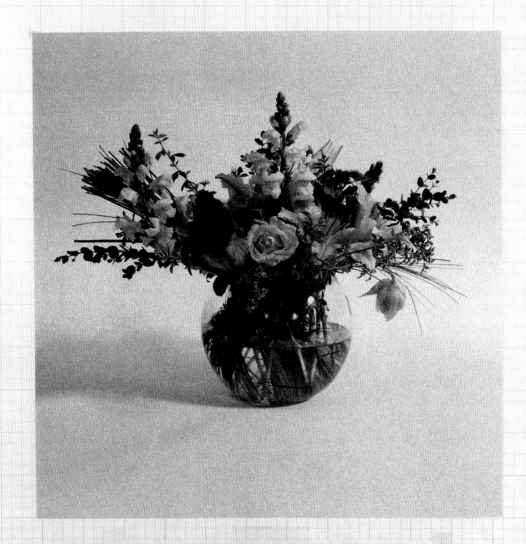

THERE ISN'T TIME

John Baldessari, Goya Series: There Isn't Time, 1997

COURTESY SONNABEND GALLERY, NEW YORK, NY

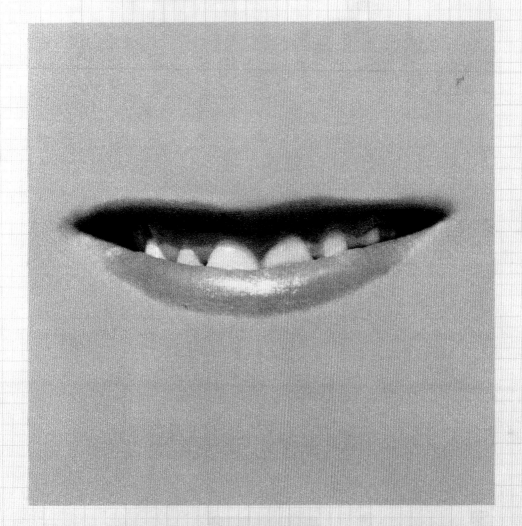

IT COULDN'T BE HELPED

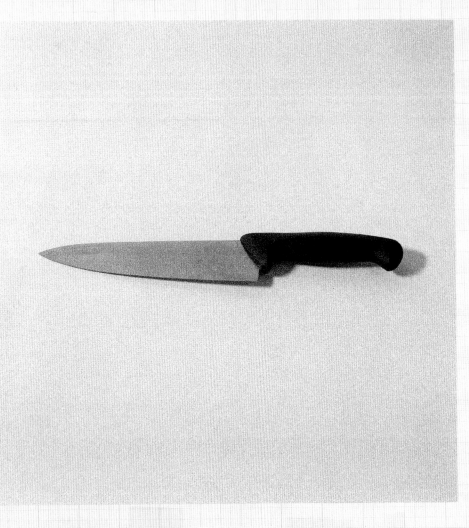

AN ARM AND A LEG

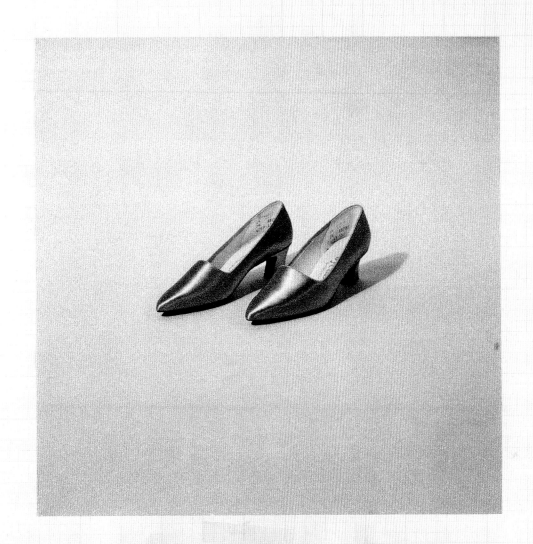

THESE TOO

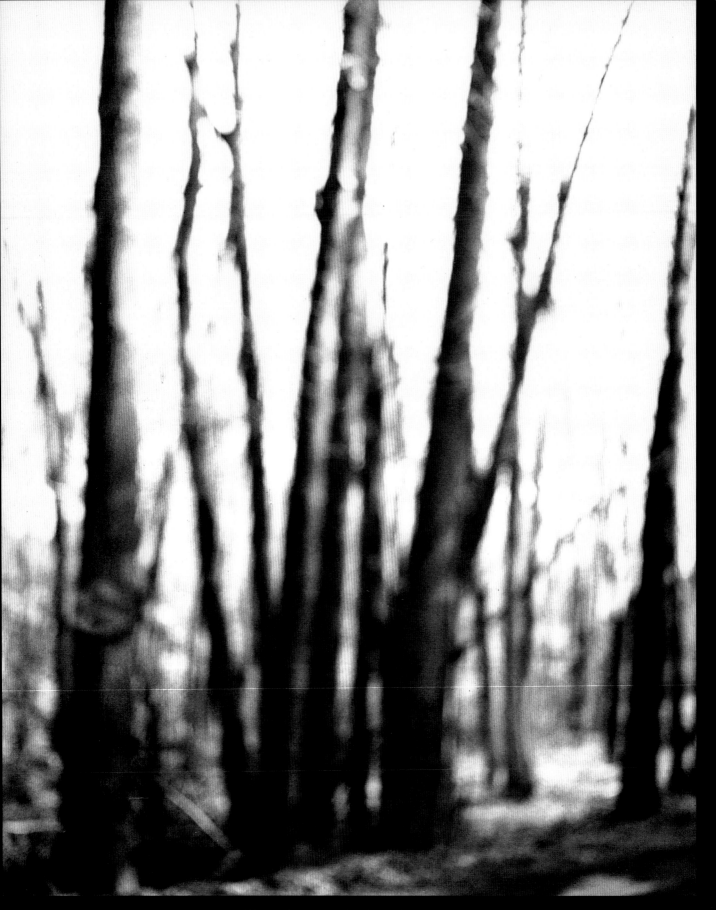

Bill Jacobson, Untitled (311-4), 1995

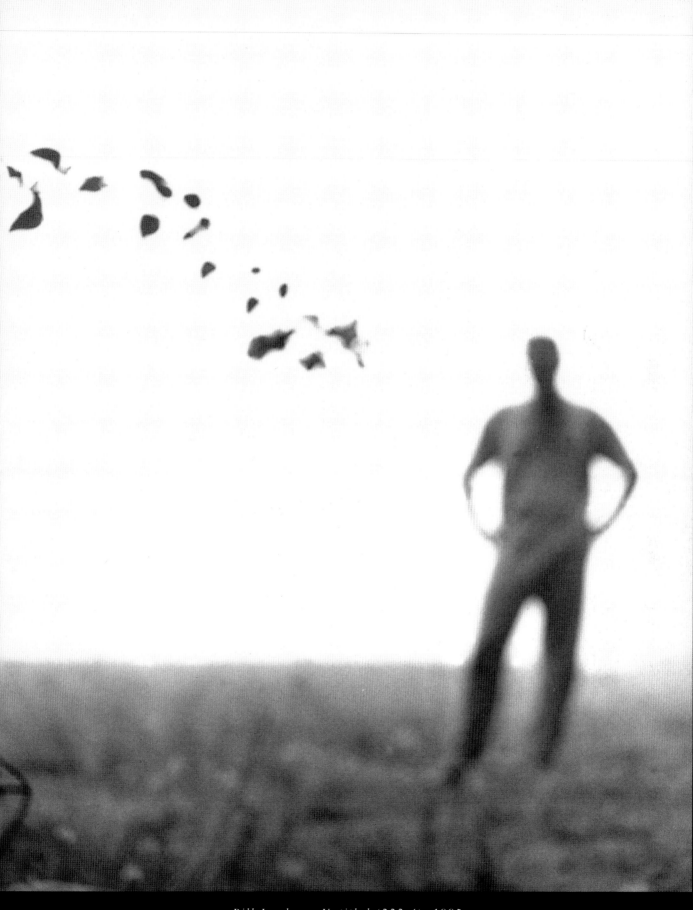

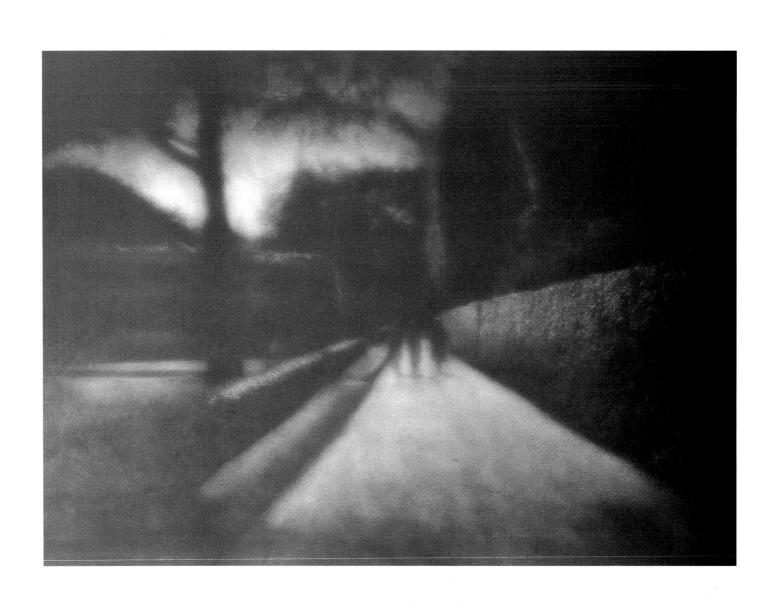

Rocky Schenck, Three Tourists, 1995

COURTESY BONNI BENRUBI GALLERY, NEW YORK, NY

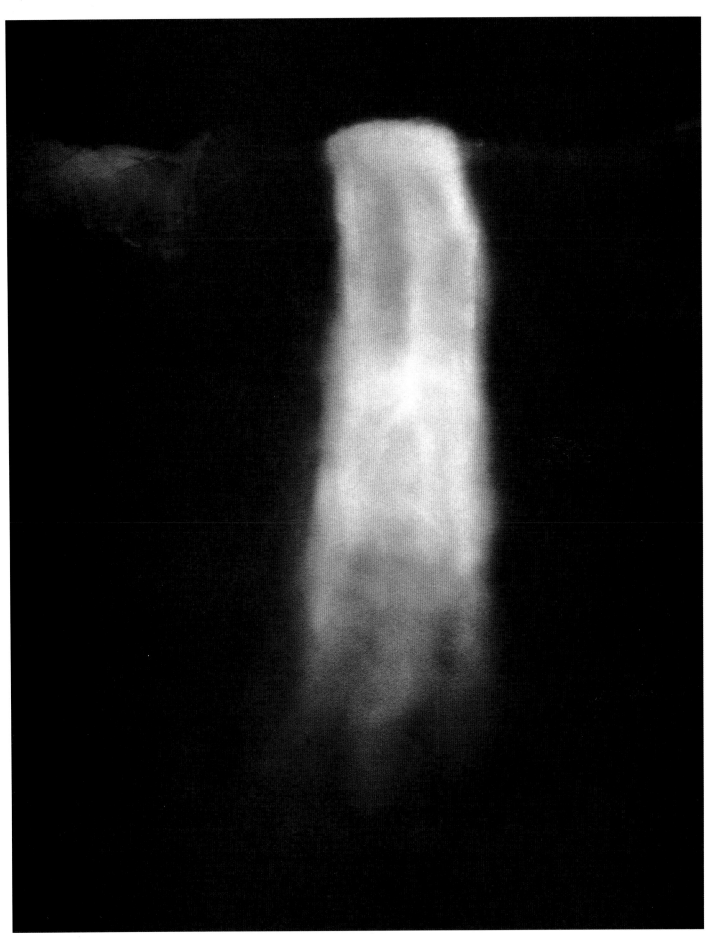

Rocky Schenck, Waterfall, 1995

COURTESY BONNI BENRUBI GALLERY, NEW YORK, NY

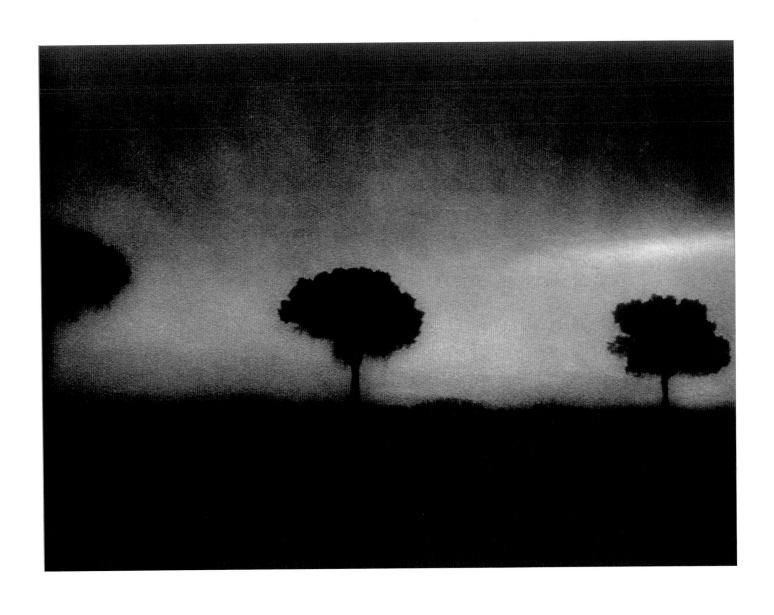

Rocky Schenck, Three Trees, 1995

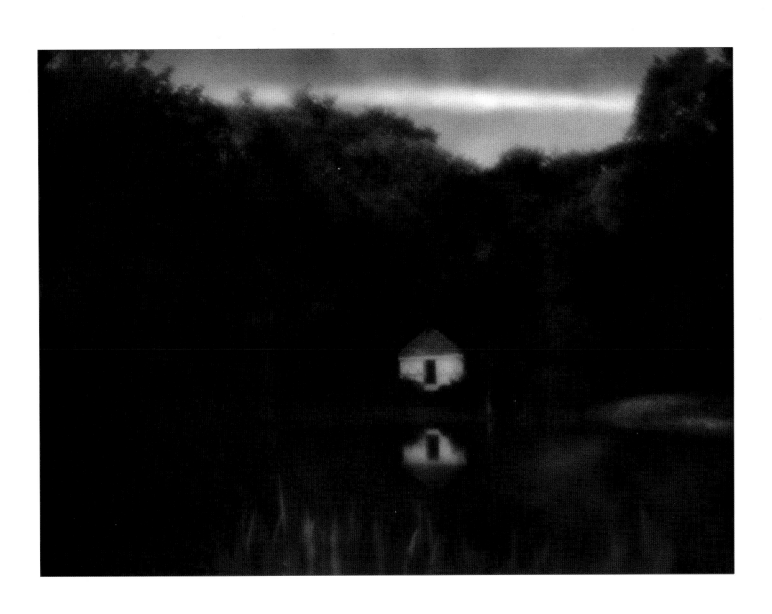

Rocky Schenck, Litlle House on the Lake, 1995

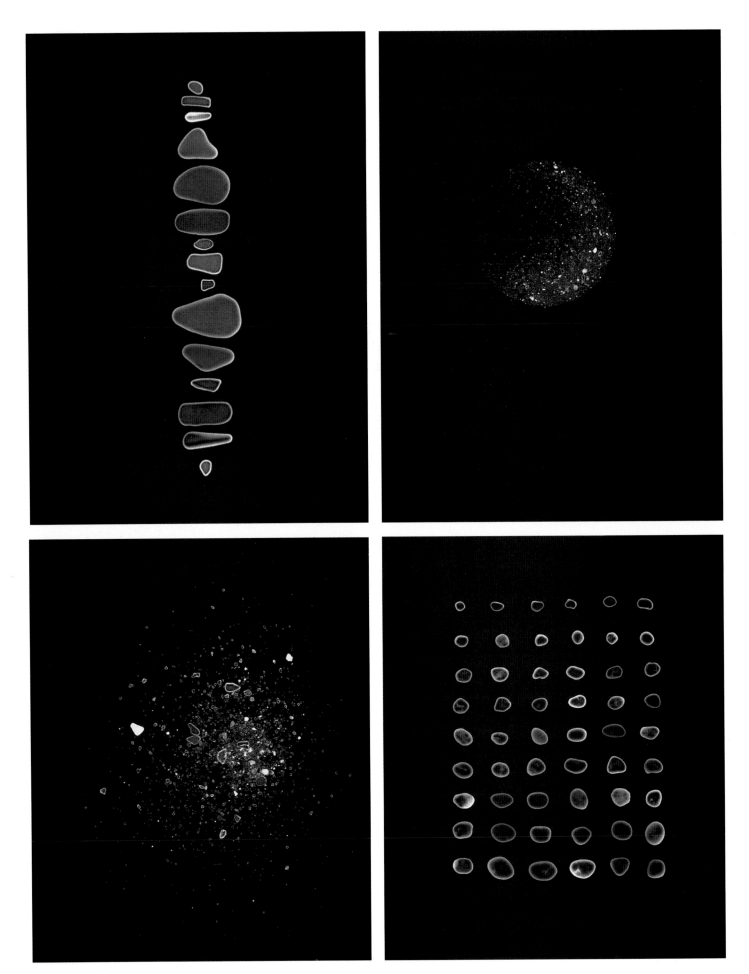

Geanna Merola
(TOP LEFT) *Untitled, Photogram #1, 1996* (TOP RIGHT) *Sand Sphere, Photogram #57, 1996*
(BOTTOM LEFT) *Sand, Photogram #56, 1995* (BOTTOM RIGHT) *Sea Stones, Photogram #28, 1995*

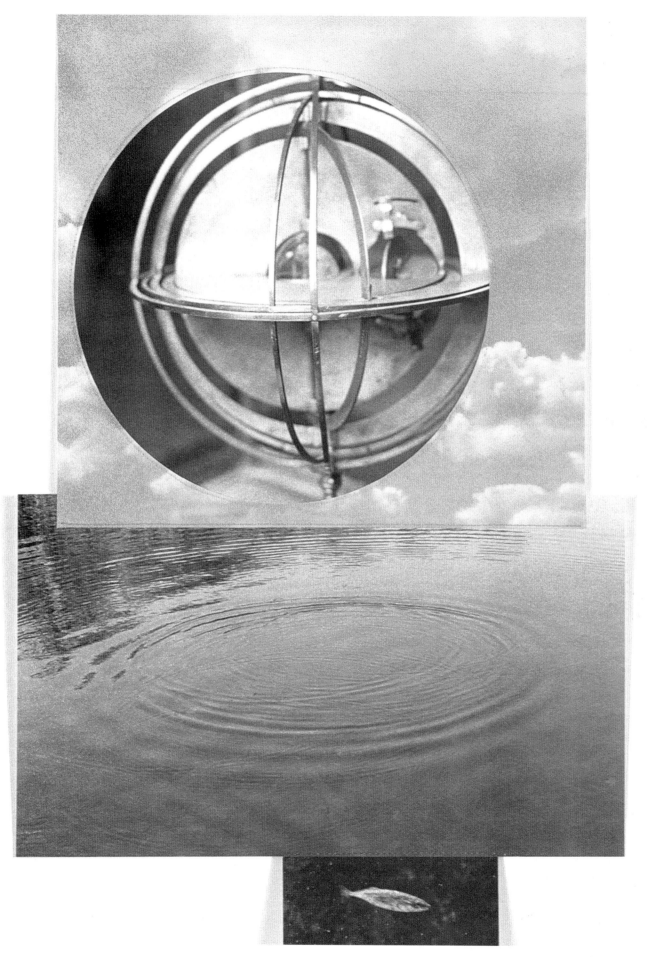

Geanna Merola, Armillary Sphere #1, 1995

COURTESY JULIE SAUL GALLERY, NEW YORK, NY

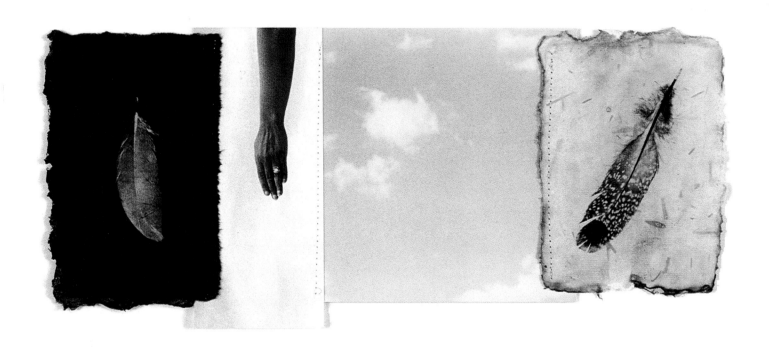

Geanna Merola, Feathers, Hand and Sky, 1995

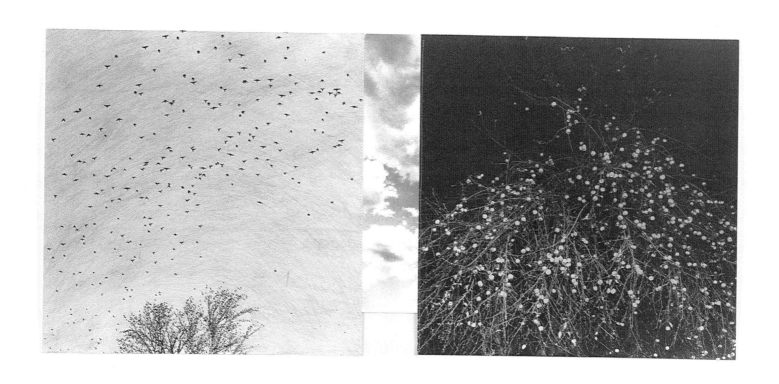

Geanna Merola, In the Air, 1995

COURTESY JULIE SAUL GALLERY, NEW YORK, NY

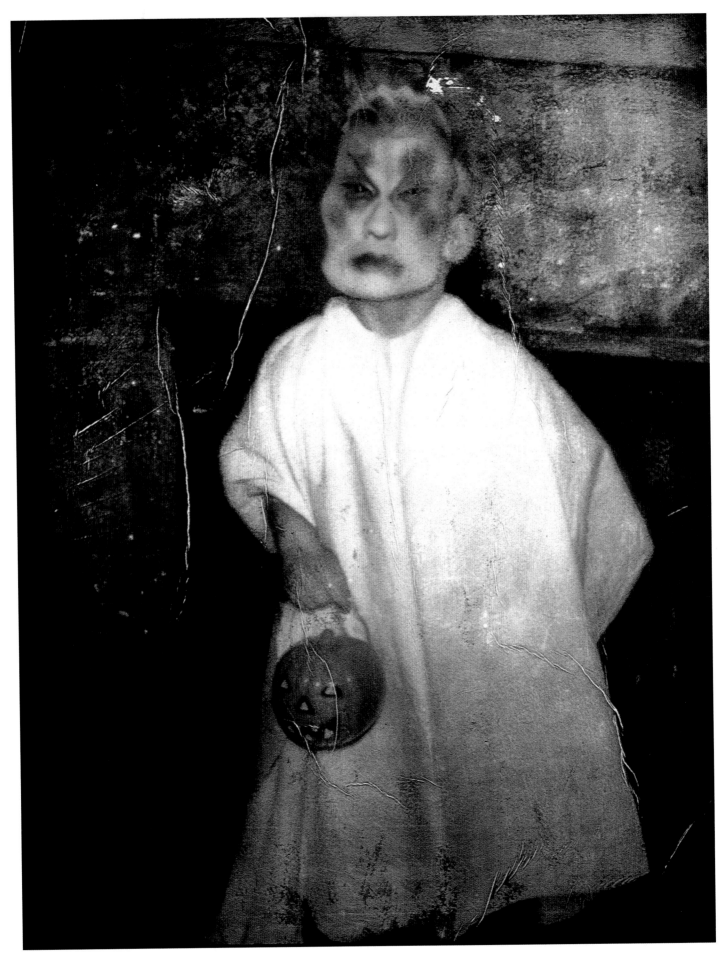

Dan Ragland, Halloween, 1995

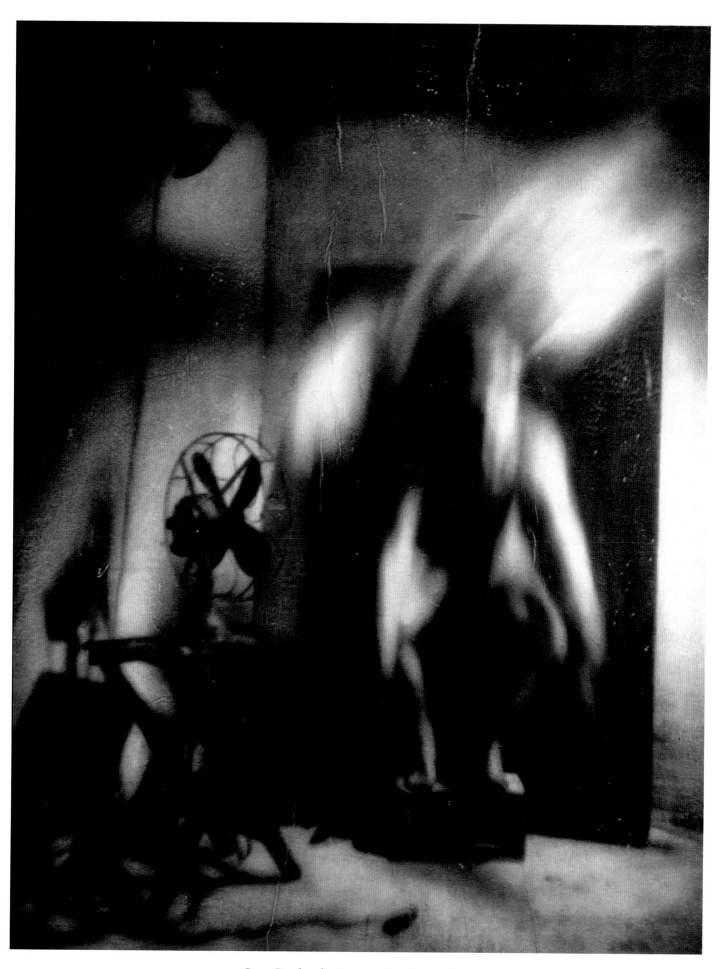

Dan Ragland, Figure with Fan, 1995

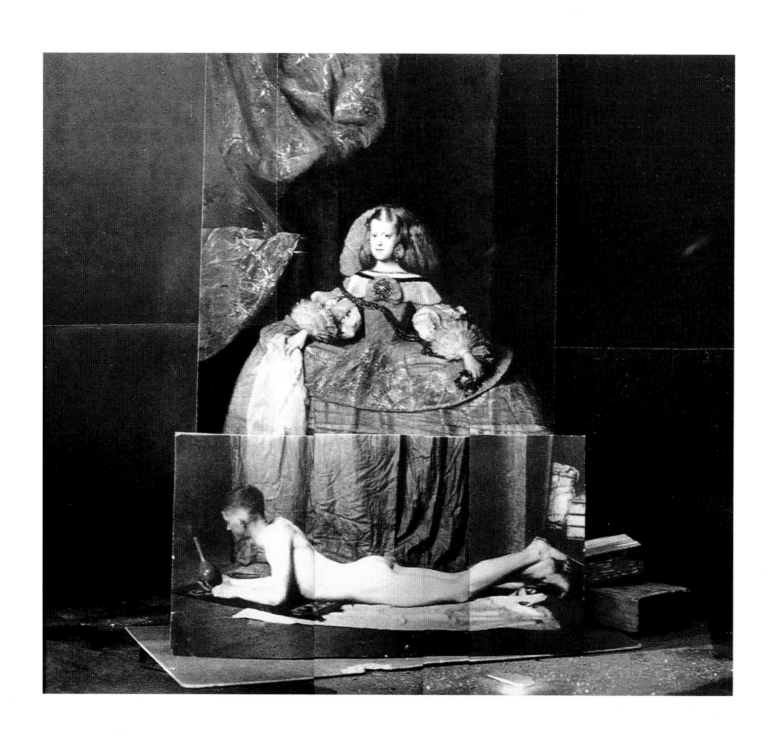

John O'Reilly, Bill Duckett as Baltasar Carlos, 1996

COURTESY JULIE SAUL GALLERY, NEW YORK, NY

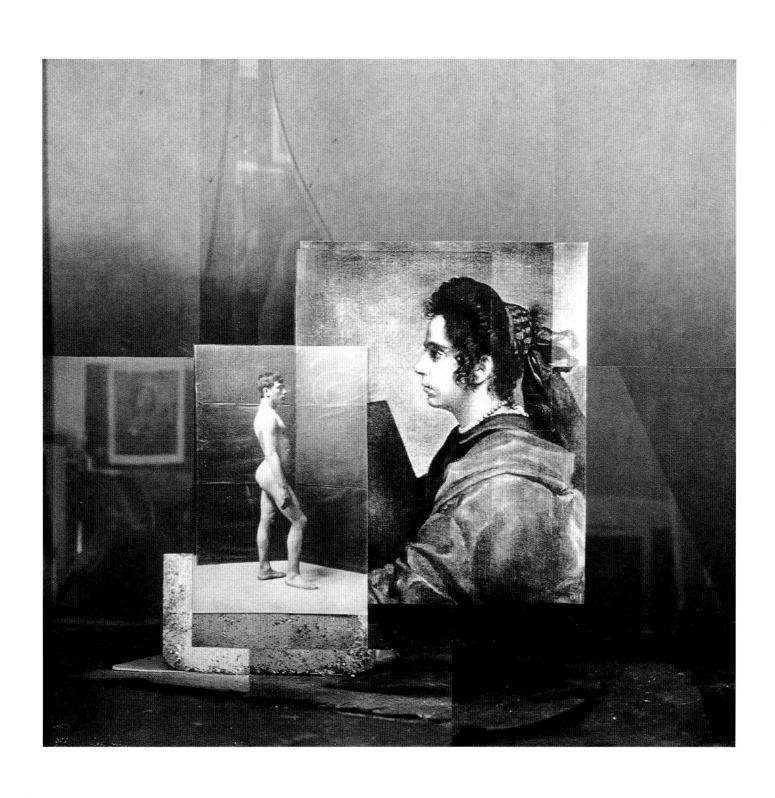

John O'Reilly, Tom Eagan and Velazquez's Wife, 1996

COURTESY JULIE SAUL GALLERY, NEW YORK, NY

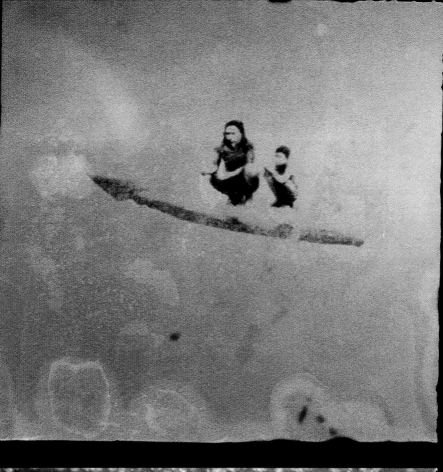

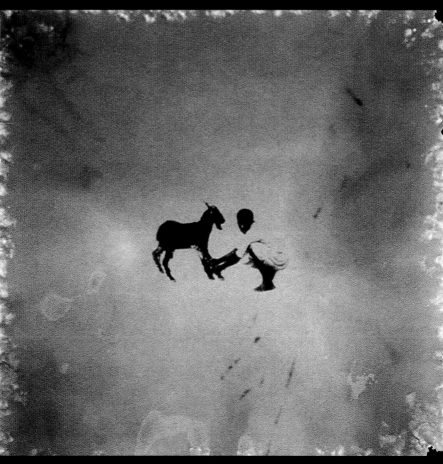

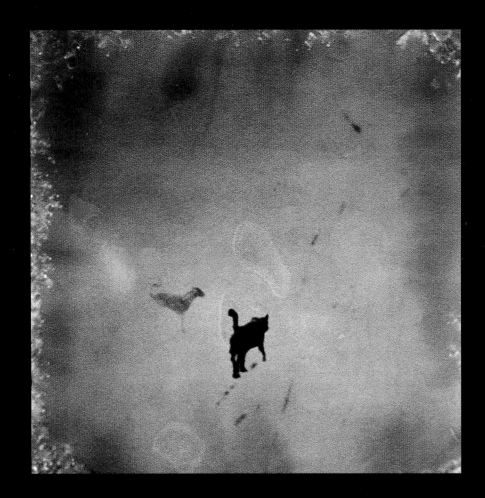

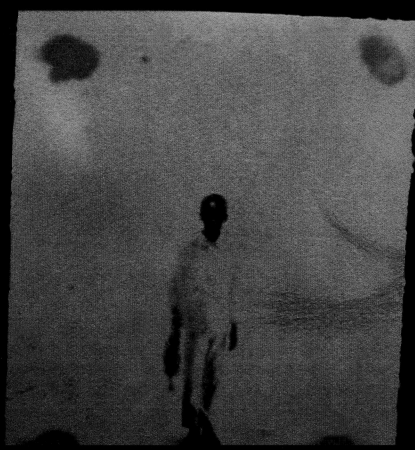

Eduardo Garcia del Real Cortils
(TOP) *History of Job–Part Three, 1996* (BOTTOM) *History of Job–Part One, 1996*

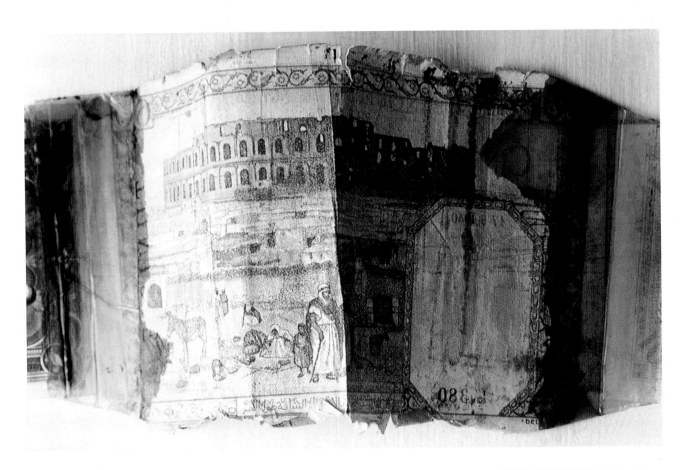

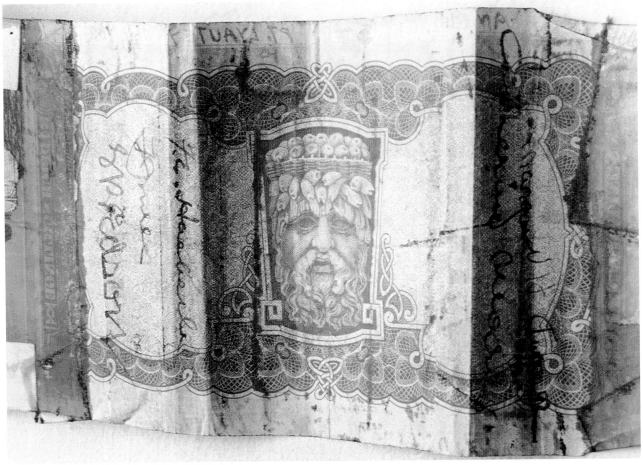

Andrew Bush
(TOP) *Tunisia, 1995* (BOTTOM) *Irish Punt, 1995*
From the Short Snorter series

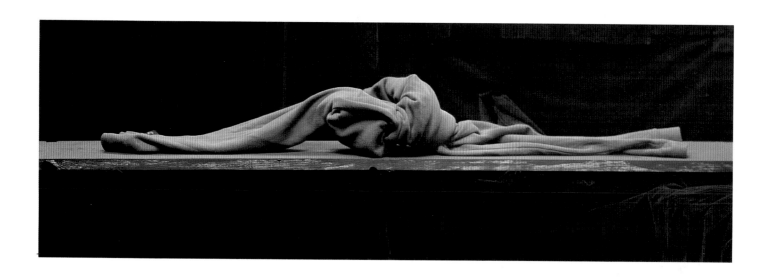

Zeke Berman, Knotted Shirt, 1995

COURTESY LAURENCE MILLER GALLERY, NEW YORK, NY

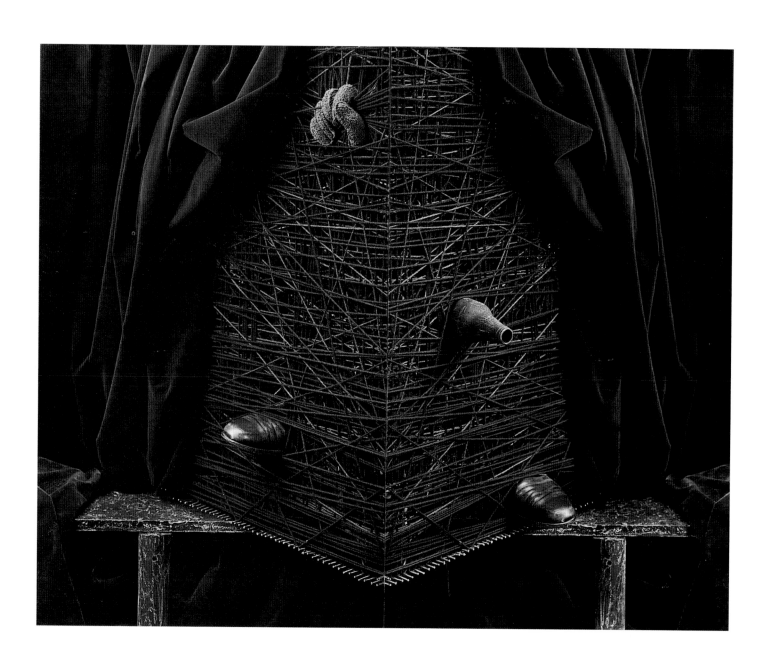

Zeke Berman, Inside Outside Diptych, 1995

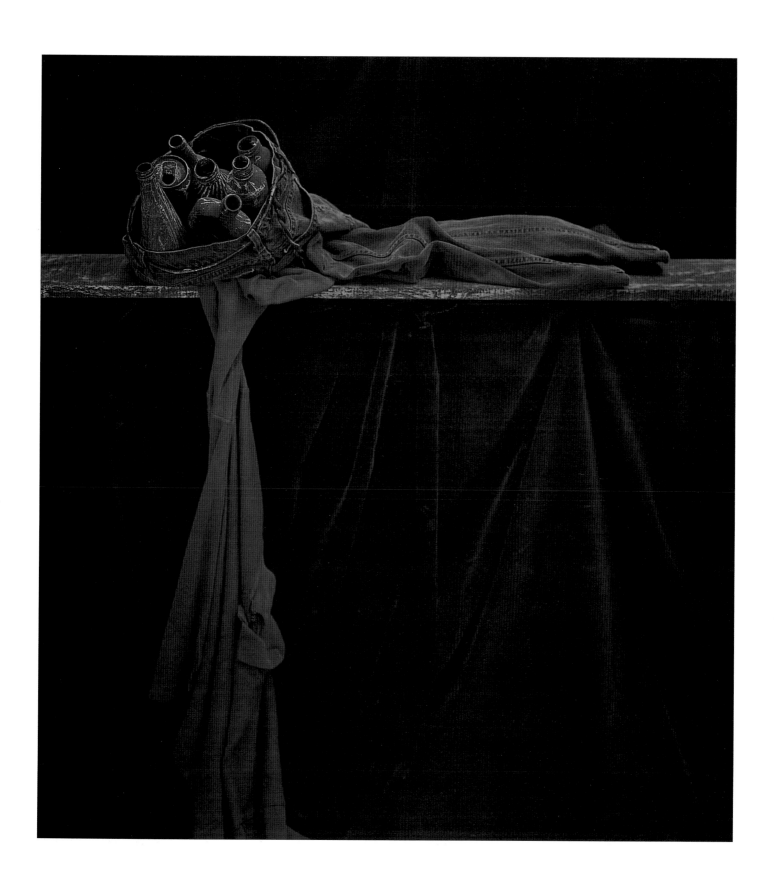

Zeke Berman, Pants, Shirt, Bottles, 1996

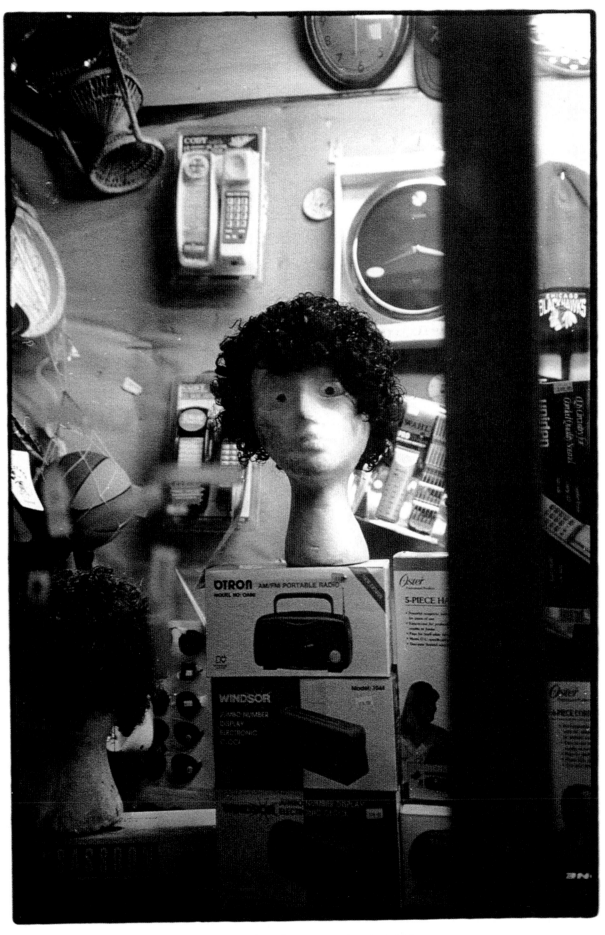

Zoe Leonard, White Foam Head, 1995

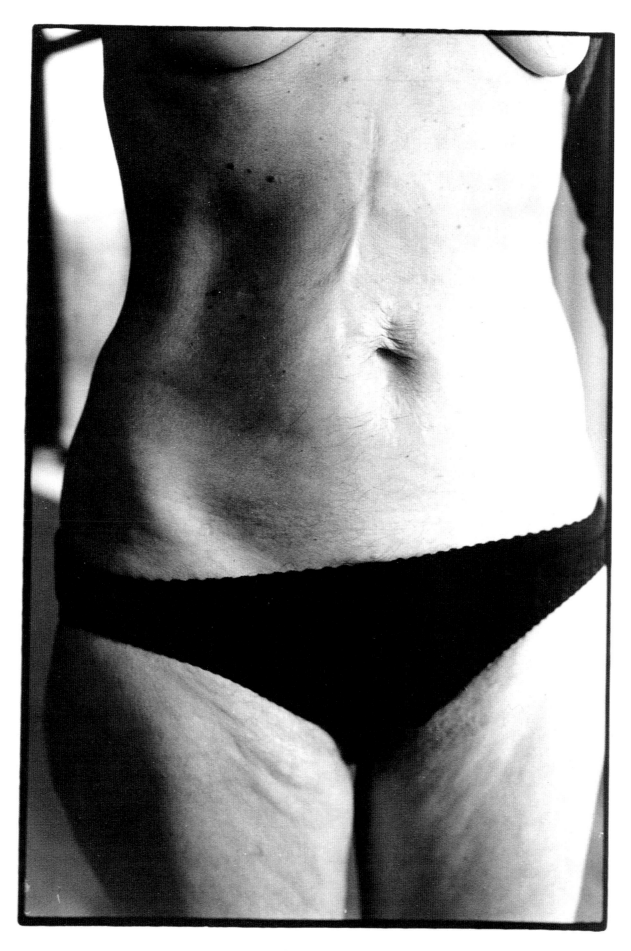

Zoe Leonard, Misia's Scar, 1995

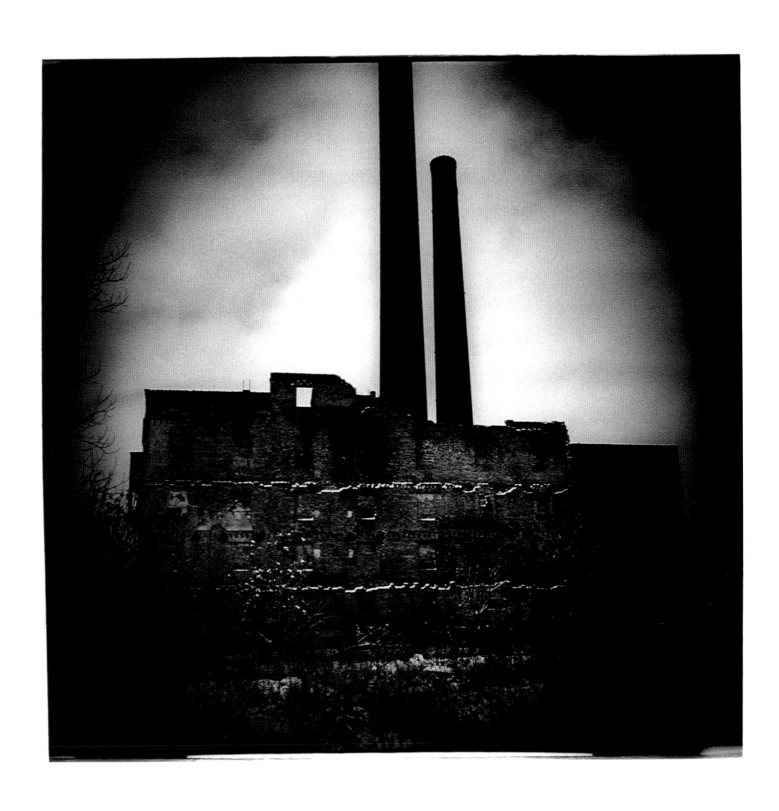

James Fee, Two Stacks, East St. Louis, 1995

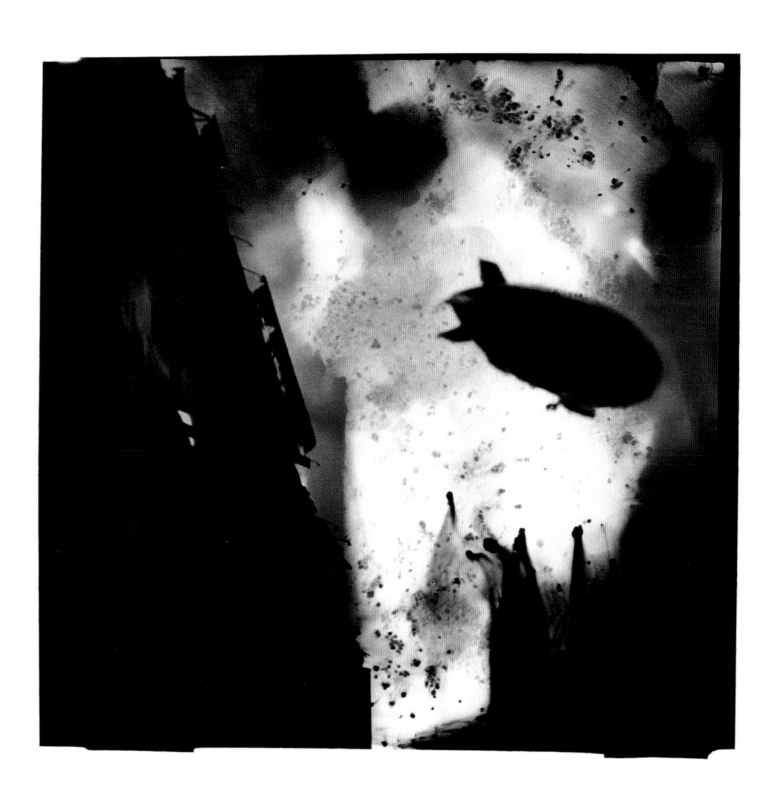

James Fee, Westside Highway, New York, NY, 1995

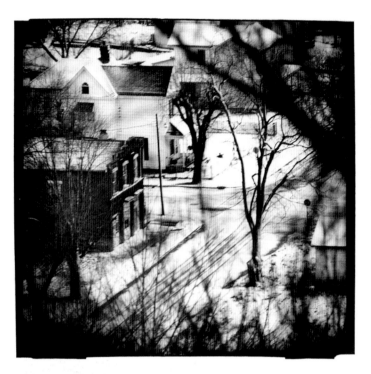
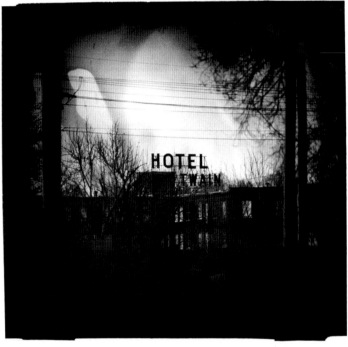
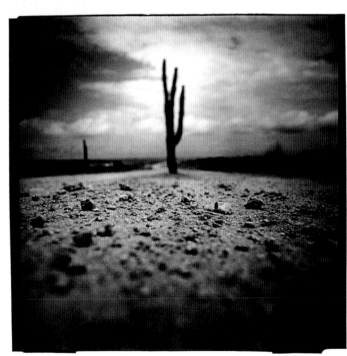
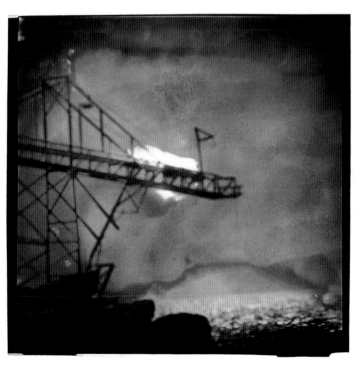

James Fee
(TOP LEFT) *Street Corner in Snow, Hannibal, Missouri, 1995* (TOP RIGHT) *Hotel Mark Twain, Hannibal, Missouri, 1995*
(BOTTOM LEFT) *Three Finger Cactus, San Felipe, Mexico, 1995* (BOTTOM RIGHT) *Scaffolding, San Felipe, Mexico, 1995*
COURTESY CATHERINE EDELMAN GALLERY, CHICAGO, IL

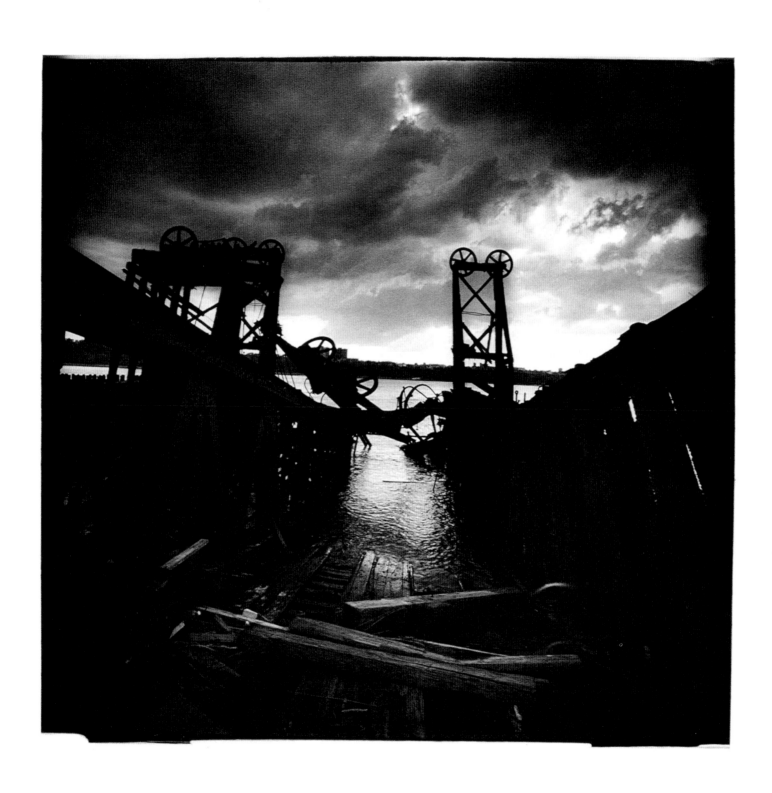

James Fee, 72nd Street Ferry, New York, NY 1995

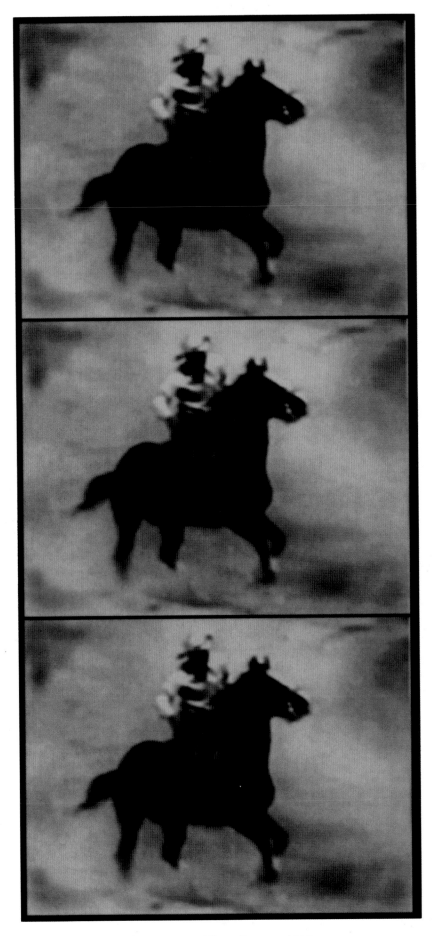

Gwen Akin, Three Horses, 1997

INDEX

VERZEICHNIS

INDEX

INDEX OF GALLERIES

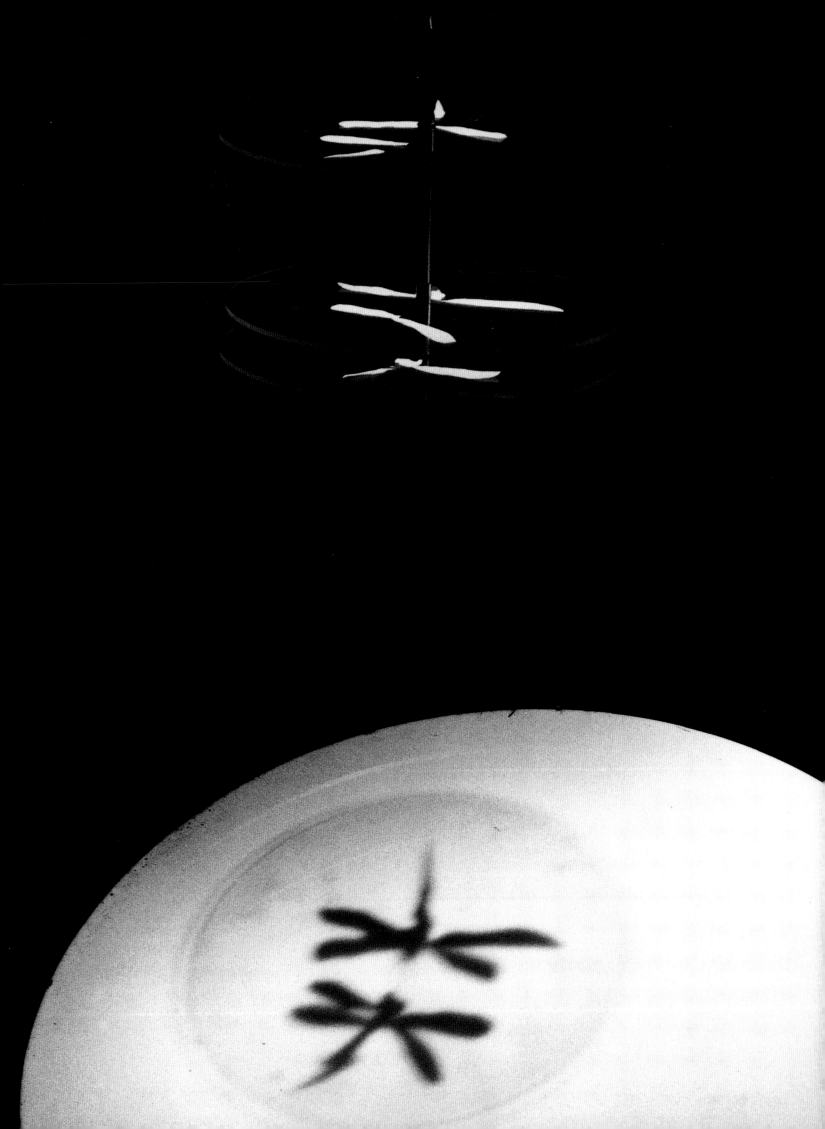